The Overlook
Treasury of Federal Antiques

The Overlook Treasury of Federal Antiques

by George Michael

The Overlook Press
Woodstock, New York

This book
is dedicated to
Philip Hammerslough,
whose unselfish assistance
to writers, collectors, museums, and restorations
inspires the study of antiquity.

First published in 1986 by
The Overlook Press
Lewis Hollow Road
Woodstock, New York, 12498

Library of Congress Cataloging in Publication Data

Michael, George, 1919-
The Overlook treasury of Federal antiques

Reprint. Originally published: George Michael's
Treasury of Federal Antiques. New York: Hawthorn Books,
1972.
Bibliography:p
Includes index.
1. Antiques—United States. 2. Decoration and
ornament—United States—Federal Style. I. Title.
NK806.M5 1986 745.1'0974'075 86-12758
ISBN 0-87951-254-7 (cloth)
ISBN 0-87951-268-7 (paper)

Acknowledgments

The majority of items shown in this book have never before been photographed or seen by the general public. I have journeyed to homes of friends and to restorations and museums where cameras are permitted in order to show some of the best of the many different and classic designs of the Federal Period.

A work of this type would be impossible without the help of many friends and institutions, both in and out of the collecting field. I wish to thank the following institutions for their kind assistance with pictures and information: The Museum of Fine Arts, Boston, Massachusetts; The Metropolitan Museum of Art, New York; New York Historical Society, New York; Cooper-Hewitt Museum of Decorative Arts and Design, Smithsonian Institution, New York; Philadelphia Museum of Art, Philadelphia, Pennsylvania; Pennsylvania Historical and Museum Commission; Western Reserve Historical Society, Cleveland, Ohio; Currier Gallery of Art, Manchester, New Hampshire; Manchester Historic Association, Manchester, New Hampshire; New Hampshire Historical Society, Concord, New Hampshire; Massachusetts Historical Society, Boston, Massachusetts; Hershey Museum, Hershey, Pennsylvania; William Penn Memorial Museum, Harrisburg, Pennsylvania; Historical Society of York County, York, Pennsylvania; Baltimore Museum of Art, Baltimore, Maryland; Baltimore Historical Society, Baltimore, Maryland; Bennington Museum, Bennington, Vermont; Shelburne Museum, Shelburne, Vermont; Wadsworth Atheneum, Hartford, Connecticut; The American Museum in Britain, Bath, England; Corning Museum of Glass, Corning, New York; City Art Museum, St. Louis, Missouri; Parke-Bernet Galleries, New York; The Henry Ford Museum, Dearborn, Michigan; The Ohio Historical Society.

Additionally, I wish to thank the friends who so kindly helped with information, advice, pictures, and permission to take pictures: Philip Hammerslough, West Hartford, Connecticut, national authority on American silver and Tucker china; Lowell Innes, Honorary Curator of Glass at the Currier Gallery, Manchester, New Hampshire; Richard Carter Barret, Director-Curator, Bennington Museum, Bennington, Vermont; Bradley Smith, Curator, Shelburne Museum, Shelburne, Vermont; Mrs. Elvira Avery, Wolfeboro, New Hampshire; June Fairchild, Cleveland, Ohio; Eric de Jonge, Chief Curator, William Penn Memorial Museum, Harrisburg, Pennsylvania; David Brooke, Director, and Melvin Watts, Curator, Currier Gallery of Art, Manchester, New Hampshire; Janet Thorpe, Associate Curator, Decorative Arts Department, Cooper-Hewitt Museum of Decorative Arts and Design, Smithsonian Institution; Kenneth Wilson, Curator, Corning Museum of Glass; Richard A. Bourne, of the Bourne Gallery, Hyannis, Massachusetts; Mr. and Mrs. Burt Halbert, Rebel's Roost Antiques, Lexington, Kentucky; Betty Lacey, Dayton, Ohio; Jabe Tartar, Akron, Ohio; and Ray Barlow, Windham, New Hampshire.

G. M.

Contents

List of Illustrations

Introduction

In the years 1770 to 1830 America evolved from a colony to a great, independent nation, regarded by many in the civilized world as a haven for freedom of expression and a better way of life. Newly arrived from many countries, the settlers took little time to become imbued with the thrust of greatness which was felt in every settlement, and craftsmen, reflecting the courage to break away from Old World traditions, struck out on their own to create masterpieces that are now collected as antiques.

Because a great spirit of federalism swept America during these years, the period, especially in architecture and the decorative arts, is known as the Federal Period. This designation distinguishes from the work being done in Europe, although craftsmen in both places were working with the same styles and designs. At the beginning of the period American craftsmen were working with styles popularized by Thomas Chippendale and his contemporaries and, later, with those introduced by George Hepplewhite and Thomas Sheraton, which retained their popularity until about 1830. In the early part of the nineteenth century the Directoire and Empire styles, popularized in France, began to creep into American cabinet shops. There was much sympathy among the Federalists with the French, since they had helped in the American Revolution and had recently undergone their own. Though early application of the Empire design resulted in some classic pieces, it led to the downfall of good taste in design, eventually resulting in monstrosities that are hardly a credit to any generation of craftsmen. The introduction of machine tools made it possible for craftsmen to experiment with ornate designs, formerly reserved for only the most skilled pairs of hands. From one wood carving, which served as a guide, other carvings were cut by machine, much in the manner a new key is made—by tracing its indentations. The influence

of the French styling was felt in our large cities, and its gaudy character was enlarged upon and embellished by the creation of large, bulky pieces with facades of machine carving and turning.

Most scholars feel that the period of true craftsmanship and good design in the United States came to an end about 1830. It is my attempt to outline the work of this last good period. The high standards set by the Chippendale and Queen Anne periods during the first three-quarters of the eighteenth century were reinforced during our Federal era.

Though age adds a patina of desirability as well as value to early and mid-eighteenth-century pieces, the native craftsmen of the Federal Period proved their ability to uphold the tradition of fine design and work. Some feel they went beyond, turning out pieces unmatched by earlier work as carving improved and inlay and veneer were used to great advantage.

Chapter 1

The

Federal Period

Begins

THE BOSTON MASSACRE—On March 5, 1770, Samuel Gray, Samuel Maverick, James Caldwell, and Crispus Attucks, a colored man, were shot in King Street, by the British troops, which were at that time quartered on the inhabitants. Seven others, Monk, Clark, Payne, Green, Patterson, Carr and Parker, were wounded. The affray led to a funeral in which four coffins lay side by side bearing on top the initials of the victims, death's heads, cross bones, scythe and hour glass. On the day of the funeral the shops were closed, and the bells of the town, Charlestown and Roxbury were tolled. A few days after the massacre the two regiments under Col. Dalrymple were removed to Castle William. Meetings of sympathy with the Boston sufferers were held in all neighboring towns; and a state of feeling was produced which probably was influential in accelerating the great revolutionary collision.

So read the account in the Boston *Gazette*, and so began the period of federalism in the thirteen colonies, which erupted into the War of Independence and a break with England.

After a successful conclusion of the French and Indian War, England began to look toward its colonies for additional revenue in the form of taxation. In their fight with the French the English

needed the aid and cooperation of the American colonists, so little thought was given to repressive taxation for fear they would not receive the cooperation they needed. The domination of the eastern seaboard, which was the settled area at the time, gave the British politicians an opportunity to pass laws for new revenues with which to fuel their lagging economy. Not all agreed; witness Sir Robert Walpole, who stated:

> I will leave the taxation of the Americans for some of my successors, who may have more courage than I have, and be less friendly to commerce than I. It has been a maxim with me during my administration to encourage the trade of the American colonies to the utmost latitude, for if they gain five hundred thousand pounds, I am convinced that in two years afterward, full two hundred and fifty thousand of this gain will be in his majesty's exchequer by the labor and product of this kingdom as immense quantities of every kind of our manufactures go thither; and as they increase in the foreign trade, more of our produce will be wanted. This is taxing them more agreeably to their own constitution and laws.[1]

In 1761 Governor Francis Bernard, of Massachusetts, signed a writ of assistance making a search without a warrant legal so that merchandise not passed through customs might be located in hiding places under suspicion. Merchants in Salem and Boston engaged the firm of Otis and Thatcher to make a defense against this law, which they felt to be unjust. Despite the impassioned oratory of Otis, the law was upheld, and those who attended the hearings in Boston left, citing that they were ready to take up arms against the writ. This was the first instance of opposition to the arbitrary claims of Britain. In 1764 the infamous Stamp Act was passed that gave rise to the famous "No taxation without representation" cry. In Boston Samuel Adams drafted a statement on behalf of a merchants' committee which observed, "Our greatest apprehension is that these proceedings may be preparatory to new taxes; for if our trade may be taxed, why not our lands—why not the products of our lands and everything we possess or use?"[2] This was the first act in the colonies

[1] Sir Robert Walpole, quoted in John Howard Hinton, *The History and Topography of the United States* (Boston: Samuel Walker, 1834), I, 182.
[2] Samuel Adams, quoted *ibid.*, p. 185.

in opposition to the ministerial plans of drawing a revenue directly from America, and it contained the first suggestion of the propriety of that mutual understanding and correspondence among the colonies that laid the foundation of future confederacy.

In 1766 a committee made up of members of the various houses of burgesses or representatives met in Massachusetts to consult about grievances and to devise some plan for relief. Timothy Ruggles, of Massachusetts, was chosen president of the group, and a declaration of rights and grievances was adopted. In August of that year an effigy of Andrew Oliver, the proposed distributor of the tax stamps in Massachusetts, was found hanging on a tree, afterward known as the Liberty Tree. (A plaque on a building at the intersection of Essex, Boylston, and Washington streets in Boston commemorates the event.) At night the effigy was taken down and carried on a bier amid the acclamation of a huge crowd of people through the courthouse and down King Street to a small brick building supposed to have been erected as distribution headquarters for the detested stamps. The building was razed, and the rioters then attacked Oliver's home. An association known as the Sons of Liberty was soon formed, with branches in New York and Boston and as far north as New Hampshire and as far south as South Carolina. These patriots denied themselves the use of any merchandise that was exported from England, and an effective boycott took hold throughout the colonies.

By the time of the Boston Massacre in 1770 the development of fine young American craftsmen was well under way—craftsmen who were destined to turn out the many items we prize as antiques today. Carding, spinning, and weaving became the daily employment of ladies of fashion. Sheep were forbidden to be used as food in order to guarantee a supply of wool, and to be dressed in homespun was a sign of distinction. Pewterers increased their output by scrounging whatever tin, antimony, and other metals they needed to ply their trade. Silver coins were melted down to provide elegant pieces turned out for the wealthy all along the seaboard, and from time to time a prize ship would be docked at a friendly harbor, and metals long withheld from America by trade with Britain were made available to native craftsmen. The British did not ship any raw materials to this country in order to protect the work of their tradesmen; they wanted to ship only the finished products in order to maintain a high level in their industrial economy. The growing lack of de-

pendence on foreign-made goods alarmed the British, and there were many spokesmen in Parliament who begged the repressive taxes be lifted in order to stimulate the economy at home, but these pleas fell on deaf ears with the exception of a brief period in 1766–1767.

On March 19, 1767, King George III went before the House of Peers and encouraged passage of the bill repealing the Stamp Act. The Americans responded to this warmly; ships flew gay colors, bells were rung, and cities were lighted. The gracious ladies who had been clad in homespun gave this clothing to the poor and reappeared in dresses imported from England. However, in May, 1767, the new Chancellor of the Exchequer, Charles Townshend, introduced a new plan of taxation for the colonies. This was to impose duties on glass, paper, pasteboard, white and red lead, painters' colors, and tea. It was cited that the tax money would be used to defend America and to defray the expense of administering civil government and justice. On June 19 it was passed, much to the discomfort of the Americans. Boston took the lead in resistance to it. At a town meeting in October it was voted that measures should be immediately taken to promote the establishment of domestic manufacturers by encouraging the consumption of all articles of American manufacture. It was also agreed not to purchase any articles of foreign growth or manufacture except those that were absolutely indispensable. New York and Philadelphia soon followed the example of Boston.

American ships soon entered the smuggling trade bringing needed raw materials into the country. One such was the packet *Providence*, which attempted to enter Newport harbor without challenge on June 9, 1772. It came under fire from the revenue schooner *Gaspee* but managed to elude it by threading its way around some shoals. When the *Gaspee* put up for the night in Newport harbor, a number of fishermen and other inhabitants of the community banded together and boarded the vessel, setting it afire and totally destroying it. The commander of the ship with his belongings and crew was ferried ashore. All Americans returned safely to their homes. The royal governor offered a reward of five hundred pounds to bring the perpetrators to justice, but after a long period of time during which no evidence was forthcoming, the matter was dropped.

On October 17 of that same year the residents of Falmouth, Massachusetts, obstructed the loading of a ship with masts for the Royal

Navy. A Captain Mowat arrived on the scene, gave the inhabitants two hours to remove themselves, and then ordered the town destroyed by the cannon of the ships in the harbor. The residents stood by helplessly as over four hundred houses and stores were destroyed. One can only conjecture at how many fine examples of early American craftsmanship went up in flames with them. Another such incident occurred in Virginia when on January 1, 1776, Lord John Murray Dunmore put into harbor and asked whether the provincials would supply his ship with provisions and received a negative answer. The townspeople themselves assisted in the destruction by doing away with houses and plantations near the water which held supplies the British could use. The entire community was reduced to ashes, taking with it again much of the work of the early artisans.

By this time the spirit of federalism was well entrenched in the bosoms of most Americans, and they rallied to Patrick Henry's cry, "Give me liberty or give me death." To fuel the war effort, all sorts of small shops and factories were set up throughout the thirteen colonies. Forges were erected for the making of cannon and other armament; gunpowder was made in practically every home; clothing of homespun and animal skins was turned out by industrious women everywhere; friendly Indian tribes assisted in the making of leather straps, powder horns, pouches, and the like; wagons of all sizes were crafted out of the farms; coopers were hard at work turning out the barrels that held gunpowder, water, and other supplies.

Yet despite the war and all the effort directed to it, many items for the home and farm were still being made to carry on the commerce of the nation. These are the items made from the time of the Boston Massacre until 1830, well after America enlarged its trade with the rest of the world. Much of what was made must remain legend, as it was destroyed. That which has remained graces the best of our museums and restorations as well as the homes of people who recognize this era as one of native creativity inspired more by the spirit of freedom than by that of suppression. Though America was still much influenced by the tastes and styles of England and the Continent, native craftsmanship imbued the pieces made during this era with a special quality, which makes them much more desirable to the American collector than the work of any other nation.

However, the battle was hard won. As early as 1670 Sir Josiah Child in the British Parliament pronounced New England "the most

prejudicial plantation of Great Britain" and gave for this opinion the singular reason that they are a happy people, "whose frugality, industry and temperance and the happiness of whose laws and institutions promise them long life, and a wonderful increase of people, riches and power." In 1731 the House of Commons took up the subject and called upon their board of trade operating in America to make a report "with respect to any laws made, manufactures set up, or trade carried on in the colonies, detrimental to the trade, navigation and manufactures of Great Britain." They learned that hats were made in the colonies in great quantity and were even exported to other countries. A law was passed forbidding hats or felt to be exported, or even to be loaded on a horse, cart, or other carriage for transportation from one plantation to another. Added to this was a rather unique law passed in 1750 which prohibited "the erection or continuance of any mill or other engine for slitting or rolling iron, or any plaiting forge to work with a tilt hammer, or any furnace for making steel in the colonies under penalty of two hundred pounds." Every such mill, engine, forge, or furnace was declared a common nuisance which the governors of the provinces on information were bound to abate under penalty of five hundred pounds within thirty days. It is no wonder the colonists felt repressed and engendered the passions that later led to war.

Actually, one of the first measures undertaken by the colonists was to establish their independence on the basis of productive industry and the "laborious arts of the country." This agreement with the exception of the addresses to the people of America and Great Britain was the only positive act of the first Congress that met in Philadelphia in 1774 and was signed by every member of that body. One of the articles states, "We will use our utmost endeavors to encourage frugality, economy and industry, and promote agriculture, arts and manufactures of this country." One of the first items manufactured in America under this new declaration was cut nails, which were turned out in the southern part of Massachusetts during the Revolutionary War, with old iron hoops for the material and a pair of shears for the machine.

With the arrival of peace in 1783 the colonists thought all their problems had been solved with respect to their own industry, but this brought a new set of problems not thought of by the venerable leaders of the strife. Foreign goods flooded the American market with

the free trade established, and this proved disastrous to craftsmen. The nation was not yet unified under a national plan, and the separate states attempted to regulate their own navigation and commerce. In 1788 citizens in Boston raised money to build three ships to carry goods made there into channels of foreign trade to help offset the balance. Tariffs were raised all along the coast, and the competition in world trade began in earnest. But industry on either a large or a small scale operated under slipshod regulations and haphazard conditions, quite unlike that which had been prophesied before the revolution. The arm that had struck for it in the field was palsied in the workshop; the industry that had been burdened in the colonies was crushed in the free states; and at the close of the revolution the artisans and mechanics of the country found themselves independent, but ruined so far as their immediate future was concerned.

On November 17, 1788, a letter from a group of concerned tradesmen and manufacturers of New York was addressed to their counterparts in Boston asking cooperation in pressing for unified endeavor to uplift the industry of the nation by working cooperatively for uniform regulations under which all could operate in harmony to the good of all. Parades were formed in cities like Boston, New York, Philadelphia, Charleston, and Portsmouth, New Hampshire, with banners waving in support of such a resolution. One of the banners read, "May the Union Government protect the manufacturers of America." Two petitions were presented to the Congress of the United States, one from Baltimore and one from Charleston, and another came within a few days from New York. This resulted in revenue laws passed in 1789, which remained in effect without changes until the Embargo Act of 1809, but by that time industrial capacity had enlarged and become strong enough to survive the fiercest of foreign competition. Production during the Federal Period came of age, and the artisans, who had patiently waited for this day, emerged as among the finest in the world, turning out a prodigious amount of goods.

The colonies were slow in developing natural resources and until the turn of the century had managed to wreak from the good earth no more than iron, bituminous coal, marble, granite, and some of the oxides used in coloring paint. Clay was abundant in every area. It was years later that anthracite coal and most of the metals were found. The anthracite was a product of the Lehigh Valley in Penn-

sylvania, and the metals were discovered in the West. The first oil well was not brought in until 1859 by Colonel Edwin Drake in Titusville, Pennsylvania.

Perhaps nothing altered the economy of the eastern part of Pennsylvania more than the discovery of the hard coal in Schuylkill County. It had been discovered as early as 1790 but was not used until 1795, when a smith near Port Carbon began to use it in his forge. His name was Whetstone, and he tried to encourage others to use it, to no avail. In 1806 another large deposit was found in the area, and another blacksmith, David Berlin, used it with success. Then in 1812 enterprising Colonel George Shoemaker loaded nine wagons with the product and took it to Philadelphia to prove its superior quality over soft coal. Coal-buyers accused him of attempting to defraud them by selling them black stones, and he had to give it away to persuade them to try it. In 1813 serious digging was under way, but not much of the product reached market in the larger cities to the south until a canal was built that enabled boats to travel between Pottsville and Philadelphia. Methods of digging were improved, and steam power was utilized to pump water out of the mines and power the improved crushers and screening devices.

Perhaps the first railroad in the country was installed in 1827 by Abraham Pott from his mines east of Port Carbon to the town where the coal was loaded on barges for the trip south. In 1829 the Mill Creek Railroad was built from Port Carbon to the Broad Mountain. The Schuylkill Valley Railroad was finished in 1830 and stretched from Port Carbon to Tuscarora. The Norwegian and Mount Carbon Railroad was finished in 1831, and it ran for four miles north of Pottsville.

Until 1820, wood was the only fuel used in Philadelphia, but as the forests began to disappear, new sources of fuel were sought. south until a canal was built that enabled boats to travel between Coal had been imported from England but was on a par with the price of wood, which even in those days ran between ten and fifteen dollars a cord. The nearby anthracite prompted the development of new fireplaces, new grates, and new stoves to burn the product, and by the time the railroads and canal were coordinated, the city gradually turned to anthracite as its primary fuel. A ton could be delivered there for about $5.00, which included the delivery of the coal to the boats at Port Carbon, $2.50; toll on the canal, $1.00; and the freight to Philadelphia, $1.50.

The close of the Federal Period was marked with this change in fuel, which had a great impact on the coming machine age. Anthracite created temperatures that far exceeded the then-popular fuels, which made all types of smelting and other metalworking easier and less expensive. There are traces of these old rail lines still in the woods in that area of Pennsylvania, and they bring a remembrance of the hard work and ingenuity of the pioneers who literally hacked their futures out of the wilderness.

When the settlers first landed in New England, they explored for sources of iron, as this was a necessity in the making of tools, firearms, and utensils. Some of the first deposits were found in the area of the Saugus marshes and in the area of what is now known as Braintree, Massachusetts. John Winthrop, Jr., the son of the colony's first governor, realized the importance of the discovery, and he sailed back to England to interest investors in the erection of an iron foundry. He recruited the capital and workers and returned to open an ironworks in Braintree in 1643. It was not a success and is believed to have ceased production in 1647. Meanwhile, a Richard Leader, formerly a merchant of Sussex, England, came to Saugus and began construction of a works there in 1646. It was called Hammersmith, and the first iron was made there in 1647. Until its demise in 1665 because of financial and other problems, it produced a good grade of ore and assisted in the training of many ironworkers who eventually left for other colonies to start ironworks. Some ended up in New York, Connecticut, and Pennsylvania as well as in many other areas of New England.

By the time of the Revolution much exploration had been undertaken for natural resources to fuel the growing manufacturing, which until this time had been so dependent on imports. Iron was plentiful in the highlands of New York, in New Jersey and Connecticut, in the Yellow and Iron mountains of North Carolina, near Brunswick, Maine, and in Pennsylvania, Ohio, and New Hampshire. Copper was discovered near Stanardsville and Nicholson's Gap in Virginia, and red oxide of zinc, along with magnetic iron, was plentiful near Sparta, New Jersey. New York contributed manganese and white ore of cobalt, and some of the latter was also found in North Carolina and near Middletown, Connecticut, and Morristown, New Jersey. Different sections of the Appalachian Mountains contributed ochres from bright yellow to dark brown to color homes and furniture. Rhode Island was discovered to be a good source of anthracite as well as black

chalk and alum slate. Until the West was opened, the greatest deposit of silver was uncovered near Portsmouth, New Hampshire.

Gold was first discovered on the border of the Yadkin River in North Carolina. By the end of the period almost a half million dollars' worth a year was dug up and furnished to the United States Mint. The region extended into Virginia, South Carolina, Georgia, Tennessee, and Alabama within an area of about a thousand square miles. America was responsible for about one fifth of the world's production at the time. Much was used in manufacture; some was shipped overseas in trade; and about half was minted into gold coins.

Graphite was located in both New Hampshire and New York State, and quantities from both areas were used for the lead pencils of the day.

Salt came from New York State and to the west. Perhaps the greatest deposit of the time was located at Salina, near present-day Syracuse, where huge boilers and dehydration vats were installed as early as 1810. Salina had a direct connection with the Erie Canal after it was completed in 1825 and was soon shipping as much as three million pounds of salt a year.

While boring for salt at Rocky Hill, Ohio, about a mile and a half from Lake Erie, the auger dropped out of sight at 197 feet. Suddenly, salt water spouted high into the air and after several hours was replaced with what was then described as inflammable air. Fires in the shops of the local workmen set it ablaze, and it leveled everything in flames for a great distance around before it expired. Thus, Ohio became the first location where natural gas was struck.

Lime and soda were prevalent in all areas, but especially so in Pennsylvania and New York State. Eventually, glassmaking became the greatest use of these products.

The search for raw materials had produced an enviable number by 1830, and many remained idle for want of manufacturing facilities to use them. After the War of 1812 America had a rather stable established industrial complex set up to take care of its needs, but as trade was renewed with Britain, almost half of America's industries closed up because of this competition. At this time iron was selling in bars at about sixty dollars to the ton, whereas that imported from England could be had at about half that price. Embargoes and duties were enacted, and by 1824 some measure of protection had been afforded American industry. In 1828 another tariff law was enacted

protecting the makers of cloth and woolens, and this resulted in rapid growth of these concerns.

The craftsmen in America were hard at work competing with their foreign cousins and at the end of the Federal Period had succeeded in dominating internal trade. An excellent description of a city home in New York at that time was given by a Mr. Cooper, an Englishman who visited America and returned home to write the following:

The house in question occupies, I should think, a front of about thirty-four feet on Broadway and extends into the rear between sixty and seventy more. The exterior necessarily presents a narrow ill-arranged facade that puts architectural beauty a good deal at defiance. The most that can be done with such a front is to abstain from inappropriate ornament and to aim at such an effect as shall convey a proper idea of the more substantial comforts of the neatness that predominate within. The building is of bricks, painted and lined, and modestly ornamented in a very good taste, with caps, sills, cornices, in the dark red freestone of the country. The house is of four stories, the lower being half sunk, as is very usual, below the surface of the ground. The door is nearly on a level with the windows of the first floor which may commence at the distance of about a dozen feet above the pavement. To reach this door, it is necessary to mount a flight of steep, inconvenient steps, also in freestone, which compensate in a slight degree for the pain of the ascent by their admirable neatness and the perfect order of their iron rails and glittering brass ornaments. The first floor is occupied by two rooms that communicate by double doors. These apartments are of nearly equal size and subtracting the space occupied by the passage, and two little china closets that partially separate them, they cover the whole area of the house. Each room is lighted by two windows; is sufficiently high; has stuccoed ceiling and cornices in white; hangings of light, airy, French paper; curtains in silk and in muslin; mantel-pieces of carved figures in white marble; Brussels carpets; large mirrors; chairs, sofas and tables in mahogany; chandeliers; beautiful, neat and highly wrought grates in the fireplaces of home work; candelabras, lustres, etc., much

as one sees them all over Europe. In one of the rooms, however, is a spacious, heavy, ill looking sideboard in mahogany, groaning with plate, knife and spoon cases, all handsome enough, I allow, but sadly out of place where they are seen. On the second floor, the rooms have curtains in blue India damask, the chairs and sofas of the same coloured silk and other things are made to correspond. The doors of the better rooms are of massive mahogany; and wherever wood is employed, it is used with great taste and skill. All the mantelpieces are marble; all the floors are carpeted, and all the walls are finished in a firm, smooth cement. The whole building is finished with great neatness and with a solidity and accuracy of workmanship that it is rare to meet with in Europe out of England.[3]

There is no question that Massachusetts dominated the field of commerce in this country at that time. It had a greater number of people at work in industry than any other state, and there were more fisheries and fishing vessels at work here than perhaps in the rest of the states combined. There was great fruit cultivation, and the spoils of these orchards found their way by ship and wagon to all parts of this country as well as to Europe and the Caribbean. Chief exports were fish, beef, pork, lumber, spirits, flax seed, whale oil, furniture, glass, cotton cloth, boots and shoes, cordage, wrought and cast iron, nails, woolens, straw bonnets, hats, paper, oil, and muskets. In Springfield the armory had been established for making of arms for the government, and about forty-five muskets per day were turned out by about 250 men. Whaling was a big industry which encouraged the building of shipyards whose output was unmatched anywhere else. The first automatic loom was set up in Waltham in 1815, and from this sprang an industry that produced textiles equivalent in quality to those made in England and which were soon to be the most accepted in this country. Quarries of marble were set up in Lanesborough, Stockbridge, Sheffield, and Pittsfield; slate at Lancaster, Harvard, and Bernadston; soapstone at Middlefield; and granite in Chelmsford and Tyngsborough. "Boston Harbor is as fine as can be found anywhere—at least five hundred

[3] *Ibid.*, II, 284.

vessels can ride anchor, yet the inlet will barely allow two abreast. More stagecoaches were in operation out of Boston than any place in the nation—there were about ninety different lines operating, which were responsible for about two hundred and fifty departures and arrivals each day." [4]

The history of New York, the second largest point of commerce, predates that of New England. A French vessel under the command of John de Verrazzano was sent by Francis I, of France, to explore for new countries to be placed under the French flag. In the middle of March, 1524, he touched land at about the area of Wilmington, North Carolina, and then proceeded south to what is now Georgia. From here he turned north and anchored in the harbor of present-day New York City. He stayed in the harbor about fifteen days and freely traded with the Indians who came aboard. He sailed north on May 5 and returned home via Labrador. His report to the king gave no encouragement to send further expeditions, as nothing was found that would enrich the king's coffers.

In 1607 a London company outfitted Henry Hudson and sent him west to discover a northwestern passage to the East Indies. Voyages that year and in the following resulted in failure. Hudson then went to Holland to work for the Dutch East India Company and in a small ship, the *Half Moon,* set sail and landed near what is now Portland, Maine, on July 18, 1609. He sailed south to Chesapeake Bay, thence to Delaware Bay, and then landed on Coney Island. From there he entered the Narrows and sailed north up the river that now bears his name. He set anchor at a point near present-day Hudson and sent men in a smaller boat to explore the river farther north, which they did until they reached the falls above what is now Albany. They found friendly Indians all along the way and did much trading. The trip down the river from Hudson was somewhat different: The Indians attacked from the shore, shooting arrows into his ship, but none of the crew was injured. His trip up and back took a month, and once he fled through the Narrows, he headed home, making no further stops. His next trip was not so successful. In 1610 he came west again and discovered the bay that bears his name in Canada. He was caught there by the winter ice and forced to spend the cold weather under incredible hardships. Finally, when

[4] *Ibid.*

the ship was set free of the ice, the crew mutinied and set Hudson, his son, and seven others, most of whom were sick, into a boat and cast them adrift on June 22, 1611. They were never seen again.[5]

Hudson's efforts and his reports on what he had found in the New World inspired his sponsors to send further expeditions to this country, which resulted in a fur trading post being erected in Albany in 1614. Further colonization took place, but it was not until 1625 that the West India Company sent two ships, one carrying Peter Minuit, to colonize present-day Long Island and New York City.

The colonization by the Dutch left its imprint on New York City and the Hudson River area. It was not until the Federal Period that it began to change into a cosmopolitan city with greater influences left by the English and the French.

[5] John W. Banks, *Historical Collections of the State of New York* (New York: S. Tuttle, 1842), p. 15.

Chapter 2

Federal

Period

Furniture

After the Revolutionary War the colonists witnessed an evolution in tastes due in part to the war itself and, also, to the continual flow of immigrants. New York City, the seat of the first national government, served as the focal point of the country; geographically located at the center of the colonies, it was also blessed with an outstanding harbor, which could accommodate a great amount of shipping with little trouble. In addition, New York seemed to be an area of greater freedom. In comparison with the other colonies religion played a minor part in its life, especially after the Flushing Remonstrance, guaranteeing freedom of worship, was signed in the 1660's. Although the area was then under Dutch control, there was no dominating religious sect. The sudden influx of people, who came from almost every nation in Europe, made New York the melting pot it is today. It developed into a rather cosmopolitan town with artists, writers, craftsmen, and entertainers all vying for the dollars being spent by the wealthy who were engaged in the growing commerce of the times. The period after the Revolutionary War was one of especially great activity, since as the acting capital of the country, New York was the home of many notables, including George Washington. It was at this time that American character began to show itself in arts and crafts, only to be dashed to bits less than a century later by the Industrial Revolution.

The revolution in France caused many of the French nobility to

escape as quickly as they could with their lives and savings but with few possessions. They entered New York in great numbers, and since many of them had enough wealth and security to purchase new homes and furnishings, the French émigrés had a great impact on the economy as well as on the styles of the times. There was much sentiment for the French, especially after their aid in the Revolutionary War. This sentiment, combined with what was then considered dash and style in the French fashion, conspired to lead American craftsmen downhill as far as purity of form and design was concerned. By 1830 practically all semblance of good taste had disappeared in favor of gaudy and bulky furniture, whose designs still haunt us today.

Before examining furniture made during the Federal Period it is helpful to know about the changing styles and tastes that preceded this period's basic designs. From the beginning of the eighteenth century furniture in America was made by men who worked with no design books; they worked from memory, re-creating pieces they had made before coming to the New World or imitating work they had been exposed to in their native countries. It is no wonder that so many varied pieces were created, some modeled directly after European fashions, incorporating different woods and ideas gathered in the colonies. During the period from 1700 on, some of the finest-styled pieces were created, which are now those most desired by collectors. Dutch and English influences predominate in Queen Anne and Chippendale styles. The delicate lines of the former have created the most graceful pieces made to date. The slender cabriole leg, which was Dutch inspired, along with fine dimensions and proportions in the case pieces, chairs, and tables and delicate carving for decoration produced a period of furniture unexcelled for purity of form and eye appeal.

That the purity of the Queen Anne form was preserved for about fifty years is a tribute to the cabinetmakers' creative thought and execution. Design books were not readily available, and hence it seems amazing that the craftsmen were able to reproduce furniture so faithfully. Confusing to the scholars of Queen Anne furniture are the number of pieces made in the Queen Anne style throughout the eighteenth century. Documentation proves their age. This survival of a style seems remarkable yet is understandable if one considers the number of craftsmen who resided in the country, too remote

to participate in the vagaries of city fashion. Some reproductions may have served as companion pieces to furniture handed down by earlier generations. These replacements and additions were made by hand with the same type of woods. They have aged enough to acquire sufficient patina to be mistaken for those turned out fifty or seventy-five years earlier. The number of Queen Anne pieces actually made during the latter part of the eighteenth century will never be known, but as with most items, as long as a style is pure, the piece will not be faulted for its lesser age.

During this time, imports from abroad were finding their way into American homes, especially through seaport cities like New York. Some scholars have expressed the opinion that American craftsmen were years behind the Europeans in style changes and techniques; others maintain it was but a few months, since any new boatload of furniture brought with it samples of the new work, which was immediately copied.

After 1700 both English and American furniture had come out of the oak period, with newer woods being used. By 1720 oak and walnut had almost disappeared in favor of mahogany. Walnut became scarce because of a disease that blighted trees in France, and the expanding trade with the West Indies had brought with it the new wood needed. The best of the mahogany came from Cuba; it was not too soft, and it was fine grained. American craftsmen worked in the available maple, birch, pine, cherry, hickory, poplar, walnut, mahogany, and various fruitwoods. Lesser woods like beech and elm were used where available. Because of the light color of the woods and the fine natural graining, it was not long before the American work outdistanced the European in popularity. Here was a raw material that could compete with the finest Europe had to offer and one that the Crown could not withhold from the colonies. Time has proved that Americans were ahead in this phase of craft competition long before they achieved independence.

Even with the arrival of design and price books, used by journeymen everywhere, cabinetmakers insisted on injecting personal tastes. They catered to the tastes of newly arrived settlers and satisfied them with the basic designs then in vogue. Yet they developed a sense of proportion in their designs that was never excelled abroad. The flamboyant Louis XIV, Louis XV, and Louis XVI furniture, which had a marked influence on English and European designers, hardly

made an impression on the American craftsmen of the eighteenth century. However, after the turn of the century, French designs did gain a hold, and quality began to deteriorate. This was not entirely the fault of the designs themselves; it was because of the industrial age, when machines took over the laborious tasks of men. Bending, shaping, and carving became much easier when done by machine, and this contributed much to the garish designs turned out during this era.

During the middle of the eighteenth century the first design books appeared in England, and their impact spread rapidly. The names of some of these designers have survived well, and period styles have been named after them; for example, Chippendale, Hepplewhite, and Sheraton, who roughly encompass the 1750–1830 era. Yet there are lesser-known designers who made important contributions—often techniques or styles that are generally credited to the better-known makers. William Jones published what is now regarded as the first pattern book, *The Gentleman's or Builder's Companion*, in 1739. Primarily a book of proportions and dimensions, it enabled the country cabinetmaker to keep in step with the city styles.

Thomas Chippendale issued his first *Cabinet-Maker's Guide* in 1754. He is probably the best-known designer working in the mid-eighteenth century. Although he is credited for almost every style change at this time, there is reason to suspect that the ideas were not entirely his own. It is thought that Chippendale may have copied designs from Ince and Mayhew, a firm that was in business from 1759 until 1810. According to Arthur de Bles,[1] Ince and Mayhew designed many of the elegant tables and chairs which are now generally credited to Chippendale's shop. Although Chippendale is generally credited for popularizing the ball-and-claw foot, he may have borrowed this design from Jacques Androuet's *Book of Design*, which was published in France in 1550, nearly two centuries before the design became popular in England. Also, according to De Bles,[2] Chippendale seemed to be a great borrower of ideas from his contemporaries, including Robert Manwaring, Matthias Lock, Batty Langley, and Sir William Chambers.

Nonetheless, much credit must be given Chippendale, for he seemed

[1] *Genuine Antique Furniture* (New York: Thomas Y. Crowell, 1929), p. 253.
[2] *Ibid.*

able to comprehend the tastes of the public and quickly adapted any new ideas to his own designs to be sure he was at least with the pack if not ahead of them. He must have succeeded, because the importance of his designs is still felt, and much of his influence turns up in furniture made today. He combined the best of Dutch, Gothic, French, Chinese, and the prevailing English designs into very harmonious pieces. His chairs were masterpieces, beautifully designed, strong, and well planned. He relied on exquisite carving to beautify his pieces and is not known to have used inlay or veneer for this purpose. To satisfy some customers, he did lacquer and paint some pieces after the Oriental motifs then in vogue.

Thomas Johnson was well known in London not only as a cabinetmaker and designer but also as a carver. He worked in what was then considered the "modern" style. Johnson may have exerted great influence on Chippendale, since he was a master of the French styles of the period, and his work reflected the taste from across the Channel. In 1758 Johnson published several works and treatises, which dealt with different facets of constructing furniture, mirrors, and the like.

The Chinese influence can perhaps be credited to Sir William Chambers. According to N. Hudson Moore,[3] Chambers had taken a trip to China and was intrigued with the Chinese style of cabinetry. The squared leg, often fluted, is generally regarded here as the Chippendale country-style leg, but credit for this must go to Chambers who first instituted its use in England. He published an important design book titled *Designs for Chinese Buildings, Furniture, Dresses, Etc.*, in 1757. We have heard reference to the "Chinese Chippendale" design in furniture—again, Chippendale received credit for someone else's ingenuity.

Robert Manwaring, who published *The Chairmakers' Guide* in 1766, is best known for his chair designs. Less is known about Matthias Darly, whose book on styles covered many types of furniture.

The Adam brothers, Robert and James, were actually architects who had been trained in classical styles. Much excavation took place at ruins in Italy, beginning in 1738, and in Greece, a decade later. Places were gradually uncovered, and a new interest grew in the elegance of the timeless architecture. The Adams pioneered in the classical concept and became very busy designing homes and furnish-

[3] *Old Furniture Book* (New York: F. A. Stokes Co., 1903), p. 55.

ing them. Their work influenced the design of the Georgian colonial homes in America. In addition, their work influenced Chippendale and one wonders how much of their work has been incorrectly attributed to Chippendale. They designed the furniture, but according to De Bles,[4] they never made it; instead they engaged such well-known shops as those run by George Hepplewhite and Thomas Sheraton to make the pieces. Naturally, this work must have influenced these men, who were later to prepare their own design books. The Adams are generally credited with the return of fluting to legs and with satinwood inlay and veneer.

Perhaps the least-credited designer was Thomas Shearer. He seems to have been responsible for a major change in style, later amplified during the Federal Period. When we think of the change from the ornately carved and heavily curved designs of the late Queen Anne and Chippendale eras, we tend to think of George Hepplewhite and Thomas Sheraton as the pioneers. Actually, Thomas Shearer deserves much of this credit. He should be regarded as the father of Federal design, with those who followed as his disciples. Shearer published *The Cabinet-Maker's London Book of Prices* a year before Alice Hepplewhite published her late husband's *The Cabinet-Maker and Upholsterer's Guide*. The many styles in Hepplewhite's book closely resemble the work not only of Shearer but of the Adam brothers. And one may very well question why Hepplewhite's name looms so high in the furniture world. Shearer should be credited with the first one-piece sideboard as we know it today. He designed them with both a bowed front and a serpentine front. He is known to have designed tables, chests, writing desks, dressing tables, and sideboards, but nowhere does a chair or settee design appear credited to him.

As of 1770 American cabinetmakers were still steeped in the Chippendale design, and many country workers were still actively turning out bandy-legged, duck-footed pieces in Queen Anne. The city craftsmen, influenced by the latest news from either new wood-workers who emigrated to America or the actual pieces themselves, continued to change their ideas to meet the demands of their rich clientele. The wealthy wanted furniture that was a little higher-styled and more ornate than pieces found on nearby farms. They

[4] P. 271.

engaged the best makers to design their work in the prevailing styles so that they would not be considered provincial by relatives who might visit them from overseas, and, above all, so that they could keep up with the Joneses.

How much furniture was made during this period of civil unrest will never be known. Many city craftsmen left for safer abodes in the country, away from occupying forces. The colonies had been in ferment for some time, and many people were more concerned with their status and future than they were with outfitting homes. Patriots mustered funds for the support of the colonies and had little to give to furniture designers.

One begins to question the attributions of many Federal Period pieces, especially when one considers the great amount of furniture that is claimed to have originated in Boston, Newport, Salem, Portland, Portsmouth, and their surrounding areas, when Boston, the largest of the New England furniture-producing cities, had fewer than 25,000 inhabitants at the time of the American Revolution. In addition, the abundance of really fine furniture made in the pre-1800 styles makes one wonder how much was actually made after the turn of the nineteenth century, when populations had burgeoned. There were many country cabinetmakers working up to the time of the Civil War making pieces entirely by hand, because they did not have, or perhaps could not afford, power machinery. In addition, there must have been some people during the early and mid-nineteenth century who preferred the clean lines of Federal furniture to the prevailing Empire and Victorian styles and would have their furniture made to order. Even the centennial pieces, made during the 1880's, have acquired a patina, which, with time, will be mellowed even further. Although the abundance of Federal furniture available today suggests that just as much of it was made after 1830 as before, lack of documentation precludes any verification of this possibility.

The basic Federal styles of furniture made between 1783 and 1830 include those credited to Hepplewhite, Sheraton, and the ambiguous title of Empire. To discuss the styles before then would basically take us out of period.

The periods following America's major wars have been marked by austerity. For a while the people seem sobered by the conflict that has raged about them and give less thought to the niceties of life and more to survival. A wartime economy, geared to the production of

related products, is not one in which arts and crafts flourish. A carpenter might consider his time better employed turning out wooden canteens, wagons, and supply carts than making furnishings for homes, few of which are built during wartime anyway. After a war, when everybody is in a hurry to return to a semblance of civilian life, speed is of the essence in turning out needed household goods. Something that can be built easily and quickly, without too much time and effort invested in style and decoration, is the one that will find greatest favor. In this respect the Hepplewhite designs were an immediate success. Their plainness of look, simple, tapered legs, squared tabletops, evenly proportioned chests, a minimum of carving—all of these characteristics appealed to the cabinetmakers as well as to their customers, and the style was very rapidly accepted. Whether George Hepplewhite was the originator of all that is credited to him is hazardous to speculate. We know he had passed on when his book of designs was printed. It is likely that his wife received the help of the craftsmen who worked in his shop, and, together, they updated his work.

During this period there were many makers influencing the trends, and they would change almost as quickly as antique prices change today. The rumblings of the French Revolution brought about an artistic chaos in that country, which had long led England and the European countries in dictating tastes and styles. The Louis XVI style finally lost favor to the revised classical style. Painted furniture became less popular as new modes of veneer and inlay introduced by the Adam brothers gained favor. And the Dutch influence, which had held sway for much of the century, was all but gone.

This was a time for straight, unbroken lines, and where broken, done in quiet taste. Hepplewhite varied from this in his use of the serpentine front and bowfront as well as the shield-back chair, for which he is generally credited. The bowfront and serpentine-fronted pieces were made by a rather ingenious method, which was easier for the craftsman and resulted in pieces that have never lost their shape over the years. Planks of secondary wood, such as pine, were stacked one above the other and glued together, the height of the pile being the front thickness of the drawer. After marking the shape of the drawer on the top plank, they would then be sawed into the curve desired, resulting in the bowed or serpentine front about an inch or more thick. This front would then be veneered to cover up the lines of the many planks that lay one atop the other. One may check this

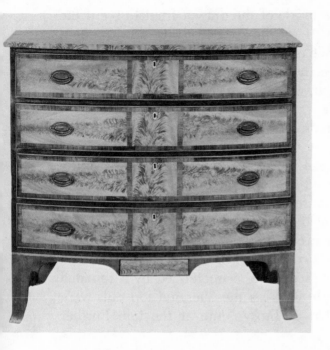

Hepplewhite-styled bowfront chest of drawers, Judkins and Senter, Portsmouth, New Hampshire, c. 1810–1815. Case is birch with mahogany banding and figured birch veneer on the drawers. The drop panel is native to this area south to Salem, Massachusetts. Henry Ford Museum, Dearborn, Michigan.

Sideboard, American, possibly from Charleston, South Carolina, made in mahogany and mahogany veneer with white pine and black cherry. circa 1800. Colonial Williamsburg.

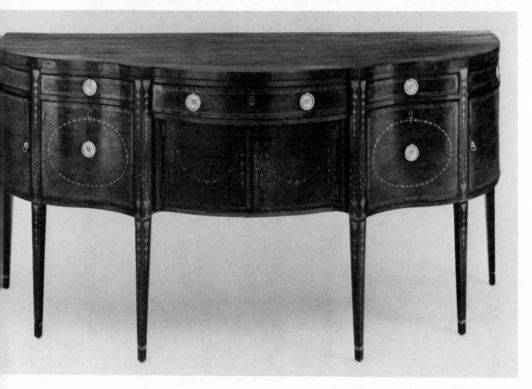

construction by looking at the inside of the drawer front to see if the lines of the planks are there. If so, they are likely to be in period, unlike those reproductions that might have had a single board bent by machine years later. Since there is no stress on the cutout front done in the old manner, the drawers will never go out of shape, unlike those bent under pressure.

The shield design was taken directly from an original Roman model, which Hepplewhite updated by using the proportions of those used by knights in the thirteenth and fourteenth centuries. Hepplewhite's shield backs utilized the tapered leg as did many early classical-style chairs of the time, including those of Thomas Sheraton. The fact that both designers utilized some of the same shapes and designs makes it difficult to trace the source of inspiration. One simple rule that might be followed in separating the two versions of shield backs is to look at the top rail. Hepplewhite's pieces are characterized by a rounded unbroken line the entire length, whereas the Sheraton top rails were executed with a horizontal bar or broken line at the top. Further

(Left) Hepplewhite-styled side chair, Philadelphia, 1790–1800. Walnut. Attributed to Daniel Trotter, 1769–1800. William Penn Memorial Museum, Harrisburg, Pennsylvania. *(Right)* Sheraton side chair, circa 1790. Mahogany with curly maple panel at top rail. Portsmouth, New Hampshire, or North Shore, Massachusetts. Currier Gallery of Art, Manchester, New Hampshire.

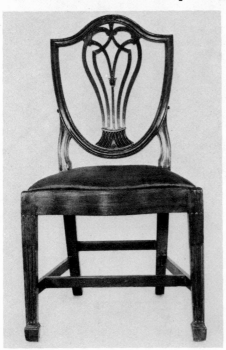
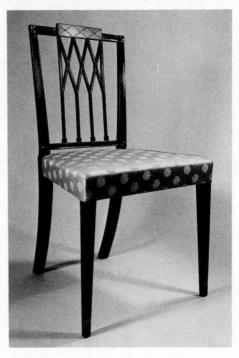

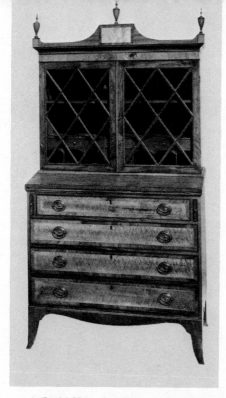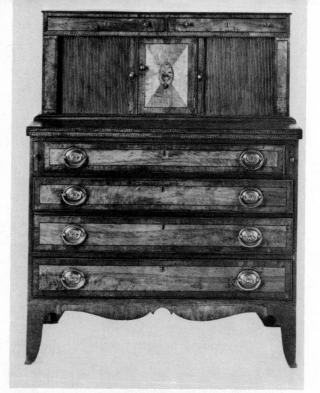

(Left) Hepplewhite-styled secretary desk with recessed upper section, Salem, Massachusetts, circa 1790–1800. Mahogany with figured birch veneer on drawers. Henry Ford Museum, Dearborn, Michigan. *(Right)* Hepplewhite tambour desk, from Salem, circa 1790–1800. Mahogany with figured birch veneer and satinwood inlay. Both pieces feature the outswept French legs. Henry Ford Museum, Dearborn, Michigan.

study of these chairs reveals that Hepplewhite chose rounded designs for his chair backs, whereas Sheraton used rectangular designs. The geometric squared designs lent themselves to a lower rail which bound the leg posts a few inches above the seat; generally, the legs extended from the floor directly to the top rail.

Hepplewhite introduced new forms for desks already popular. He made them lighter by raising them on delicate legs. To the slant-top desk, which was first popularized in the Chippendale period and earlier, Hepplewhite added veneered surfaces decorated with inlay to replace the earlier solid surfaces, which had been decorated with carving. Veneer and inlay became extremely popular forms of decoration, and native woods such as tiger and bird's-eye maple were often used. Many slant tops continued to be popular in America well into the nineteenth century on an individual basis. In England, however, the slant tops became obsolete and were replaced to a great extent by a new desk, introduced by Thomas Sheraton in 1790, featur-

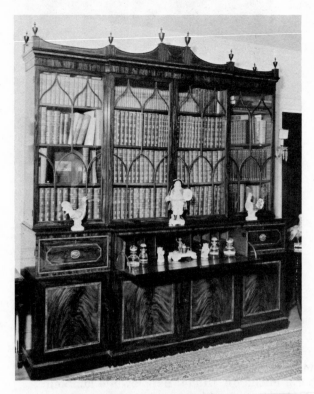

Hepplewhite-styled breakfront. Mahogany with various woods used for veneer and inlay. Most likely New York, 1790's.

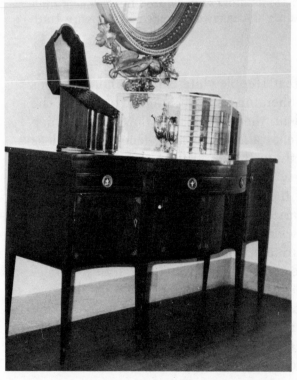

Hepplewhite-styled sideboard attributed to Matther Egerton, New Brunswick, New Jersey. Mahogany with satinwood inlay; secondary wood poplar. Exaggerated serpentine front. Doors and top have inlaid lines and quarter sunbursts in corners. Ring handles frame blue-and-white enamel plaques. Karolik Collection, Boston Museum of Fine Arts.

ing a "tambour." The tambour part of the desk served to enclose small drawers and consisted of vertical strips of wood which moved horizontally in two sections from the center.[5] Another design attributed to the Hepplewhite era and used on desks were "French bracket" feet, which swept outward in a curve, giving a light, graceful appearance.

Hepplewhite designed some massive pieces, including huge break-fronts that measured up to twelve feet in length and were as high as ceilings permitted. Many of the breakfronts found in our country are thought to have been made in England. Examination can quickly determine their origin, and we shall discuss the differences in English and American construction in a later chapter. Breakfronts may have been an enlargement of Hepplewhite's design for the cabinet-top desk, which was the first of the multidrawer pieces with glass cupboard doors and a felt-covered writing top that hinged out when needed. This design may have been enlarged at the whim of customers who wanted large bookcase areas with storage drawers beneath. Fortunately, breakfronts come apart in sections for ease in moving, and most are equipped with brass handles at both ends. Handles on furniture to aid moving were not new then; they appeared as early as the Queen Anne Period.

In addition to breakfronts, Hepplewhite made many massive sideboards. Thomas Shearer had introduced the sideboard in the 1780's, and they immediately became very popular. Hepplewhite's sideboards were decorated with inlay in a variety of motifs, including the urn. However, since much of the furniture made by Hepplewhite utilized designs created by the Adam brothers, the attribution of these pieces can only be speculative. We do know that urns on the Adam-designed sideboards were most often squat and low, whereas those on Hepplewhite's sideboards were taller and slimmer. Later, Sheraton also made sideboards, and these may be differentiated by their legs: Sheraton legs are tapered with concave corners; the Hepplewhite legs were designed with convex corners.

Early Federal Period chairs were not so strong and durable as those preceding them. Chippendale designed rather rugged-looking chairs, and they were criticized for being squat and ungainly as well

[5] Marvin Schwartz, "Furniture 1640–1840," in Helen Comstock, ed., *Concise Encyclopedia of American Antiques* (New York: Hawthorn Books, Inc., 1965), p. 651.

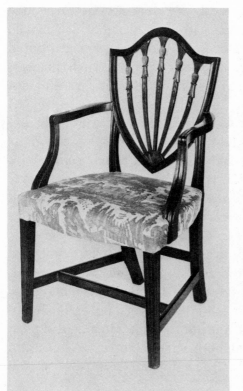 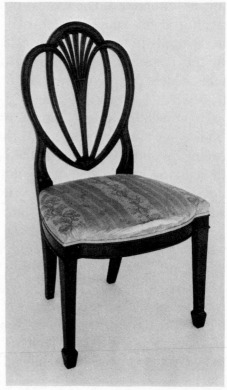

(Left) Hepplewhite-styled armchair, Massachusetts, 1790–1800. Mahogany. Re-upholstered in 1953 by Ernest Lo Navo. Henry Ford Museum, Dearborn, Michigan. *(Right)* One of a pair of Hepplewhite heart-shaped shield-back side chairs, about 1790–1800. Made by Adam Hains, of Philadelphia. Height 32¼". Philadelphia Museum of Art; given by Mr. and Mrs. David H. Stockwell.

as too dependent upon the Dutch and Chinese influences. Hepplewhite, on the other hand, may have gone too far in the other direction. Although his chairs were light and airy in appearance, they lacked strength.

Cutout, carved, and pierced backs gave way to Hepplewhite's rounded designs, which depended on veneer and inlay for decoration. Carving is found on some of the chairs of this period, and the carving design that is especially used by Hepplewhite is a grouping of Prince of Wales feathers. Hepplewhite chair backs are most often found in the shapes of the shield, oval, and heart. The legs of his early chairs show a minimum of tapering. A few were made after the French styles;

a rare few resemble Louis XIV, and others, which feature the fluted leg, seem very Louis XVI. These chairs with fluted legs are thought to have been Adams designs, to which Hepplewhite may have added his own chair backs. In addition, Hepplewhite made chairs with pierced, splat backs, a Chippendale design, in Hepplewhite frames. The technique of gilding on black lacquer is found on some of his early chairs. Horsehair cloth, widely used during the Empire and Victorian eras, was also in great demand at the beginning of the Federal Period, and Hepplewhite often used it for seat covers.

The tapered leg lent itself to the development of a foot, which gave it strength as well as style. It is merely a raised, tapered design superimposed on the existing leg and is referred to as the "spade" foot.

Nowhere did the graceful Hepplewhite lines show to better advantage than in the tables he designed. The tapered leg especially lent itself here. The previous period had brought with it rather heavy leg designs, including both the cabriole and the squared-Chinese. Their proportions were too massive for the delicate tops, especially those made in America from New York to the South. The New England tables with Chippendale legs managed to convey a light, well-proportioned look, but these eventually gave way to the sheer, clean lines of the new Federal Period pieces.

Though the small Pembroke table with shaped leaves came before his time, Hepplewhite is responsible for making the best looking of them. His tapered leg lent itself especially well to delicate small

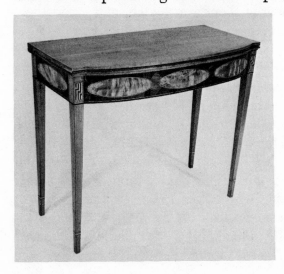

Hepplewhite-styled tilt-top card table (one of a pair), New Hampshire, circa 1790–1810. Cherry with figured birch and mahogany veneers. Currier Gallery of Art, Manchester, New Hampshire.

(Left) Early Federal Period tilt-top game table, with ovolo cutouts. In cherry with satinwood inlay and veneer. Manchester (New Hampshire) Historic Association. *(Right)* Cherry tilt-top game table in perfect proportion. Height 28", width 36". This is the table discussed in the text.

tables. Quite often, casters were employed so that the pieces might be moved without damaging the fragile legs. Though tilt-top game tables were not new, Hepplewhite refined them by adding bowed and serpentine fronts, with top boards shaped to match, and stood them on delicate tapered legs giving them an elegant sense of proportion. Later Americans carried the game tables a step further by veneering and inlaying with the best of figured woods against darker cherry or mahogany. Perhaps the finest one I have ever seen is made entirely of cherry, measuring 28" from the floor, 17½" width in single board top and raised leaf, with leaf raised to 45½" height against a width of 36". The legs are finely tapered, extending 22½" to the floor beneath the drawer. Many such tables are made with no drawers and are decorated with veneer and inlay. This cherry table was probably made by a country cabinetmaker who either had a great sense of proportion and let his work and wood speak for themselves or was a bit lazy and made the table as easily and simply as he could, with squared dimensions and flat surfaces. The flat tapered legs lend themselves well

to inlay. Hepplewhite made some with a fine line of holly and others in a floral motif. A favorite in this country, especially in the Baltimore area, was the bellflower inlay (see pages 40–41).

Perhaps Hepplewhite's ultimate design was the banquet table, the most functional of all dining tables made today. The banquet tables were made in two sections; each end section was made in a half-round shape with a huge leaf dropping to the floor at its side. When placed together, the sections would form a perfectly round table with leaves hanging out of the way. One or both leaves could be raised at will, resting on one swing-leg, to lengthen the table, usually to about nine feet. If greater length was desired, a regular-style, squared, drop-leaf table was made to be placed in the center, raising one or both leaves as desired to meet the end sections. The raised leaves would be held together with a brass U-shaped clip. Most of the American-made Hepplewhite banquet tables were made in the Baltimore area. Yet the table illustrated, an exceptionally fine one,

Impressive Federal Period banquet table with bellflower inlay, labeled by John Townsend, Newport, Rhode Island. John Brown House, Rhode Island Historical Society.

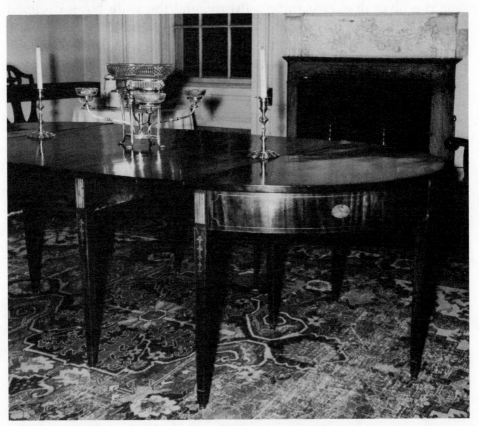

was made by John Townsend, of Newport, Rhode Island; it is currently exhibited in the John Brown House in Providence.

The banquet-table design was carried on by Sheraton, whose efforts show the turned and reeded legs, and in Empire design with the rope-turned legs. Then it disappeared and gave way to the telescope extension table with inserted leaves, which was invented by Richard Gillow, of London, about 1800. In the smaller house of today, storing table leaves is a problem, whereas with the Hepplewhite banquet design, they are self-storing, and center-section tables can be used as extra side tables in a dining room until needed when company comes. It is amazing that some present-day manufacturer isn't reproducing this style, as it is the most practical and perhaps the most beautiful ever built.

During the Federal Period knife boxes, which predate silver drawers in sideboards, become the vogue. Adam, Shearer, Hepplewhite, and Sheraton all made them, in much the same fashion, to rest singly or in a pair atop the sideboard. In those days mahogany was chiefly used for the sideboards with inlay of satinwood, holly, tulip, snake, yew, and zebra.[6] The knife boxes were inlaid to match when ordered together. Most opened on brass hinges, but silver was used for handles and escutcheons in keeping with their contents. During Sheraton's time the silver drawer became a fixture, and the knife boxes declined in popularity. By the end of the period they were gone, and many must have been relegated to oblivion in attics and barn chambers when they were no longer needed.

The conflict between Hepplewhite and Sheraton styles is most apparent when one considers the beds made by both. Benefiting by Shearer's work and the Adams designs, Hepplewhite went along with the fluted posts on the four-poster beds, which makes attribution rather hazardous. One would have expected a tapered post in the style of the leg for which Hepplewhite was so famous. I have seen only one such tapered-post bed, which I purchased some years ago in New Hampshire. The four posts are tapered as if they were inverted table legs and are held together by simple squared pegged boards at

[6] In his book *American Furniture of the Federal Period* (New York: The Viking Press, Inc., 1966), p. 28, Charles Montgomery reports that much of the veneer wood was figured birch, which is often mistaken for other more exotic woods. Also, much reputed "mahogany" was nothing more than mahogany-stained birch, which symbolized Yankee thrift in utilizing readily available wood instead of the more expensive import.

head and foot. In its simplicity there is great charm. The tapered-leg style, which was so popular during the Federal Period, may have influenced the cabinetmaker. However, such a design does not appear in Hepplewhite's book. A wider fluting was used on the beds that were made in the earlier part of the period. The later Sheraton pieces show narrower, more delicate fluting, fine reeding, and the bulbous design that is generally credited to him. The introduction of the carving of the acanthus leaf in conjunction with fluted or reeded legs and posts came as early as Shearer's time. One cannot associate this type of decoration exclusively with the early Sheraton or later Empire periods, although this carving came into full flower then. The Empire pieces seem more heavily carved, are more massive in their proportions, and utilize symbolism such as pineapples at the top. The four-posters with canopy tops disappeared about 1830 and were replaced with beds made with high posts with no canopies and, eventually, the lower styles, such as the sleigh and bell and ball, and other styles of the post-1830 period.

We have attempted to set the background for the Federal Period furniture by tracing the efforts of the men who pioneered the designs we associate with it. Design books found their way across the Atlantic, where they were eagerly studied by colonial craftsmen. The influence of the designers was felt more in the coastal cities where the English had settled than in the inland areas which appealed greatly to settlers of other extractions in search of the fertile soils, farmland, and climate they had experienced in the old countries. New England never ranked high as an agricultural area because of the rocky soil and short summers. Her settlers inclined more toward commerce, the sea, and manufacturing. The fastest ships were launched from New England boatyards, and they were soon to overtake England's vaunted supremacy of the sea. They carried the goods of many nations, and Yankee skippers became the trading merchants of the world. American ships could be found in almost every port exchanging American goods for those of the world. Harbors like Boston, New Bedford, Salem, Newburyport, and Portsmouth were always alive with activity, and the wealth that was showered down on these communities was immediately translated into fine homes and furnishings. The postrevolutionary period was a good one for cabinetmakers. They, along with joiners and carvers, were kept busy as they competed with English and other European imports. In view of the immense quantity of American-

made pieces found in New England, one can conjecture that the local work was more desired than the furniture made in New York, Philadelphia, Charleston, Mobile, and New Orleans—areas that were still dominated by European tastes.

Wealthy settlers in New England wanted the latest styles to be in their homes but preferred the lighter and beautifully grained woods over the somber dark woods of the Continent. The workmen injected a feeling of high, delicate style, which contrasted with the heavier, perhaps more durable, pieces that were imported. The coastal areas benefited from the work of more skilled craftsmen. Many immigrant craftsmen went to work as indentured servants upon their arrival. The further one goes back into the history of our then wild country, the less flair one notices in the work of the cabinetmakers.

The German settlers in Pennsylvania developed their own styles very quickly, based on the European patterns prevailing in the coastal areas. Their pieces were solidly made, but they were heavy in concept and lacked the graceful look and high style favored near the coast. Philadelphia was a center of fine furniture-making, yet its adherence to the English styles provided makers there with little opportunity for innovation. The craftsmen were the finest, yet they worked more to duplicate English work than to build upon it, and hence the period was rather sterile so far as creativity was concerned. The Philadelphia pieces shriek of not being New England, and the buyer must examine them closely to determine their origin. The quickest method is to check the drawer bottoms and the backboards on a cased piece. American backboards were almost always hewn plank pine and attached horizontally. The drawer bottoms were single chamfered pine planks running the width of the chest, which would be lengthwise to the drawer. Backboards on an English piece most often ran vertically, and the drawer bottoms were made up of two or three boards which ran the width of the drawer, or from the front to the rear of the piece. Checking further, one must examine the secondary woods to determine if they may be native to only one country or another. The workmanship of fine makers is known and documented and can be checked, such as the detail in carving, proportions, manner of dovetailing, and whether pegging was employed.

The woods used in furniture, when done in various combinations, can sometimes offer a clue as to the region of manufacture. There were some three thousand settlers living in Virginia at the time

the Pilgrims landed in Massachusetts, yet little is known about the furniture made there. References to pieces made later than this time reveal that walnut, cherry, and pine were the woods most often used. Walnut was abundant, and the wood had a very fine grain. It could be polished to a fine sheen and worked more easily than oak with the tools of the day. Often, early plantations were built with walls completely paneled with walnut. Pine, both white and yellow, was plentiful and was often used in the common furniture of the day, as well as being used as a secondary wood in the finer pieces. In addition, drawer slides, pulls, and backs of chests and desks were mostly done in pine. After the beginning of the eighteenth century oak was used for some framing. It was rarely used as a primary wood once mahogany was introduced to the colonies. About 1720 a blight hit the walnut trees, not only in this country, but in France, where they were also plentiful. Mahogany became the favorite primary wood for furniture and never lost its dominance along the entire length of the coast. Both wild and domesticated varieties of cherry were plentiful in Maryland and hence its popular use there. Two types of cherry, red and white, were used up until Victorian times in the entire southern region. Some white cherry can be found burled, and veneers made from it can be mistaken for maple. Southern pieces made of red cherry must be carefully checked before determining the veneer.

In Maryland white pine, ash, oak, and gum wood were used for framing right through the Federal Period, and holly, satinwood, boxwood, and some maple were used for the inlay, especially on pieces with tapered legs. Tulip and poplar were used in the South for framing, and it is difficult to tell one from the other. Both are relatively soft woods, easily worked, and have little tendency to warp or twist. They were used extensively in the Philadelphia and New York areas but were little used in New England. There was some trading of wood between the southern and northern colonies, but it seems that most came north, such as cherry and walnut. There is little evidence that much New England wood went south. Mahogany came from the West Indies as part of the triangular trade set up by the early merchant ships. A ship setting sail from New England might carry rum, dried fish, tar, turpentine, and other products to Africa. There the vessel might be loaded with slaves, who would be taken and sold at an island in the Indies. Then the vessel would be loaded with sugar for rum-making, lumber, and citrus fruits for

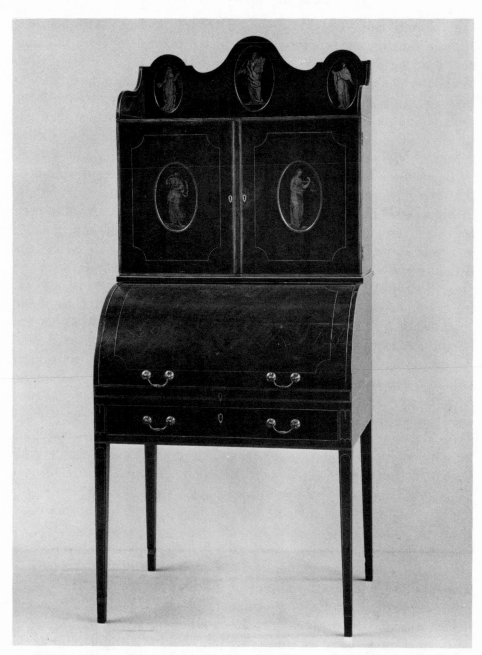

Cabinet-top desk, circa 1800. Provenance: Mount Mill, later Bloomingdale, Queen Anne County, Maryland. This is indicative of the high style for which Maryland furniture of the Federal Period is noted. The Metropolitan Museum of Art, New York; Fletcher Fund, 1934.

36

the colonies, possibly making first stops at southern ports. At these ports the mahogany might be partially replaced with southern cherry and walnut, along with cotton, rice, and other foodstuffs for return to New England. Some of the lumber might be used for ballast and cradles, which would prevent loads from shifting.

Charleston was a great center of commerce and wealth, and it was not long before great plantations as well as town dwellings began to rise. In the early part of the eighteenth century houses were built mostly of brick and wood, with some stone where supplies of it were immediately available. The great Charleston fire near the middle of the century laid waste to much of the fine housing. Most of the housing was rebuilt in brick and survives today. The English influence on furniture was felt strongly in Charleston. Fine makers, such as James McClellan, Josiah Claypool, and William Watson, laid the groundwork for a whole new group of cabinetmakers who found this richest city in the South an ideal place to work and make a good living.

At the time of the Boston Massacre the Chippendale style was very much in vogue in the South. The cabriole leg and ball-and-claw foot were brought to a point of elegance there by such makers as Thomas Elfe, Solomon Legere, Joshua Eden, and Peter Hall. In the North the

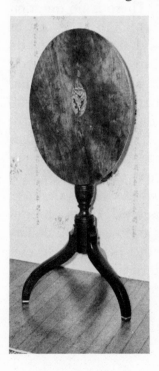

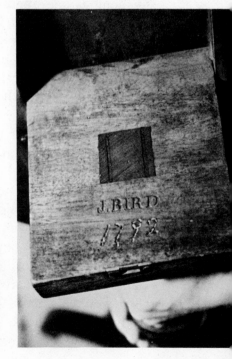

Tilt-top table by Johnathon Bird, Charleston, South Carolina, 1777–1807. Bird came to this country from Yorkshire, England. It is one of the few known examples with his name, and dated as shown. It is in cherry with well-turned post and scimitar leg. Hammerslough Collection.

Moravians, a religious sect that had migrated from eastern Germany to the Carolinas, Virginia, and Pennsylvania, made furniture for their own use and for their churches. Unlike most religious sects, who worked mostly in austere designs, they incorporated much of the Chippendale style into their work.

As the Federal Period designs came into popularity, the southern makers seized upon them, as they had the woods, making their pieces much lighter and prettier. The tapered leg lent itself to inlay and veneering. Such skill was achieved in this work that entire panels were made up to extend the length of the leg. An entire leg would be veneered with ready-made inlay designs, all done in one gluing job. This gave rise to a whole new profession—that of making entire surface inlays which could then be bought by any cabinetmaker to beautify his work. Even today one may buy these ready-made inlay panels to glue to any simple furniture to beautify the piece instantly. This process was especially perfected in the South and as far north as Baltimore and produced some of the prettiest pieces of the period. Veneer and inlay work, combined with the painted decoration, makes Baltimore's furniture rank high among early collectibles.

When Duncan Phyfe set up shop in New York City, he employed as many as one hundred craftsmen in his shop. There is no question that the influence of his designs was felt in the South. The size of the homes, with their very high ceilings, dictated that the pieces made for them be massive in size and tall in stature, so as not to be lost in the rooms: hence, the many huge and rather monstrous-looking southern pieces of the later Federal Period. Except where needed, these pieces go begging for buyers. Many that found their way north have landed in woodpiles, as the homes are much too small to accommodate them. Fortunately, the burgeoning trade in antiques from region to region has helped preserve some of these pieces. Huge vans leave from northern points every week, loaded with antiques destined for the homes for which they were originally designed. Huge Empire-styled sofas, for instance, might sell for only ten to twenty-five dollars in New England, but after passing through the hands of several dealers, and including the costs of shipping, insuring, and the like, then might sell for five to ten times that amount in the South, where they would be more appreciated.

One should check the labels on these pieces, since most cabinetmakers were marking their pieces after the turn of the century.

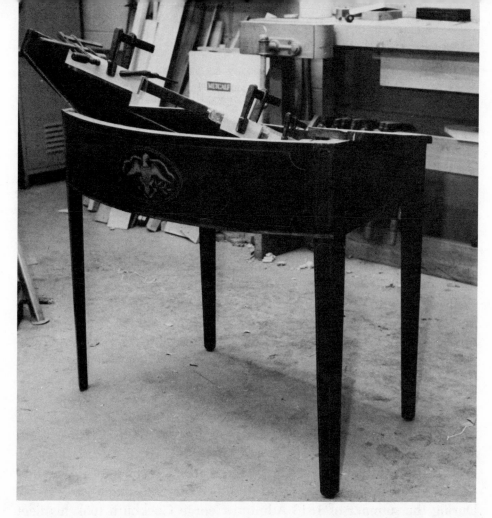

American desk made in Annapolis, Maryland, circa 1797, by John Shaw, probably for the House of Delegates. Mahogany with satinwood and various woods, with lift top, round back, and tapered legs. Inlaid with line inlay, corner panels of burl wood, and on the back a displayed eagle in an oval. Pen rack on top. It is shown here during its period of restoration at the craft shop, Boston Museum of Fine Arts.

Actually, much was made to be sold through furniture warehouses and might be labeled only with the name of the warehouse proprietor, who through such association might mistakenly be considered a maker himself. Names of proprietors like Quackenbush, Sass, Sigwald, Peigne, Marlin, Mellichamp, and others might appear during this period. However, zealous housekeepers and maids who took immaculate care of the pieces might have removed such labels, feeling they added nothing to the pieces—a procedure that has caused great problems in documentation.

During the latter part of the period the Charleston area took to the spiral turning of legs, bedposts, and furniture pilasters and also to the pineapple design in furniture carvings, tops of bedposts, and chair backs. Some have referred to this era as the Pineapple Period in the South.

All during this time the growing settlement of Annapolis and the community of Richmond, which enlarged rapidly at the end of the Revolutionary War, were developing craftsmen of their own. The former is an early settlement, which because of its proximity to the ocean served as a window to Europe and was the stopping-off place for many skilled immigrants. The capital of Virginia was moved from Williamsburg to Richmond after the war, creating a boom in Richmond, which soon developed its own furniture-makers. The McKimm brothers, John Alcock, and William Pointer are among those who worked there at the turn of the century. When the District of Columbia became the nation's capital, the furniture-makers experienced a prosperity not known before; hence, much of what was made south of Washington, D.C., might readily be found in Washington itself. Baltimore and Annapolis contributed much that is classic in form and sought by collectors today, yet very little is readily available. The War of 1812 did not help much, as the British sought to destroy many coastal towns in the area, and in doing so blew up much early work. During the summer of 1813 Admiral George Cockburn took his fleet into Chesapeake Bay and destroyed farmhouses and plantations all along the way. The communities of Frenchtown, Havre de Grace, Fredericktown, and Georgetown were sacked and burned to the ground. An attack on Norfolk was repulsed by troops stationed with cannon on Craney Island, which is in the harbor. Another attack on Hampton resulted in the capture of the fort there and the leveling of many of its structures.

The area south of Washington was responsible for most of the Hepplewhite-styled banquet tables and tambour desks that have been found over the years. The bellflower inlay design was popular and is carried out on all four sides of the tapered legs. Though English in concept, it is not difficult to tell the American pieces simply by the more graceful designs and woods used. Occasionally English counterparts are found in the South, styled in mahogany and walnut. In contrast, American pieces are most often styled in the lighter mahogany or cherry with native inlay woods. However, one cannot

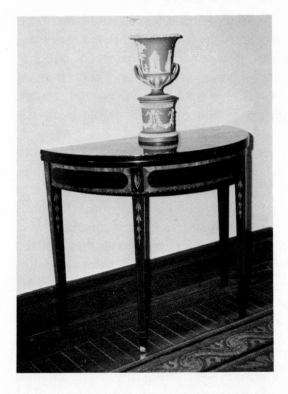

Baltimore-styled tilt-top table with pronounced bellflower inlay. This is a classic example of tapered-leg design. Western Reserve Historical Society, Cleveland, Ohio.

be sure if a piece is southern or New England unless the secondary wood is tulip or poplar, or the legs are heavier. The noted Seymours in Boston made such tambours at the turn of the century in the same style and proportions with the exception of shaping a more slender leg.

The southern sideboards carried with them the influence of the English designers, especially Hepplewhite (concave corners) and Sheraton (convex corners). Early in the century the serving pieces utilized marble tops, but these were discarded during the Federal Period in favor of wood. Knife boxes were in general use but are thought to be made by English rather than American craftsmen. The appearance of narrow wine drawers toward the center of the cabinet area, not seen in the English pieces, was another innovation credited to the South.

Gateleg tables were popular in the South. In the larger homes these tables were used in conjunction with each other to provide enough eating area for the huge dining rooms. The Chippendale period introduced a simpler swing-leg table which was generally

made perfectly square in its dimensions so that leaves could be raised and extra tables could again be placed next to each other to increase the seating. When Hepplewhite styled a round-cornered banquet table in which the leaves dropped along the center rather than at the ends, cabinetmakers all over the country seized on the design. It was especially well exemplified in the South, particularly in the Baltimore area.

Hunt boards, or tables, native to the South, were made as far south as Georgia. Most often they are used as sideboards or serving tables and occasionally as hall tables. They have either tapered or fluted legs and usually contain several drawers; some models have small cupboard areas. They were made of walnut, mahogany, or cherry, and inlay will be found on some. The early settlers in the South were students of the hunt and are thought to have used these hunt boards as buffet serving pieces.

Another item native to the southern area is the cellarette, which served primarily as a liquor cabinet. Cellarettes appeared in the early part of the eighteenth century and were refined during the latter part of the century with Federal designs. They first appeared on small ball feet and were gradually lifted on legs culminating in the tapered or fluted designs. Mahogany and walnut were the favored woods. The average size of the cabinet section was about two feet wide and eighteen inches in depth, and its height from the floor was approximately forty-six inches. They were originally designed to hold bottled liquors; a drawer beneath the main cabinet might hold glasses and napkins, and a pullout slide was available for pouring and mixing. This item was not generally made in the North, although there may be some rare exceptions.

Tables were made in all styles in the South, and with the advent of gaming all types of game tables were made. But the small butterfly as well as the later piecrust-topped, tilting tea tables were not the subject of much manufacture. Southern tables differed from the northern ones in one respect: Their tilt-top tables were generally made with five legs, so the top might rest on the fifth leg when lowered, whereas the northern tables utilized one of the four legs as a swing leg to support the lowered top. This does not imply that all southern tables were made with five legs; however, the style is peculiar to the area and helps in determining the provenance of a piece.

Nowhere was the Pembroke design carried out in greater elegance than from Philadelphia down through the South. These small dropleaf tea tables were made in excellent proportions and decorated with especially fine inlay and veneer work. Worktables and sewing stands were well made, mostly in walnut and mahogany, but in the latter part of the period maple was often used, since it lent itself well to the turned leg and bowfront. Carving is not characteristic of most southern pieces, and the quieter look of southern furniture makes it easier for one to determine the place of manufacture. This restrained work rates on a par with the Federal furniture made in New England, and the difference in style has created different camps of appreciation for regional furniture.

Along with the rest of the country the South went through the transition from Bible box to desks and secretaries. The desk-on-frame was made, graduating into the slant top and evolving into the tambours, tall secretaries, and fall fronts. The serpentine design, French feet, and broken-arch tops became popular. The later broken-arch-topped desks were made with ogee feet. The tambour and cupboard desks rose to new heights in design with classic proportions and much

Cherry slant-top desk with graduated drawers made in Kentucky during the Federal Period. Fluted post at the corner and ogee feet are in keeping. Rebel's Roost Antiques, Lexington, Kentucky.

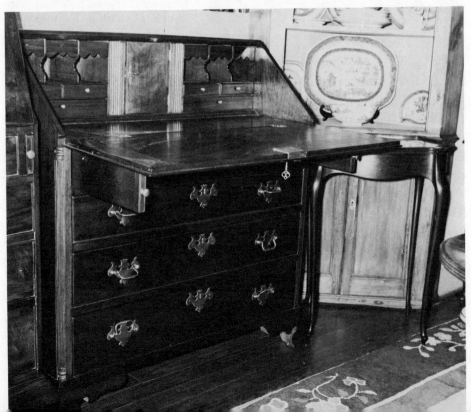

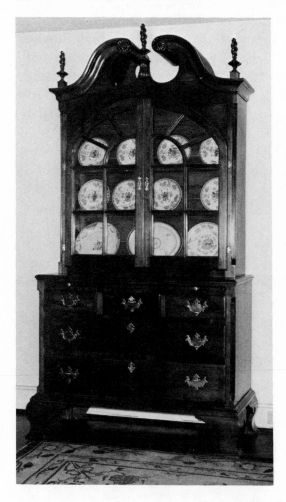

Late eighteenth-century secretary in walnut and mahogany showing fluted columns at corners and ogee feet. Found in Kentucky. Rebel's Roost Antiques, Lexington, Kentucky.

inlay. For some reason the block-front design, which had been pioneered in New England, did not make an impact on the South, though it did come down as far as Philadelphia. Oval- and circle-designed inlays and veneers often decorated the desks made in the South, and the style of this work contrasts greatly with that found on northern pieces.

In the South huge breakfronts were designed to fill large rooms. The sizes do vary, since most of the breakfronts were built to order. Most show extensive veneering and inlay, as it was felt that the massive pieces needed some relief in contrasting woods to help reduce the appearance of their size. Most were built flush to the floor, but

some are raised on low feet. The making of breakfronts flourished during the first part of the period, although many breakfronts have come from England over the years.

Everyone admires the beautiful cherry corner cupboards that come from the South. Originally, cupboards were built into the corners, but during the middle part of the eighteenth century they were freed from their imprisonment there and were built as free-standing pieces which could be moved at will and taken from home to home. The earlier models were very simple, but as the century progressed, many were carved, and during the Federal Period much inlay and

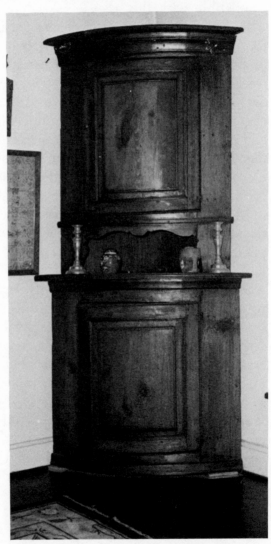

Unusually fine cherry corner cupboard, early nineteenth century, Kentucky. Rounded doors and pronounced moldings at top and shelf give it good proportion. Rebel's Roost Antiques, Lexington, Kentucky.

veneer were applied. The corner shape was broadened to the rectangular china cupboard we know today, and glass doors were added. The earliest cherry cupboards were well pegged in construction, and many were built with separate doors at top and bottom. Open hutches were common, and again cherry was the popular wood. The more refined cupboards were designed with shell backs at the top, a design also well regarded in Philadelphia. Later the broken-arch design was used. Feet of all kinds—especially the French, ogee, and bracket—were used throughout the period. A short, strong base structure was built to hold their weight, and these designs were compatible with the base.

If it were not for the woods used, it might be difficult to tell many southern chests of drawers from their northern counterparts. Style, proportions, base, and leg structure were similar, because of the freer exchange of ideas made possible by improved transportation and communication. After the revolution all the states embarked on canal projects and turnpike-building. A multitude of shipyards created and pressed into service for wartime vessels turned their efforts toward merchant shipping, and very quickly the eastern seaboard developed new harbors and improved old ones to accommodate the flow of goods from one section of the country to the other. Craftsmen went south to escape the cold northern winters and took with them their talents and ideas on cabinetmaking, which must have been incorporated into the already similar styles there. However, in the South darker woods, such as mahogany and walnut, were most often used, whereas in the North the lighter maples, birch, cherry, and mahogany were often contrasted with the veneer and inlay of lighter-colored woods. Both the North and the South employed crotch-grain mahogany on drawer fronts. When this technique was utilized, the same crotched log would be sheared enough times to provide the veneer to beautify drawers which would match in grain when fanned out in an upward thrust. The bracket base of the declining Chippendale Period, the French foot, ogee foot, and fluted leg were used in both areas. One fairly good rule to employ in judging the possibility that legs have been cut on a Sheraton-styled chest is to measure it; its height should be the same as its width. The average four-drawer chest should measure about forty by forty inches. The relatively

fragile legs and bases of chests are the areas of most repair. No chest should be purchased without first examining it for signs of repair, although in most cases good repair should not harm the piece much.

Southern-made chairs and settees were very similar to those made in the North, and there is very little to distinguish them. At one time it was thought that the Windsor chair was not made in the South, but much evidence has appeared to prove otherwise. The full range of tapered- and fluted-leg chairs was turned out with appropriate back, inlay, and veneer. Most of the simple chairs had pine-plank seats, and various secondary woods were used for legs and backs. The settees, which range from the Chippendale to the Empire styles, rate on a par with those made anywhere. Most of the Chippendale settees are found with upholstered backs, whereas Hepplewhite's designs encouraged a top wooden rail, most often carved or veneered. The earlier Sheraton settees featured upholstered backs, whereas the later ones turned to the wooden top rail, which became standard with the Empire settees.

During the eighteenth century canopy-topped beds were made in abundance, with the posts remaining quite plain until the early part of the period when the footposts were decorated with reeding and quite often with spade feet. In general, the headposts remained quite plain until the Sheraton styles set in, when all four posts were suitably decorated. The Empire beds, including even the frames that supported the canopy, were heavily carved. The pineapple design made its appearance, and the acanthus leaf along with fluting was employed. Eventually these designs gave way to the spiral twist or rope carving that prevailed throughout the period.

Much has been written to develop a great understanding and appreciation of Philadelphia furniture of the Chippendale Period. The amount of written work devoted to the Federal Period is woefully lacking, although new interest has inspired a great deal of recent research on the contributions of this city. About fifteen thousand people lived in Philadelphia in 1750. Immigrants were to bring with them ideas as well as the ability to execute them into some of the finest pieces of furniture ever made in America. Names like Benjamin Randolph, Jonathan Gostelow, John Folwell, Edward James, Thomas Tufft, and

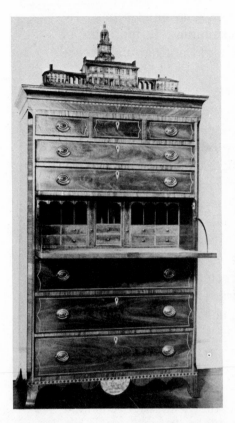

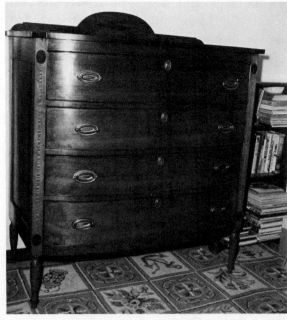

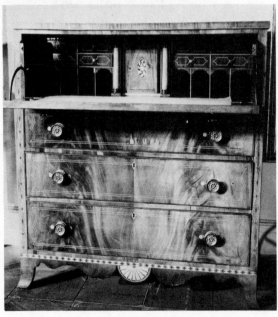

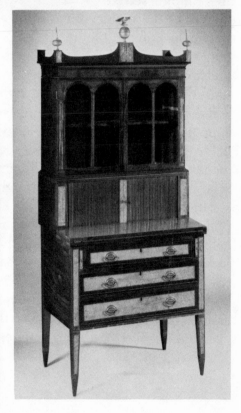

Thomas Affleck are but a few that rank high with collectors today. As the third quarter of the century progressed, this bustling seaport grew into a major economic area. Pennsylvania attracted many Europeans who found the soil, climate, and woodlands similar to that of their native homes. Shipping increased at a rapid pace, and this resulted in a large and prosperous merchant class. Tastes for the finer things in life were developed by the wealthier citizens. During this time strained relations with England and the embargoes placed on many goods imported from there resulted in the development of crafts of all kinds. Furniture-makers met the challenge and proceeded to produce pieces unrivaled in England and done with a flair not found in other American cities.

Paving was introduced to many streets, and with the improvement in roads a trip to New York City by stagecoach took only three days. Coffeehouses expanded in number, and they became havens for freedom-inspired patriots. Early in the nineteenth century an English traveler wrote:

> Philadelphia, the reverse of Lisbon, at first presents no beauties; no domes or turrets rise in the air to break the uniform stiff roof line of the private dwellings; and if I remember right, the only buildings which show their lofty heads above the rest are the State house, Christ Church, both built prior to the revolution, a Presbyterian meeting house and a shot tower. The city, therefore, when viewed from the

Opposite page: *(Top, left)* An impressive tall chest with French feet of the early Federal Period. The secretary section closes to look like a drawer. Mahogany veneer and satinwood inlay. The beaded molding at the top is unusual. No attribution as to maker; most likely the Philadelphia area. Hershey Museum, Hershey, Pennsylvania. *(Top, right)* Sheraton chest, bowfront, cherry, with marquetry of tiger maple and mahogany. New Hampshire, circa 1800–1810. *(Bottom, left)* A high-styled mahogany-veneered desk from the Philadelphia area. There is no attribution as to its maker. It is late eighteenth-century. The lower fan inlay could be a mark of its maker. Hershey Museum, Hershey, Pennsylvania. *(Bottom, right)* Elegant Boston-styled Hepplewhite tambour secretary. Wood is mahogany with bird's-eye maple marquetry and mahogany banding on drawers. It is in the style of the Seymours, late eighteenth-century.

water, and at a distance, presents anything but a picturesque appearance. It is somewhat singular too, that there should be such a scarcity of spires, and conspicuous buildings, there being no fewer than ninety places of worship, besides hospitals and charitable institutions in great numbers. Fifty paces on shore, the stranger enters the city which possesses an interior almost unrivalled in the world. He is struck with the air of simplicity, yet strength and durability which all the public edifices possess, while the private dwellings with their neat white marble steps and window sills bespeak wealth and respectability.[7]

Philadelphia quickly grew to be second only to New York City in size, and in 1830 had about 200,000 inhabitants as opposed to the latter, which had about 7,000 more. As early as 1722 there were a hundred cabinetmakers, joiners, and carvers listed in the city, and one can only conjecture the number actively at work in the early part of the 1800's. The city was laid out by William Penn in 1682 and originally had the shape of a parallelogram about two miles in

[7] John Howard Hinton, *The History and Topography of the United States* (Boston: Samuel Walker, 1834), II, 284.

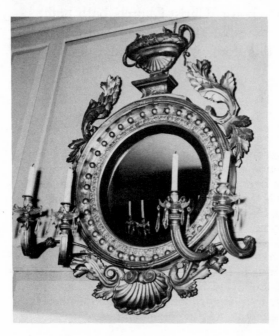

Impressive girandole mirror of the period. Note the shell and urn carvings and added touch of cut-glass prisms. Gilded. Pottsgrove Manor, Pottstown, Pennsylvania.

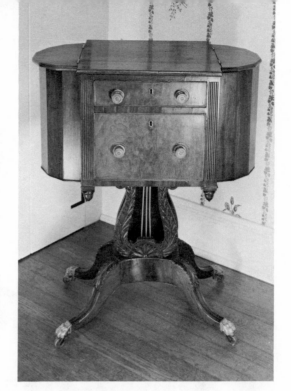

Empire-style sewing table by Henry Connelly, Philadelphia, circa 1810–1820. Mahogany with lyre post and Phyfe-styled pedestal base. Hammerslough Collection.

length and one mile in width. The Quakers who settled it were people who showed compassion for their neighbors and proved to be good businessmen in their commercial endeavors. Their desire to live in good homes with good furnishings contributed greatly to the economy and kept many craftsmen busy at their trades.

The noted William Savery, who worked until his death in 1788, has been credited with much fine work, possibly more than he did. He was a Quaker and was restrained in much of his design. Records show that he was more a chair-maker and joiner than a cabinetmaker. It has been suggested that he just repaired chairs and put his labels on them. Savery made the rare Pennsylvania five- and six-slat ladder-back chairs in the Queen Anne and Chippendale styles. Since George Hepplewhite's *The Cabinet-Maker and Upholsterer's Guide* was not published until 1788, there is good reason to believe that Savery did not see these designs, although a few cabinetmakers were working with them, based upon imported pieces that they had seen.

Henry Connelly, born in 1770, soon rose to the ranks of popularity by doing work for such notables as Captain John Carson, commander of the *Pennsylvania Packet*; famed merchant and man about town Stephen Girard; and Henry Hollingsworth, a Quaker banker. His brother John was a very popular auctioneer of the day. Connelly moved his shop from Chestnut Street to Society Hill at 44 Spruce

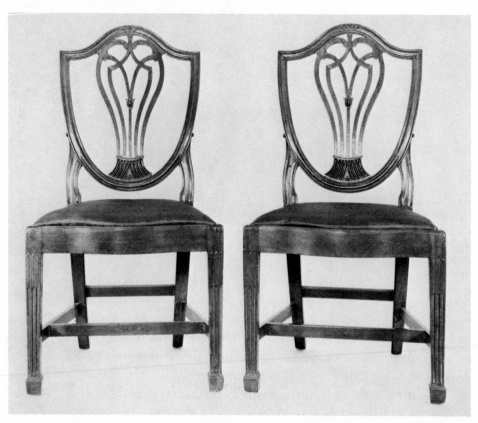

Walnut shield-back side chairs attributed to Daniel Trotter, Philadelphia, 1790–1800. Of special interest are the stretcher construction and the small carved tulips at the center of the backs. William Penn Memorial Museum, Harrisburg, Pennsylvania.

Street and then to 8 Library Street, where he worked until his retirement in 1824. He worked during the period of Hepplewhite's tapered-leg design, but information on his work is lacking. He worked in both Empire and Sheraton styles but did not succumb to the monstrous designs indulged in by others, perhaps because he retired before they became popular.

Ephraim Haines was five years younger than Connelly. He came to Philadelphia from Burlington, New Jersey, with his widowed mother and apprenticed to Daniel Trotter, who had a shop in Elfreth's Alley, one of Philadelphia's most charming restorations today. Trotter is best known for his chair-making, but other pieces have been

attributed to him. Haines married Trotter's daughter and eventually took over the shop. With Trotter he designed the famous pretzel ladder-back chairs. After establishing himself as the new owner of the shop, he began to expand by buying out the shop of William Rush, a noted wood-carver. Haines and Connelly worked for the same clients, and it is difficult to differentiate between their work. There is even question that Haines did much work himself after taking over Trotter's business. He advertised as being in the lumber business, and he acted more as a warehouser of furniture, which was most likely made to his specifications. His labeled pieces are perhaps more his warehouse label than his own personal manufacturing label.

In the time of these craftsmen the acanthus-leaf carved design became more restrained, and a wide banding of veneer, most often of satinwood, became popular. As the Empire designs crept in, the lyre shape came into favor in New York and Boston. Brass ball feet, brass pulls, and later pressed- and cut-glass pulls became fashionable. Tulip and poplar were used extensively as secondary woods and help to determine the locale of manufacture.

One notable holdover from the Chippendale styles was the ladder-back, or pierced-splat–back, chair. Seen with the tapered leg and

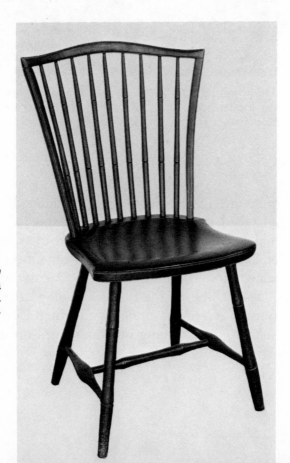

Late eighteenth-century side chair by John Letchworth, born in Philadelphia, 1759. Philadelphia Museum of Art; given by Miss Lydia Thompson Morris.

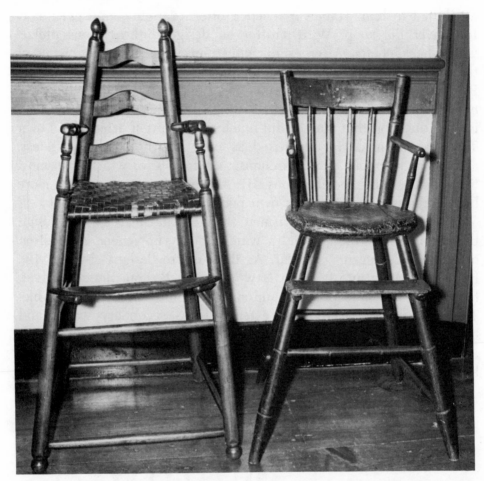

Separated by the turn of the century are these high chairs. At left an interesting ladder-back type with unusual ball foot and at right a later pine-seated model with spindle back. Pottsgrove Manor, Pottstown, Pennsylvania.

quite often spade foot, it is sometimes difficult to assimilate this chair into Federal Period style, yet some of the leading cabinetmakers, reluctant to let go of it, continued to make this cherished piece. Most of them have fluted front legs. Shield-back chairs were popular, and many show the familiar urn, leaf carving, and rosettes.

Meanwhile, in the fast-developing farmlands to the west the Pennsylvania Germans along with other European immigrants were developing and turning out their furniture in the rugged country style.

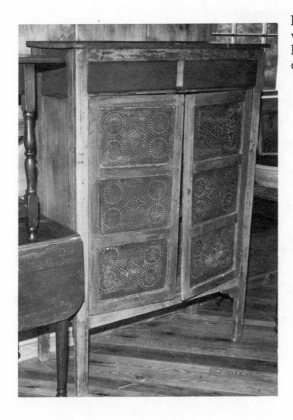

Pierced tin pie safe, Pennsylvania. The value of these is based on pattern of the design and the condition of the piece.

Pennsylvania or Ohio dough box on legs in pine and maple. At left is primitive ratchet candlestand. Jonathan Hale Homestead, Western Reserve Historical Society, Bath Township, Ohio.

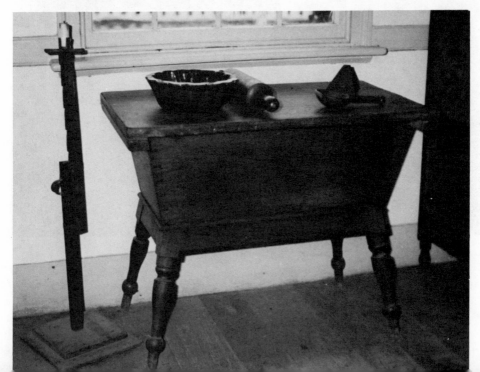

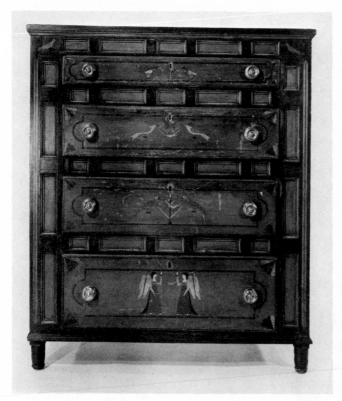

(Left) Pennsylvania German chest of drawers, 1780. Folk painting adds interest and value. Height is 51¾"; wood is walnut. Clarence W. Brazer Collection, Philadelphia Museum of Art. (Below) Typical painted Pennsylvania dower chest with tulip decorations and well dated at the top. Pennsylvania Farm Museum, Landis Valley, Pennsylvania.

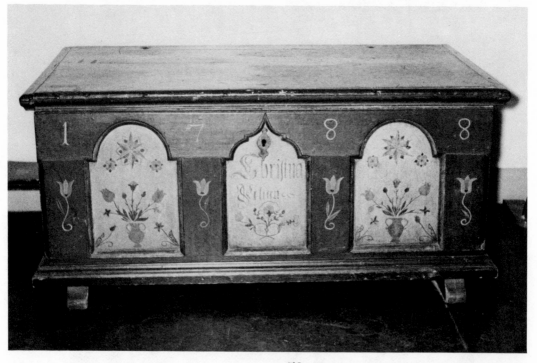

Many who worked in wood were not skilled craftsmen, yet in their construction they showed knowledge of the designs favored by their city neighbors, and some attempted to duplicate this work in their humble shops with the most primitive of tools. Gradually, fine workmen sought the refuge of the country, and some moved west to ply their trade. Some of the favorites we find from this area are the pine dough boxes, dower chests, huge kasts (cupboards), corner cupboards, hutches, and four-post and trundle beds. The multicolored decorations on these pieces lend much to their value, and those signed and dated are highly valued. Although one may not be able to attribute a style to this work, most of it seems to have had its origin in the countries whence the settlers came. The English influence and trade journals of the master cabinetmakers did not seem to exert a great influence. However, as stated before, many designs along the seaboard crept inland and had an influence on the styles there. Quite a rarity in the area would be a single bed; doubles were the rule.

In 1773 many people left the Philadelphia area because of an

(Left) Pennsylvania German mirror, circa 1800. Height 31½". Painted softwood. Titus Geezey Collection, Philadelphia Museum of Art. *(Right)* Pennsylvania Dutch *Schrank* (wardrobe), dated 1779. Walnut. Height 6' 11". Philadelphia Museum of Art.

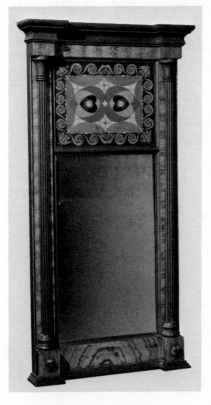
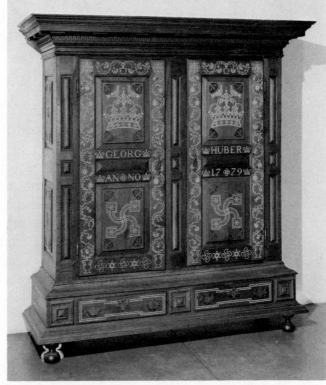

outbreak of yellow fever. Among them was a cabinetmaker, James Barry, who had done his apprenticeship in England. He settled in Savannah, Georgia, and became perhaps the best known in his trade there. In 1798 he returned to Philadelphia. His work was characteristic of the high style favored there, using primarily mahogany woods. Other Savannah cabinetmakers, about whom little is known, are John Lowery, Isaac Fall, Gabriel Leaver, Stephen Blount, and Matthias Darly.

Kentucky had become fairly well populated by the end of the American Revolution, with many settlers going there from Pennsylvania. The soil was excellent near the Green River, and there were huge stands of timber which were quickly turned into housing, furniture, and other necessities. There were huge farms for the raising of horses, which thrived on the excellent grass and climate, and it was not long before the horses were exported to all parts of the country. Other animals were raised for food export, as grain was easily grown and used to fatten them. Needless to say, the economy thrived and was very stable, giving rise to many people of wealth who wished the finest homes and furniture. Many cabinetmakers and carpenters moved here and helped to make excellent pieces, most of which have remained in the state. Records suggest that the cabinetmakers were most active after the turn of the century. Their styles or designs were naturally affected by those to the north in Pennsylvania and Ohio, and much was turned out of sufficient quality to be judged with top makers elsewhere. John Goodman, who worked between 1790 and 1810 in Frankfort and Lexington, is highly regarded. He not only made furniture, but is known to have made at least one piano, which is owned by the Kentucky Historical Society. Others in Lexington were James Megowan, Joseph Green, Benjamin Parish, Samuel Rankin, Robert Wilson, and Thomas Whiting. Peter and Edward Goodall worked in Glasgow, Jesse Head in Harrodsburg, and Thomas Lincoln in Hardin County.

In April, 1777, more than two thousand British troops invaded Danbury, Connecticut, and thoroughly devastated the town, which was a depot of the Continental Army. Houses, churches, stores, barns, and food supplies were burned or sacked. The troops were unable to harass it by land, so did it by sea. Coming ashore on July 5, 1777, they stormed Hartford. Two nights later they devastated Fairfield, and on July 11 gave the same treatment to Norwalk. Many were

killed or taken as prisoners, and their houses and businesses were destroyed. It was not until 1781 that the British renewed these terrible deeds and practically razed New London and Groton. As a result of these acts, the residents in this area of Connecticut were known as The Sufferers. They appealed to the General Assembly of the Continental Congress for relief and help, but it was not until May, 1792, that Congress acted in granting land in the amount of about a half million acres just south of Lake Erie, known in Ohio as the Firelands, to anyone from this area who wished it. The land lies between present-day Erie and Huron counties with the exceptions of the townships of Danbury and Ruggles. It was chartered to the original Connecticut colony, which already held a large strip of land extending across Pennsylvania to these new holdings. It was seventy-five miles wide and extended from "ocean to ocean." To examine and settle all claims from the Connecticut people who had suffered at the hands of the British took thirty years, and by the time all the Indian treaties had been signed and the land surveyed, many of the orignal settlers had died.

In 1786 Connecticut ceded much of its land holdings to Congress but reserved a strip about 120 miles long, extending from the western boundary of Pennsylvania to Sandusky, Ohio. It was then called New Connecticut or Connecticut's Western Reserve. The New England reference has been dropped in favor of calling it the Western Reserve. Three million acres were purchased by the Connecticut Land Company for about forty cents an acre, and in 1796 the company sent Moses Cleveland along with surveyors and engineers to subdivide the reserve into townships. Members of the original surveying groups received grants of land in return for part of their services, yet only six returned there to live. Cleveland never came back, but one of the towns he plotted bears his name to this day.

Settlement was slow because of the extreme hardship of living in the area. Malaria was present, and most were unable to raise enough food to live properly. It was not until the latter part of the Federal Period that settlement became practical, and the area grew. One of the earliest settlers was Jonathan Hale, who bought land from the Land Company and started life there by going ahead of his family to clear land and build a home. He arrived in June, 1810, and found a squatter there. The man had cleared some of the land and built a log cabin. Informing him of his rights, Hale amicably traded his horse

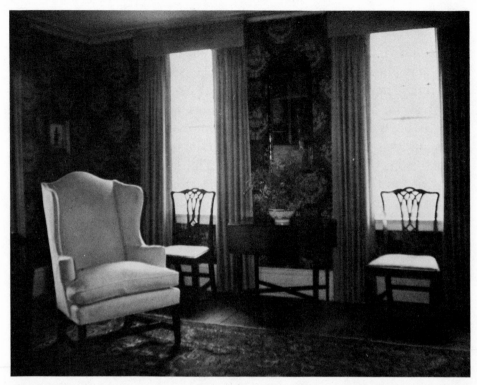

Connecticut furniture very far from home in the Dunham Tavern in Cleveland, Ohio. This area was formerly known as the Connecticut Western Reserve and was settled by many New Englanders. Here are Chippendale-styled chairs, Federal Period wingback chair, and cross-stretcher drop-leaf table.

and wagon for the cabin, and the squatter moved on. His family arrived in the fall, and life began with few of the comforts that had been enjoyed in Connecticut. By 1826 Hale had prospered enough to build a fine brick home, which has been preserved to this day and is now maintained by the Western Reserve Historical Society. It serves as an excellent example of early life in Ohio and includes much of the furniture and artifacts used at that time. There is much similarity in the furniture of western Pennsylvania and Ohio, as it was made of similar wood and in the same rugged country style. Native New England and Connecticut pieces were taken by early settlers to their new homes and are still well preserved. It is not unusual to find much of the early fine cabinetry of the coastal areas so far inland, as this was basically a New England settlement in people and personal goods.

The Summit County Historical Society in Akron, Ohio, has a comb-back Windsor rocker, which is listed as having been made there about 1820. In Ashtabula a firm by the name of Coventry and Harris was making Hitchcock-type chairs with rush-bottomed seats in the 1820's. In the 1812–1820 period, fancy chairs are listed as having been made by J. Roll and a Sam Stibbs, from either Cleveland or Cincinnati. An H. Riggar worked in Columbus as early as 1805 turning out Windsor chairs with a Rhode Island influence. Geo. Dunbar was active in the 1820's and 1830's in Canton making chairs and settees, some of them well decorated. Henry May, of Chillicothe, turned out seventeen varieties of chairs to order in the years 1812–1815. Clark and Cros-well—or Croswell and Clark (the name appears both ways)—worked in Cincinnati about 1820–1823 and made fancy-styled chairs as well as Windsors. J. Perkins, C. Swain, Chester Harding, Ephram Michaels, and Richard Lloyd, of Cincinnati, were also prominent designers of the period. Albert Broomhall worked in Goshen, D. McCrum in Circle-ville, and Hiram Hanes in Columbus, to name but a few others. It is amazing how rapidly the crafts followed primitive settlements, but one can only read the histories and marvel at the rapid growth of Ohio. Its waterways and canal systems, along with many natural resources and

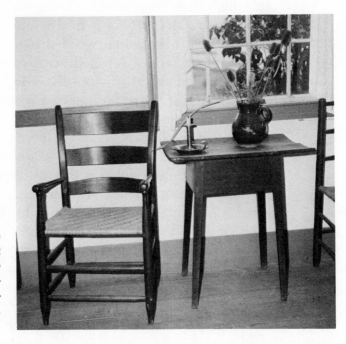

Ohio country furniture of late Federal Period. Thumb-back armchair and cherry tap table with well-splayed legs. Jonathan Hale Homestead, Western Reserve Historical Society, Bath Township, Ohio.

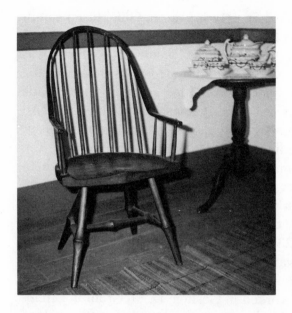

Early nineteenth-century Ohio Windsor-type armchair. Note unusual turnings of well-splayed legs and saddle seat. Jonathan Hale Homestead, Western Reserve Historical Society, Bath Township, Ohio.

the necessity of making what was needed right at home, created a commerce that grew by leaps and bounds.

The furniture of that early period, although rugged and functional, ranks high with furniture of other areas made under the same conditions. There was plenty of maple in Ohio, so many of the early pieces were made of this figured wood. In 1829 Cincinnati alone had fifty-two cabinetmakers of sufficient rank to be listed. Their work ended up going down the Mississippi River to border towns along the way. Hence, it is possible to find much Ohio-made furniture in places like St. Louis and New Orleans. Isaac Lee, a chair-maker, was responsible for many chairs that ended up on the river steamboats, and the boat's name is most likely the name found stenciled under the seat. Perhaps the earliest furniture noted is that of Lyon and Maginnes, circa 1800, of Hamilton Road, which is probably a reference to the main road between Cincinnati and Hamilton. This concern made dining tables, fancy tables, side tables, and escritoires, plain or veneered.

In 1818 the Cincinnati and river-region areas had a greater concentration of chair-makers and cabinetmakers than any other section of Ohio, Kentucky, Illinois, or Indiana. The *Cincinnati Cabinet-Makers' Book of Prices for Manufacturing Cabinet Ware* was "Printed for the Cabinetmakers by Whetstone and Buxton" in 1820. This price

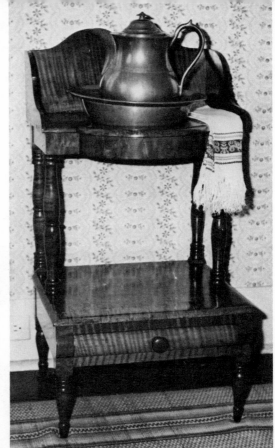

(Right) Early nineteenth-century Ohio tiger-maple washstand with pewter pitcher and basin. Design of this is outstanding. Jonathan Hale Homestead, Western Reserve Historical Society, Bath Township, Ohio. *(Below)* Windsor rocking cradle. Solid wood bottom, bamboo-turned spindles. Birdcage top at head. Painted green. Circa 1800. Henry Ford Museum, Dearborn, Michigan.

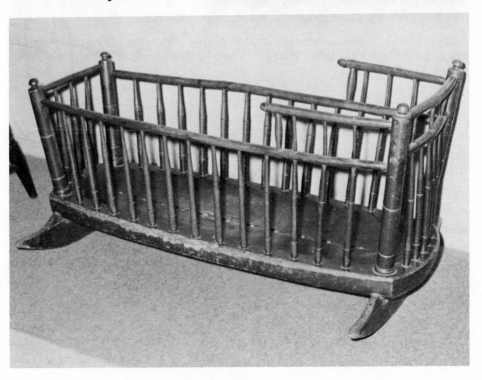

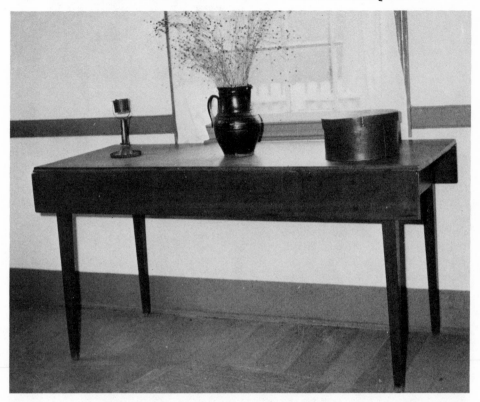

Early nineteenth-century harvest table in maple with unusually narrow leaves. Jonathan Hale Homestead, Western Reserve Historical Society, Bath Township, Ohio.

book was the first published west of the Alleghenies and was used extensively. The river area was first settled by former members of the Virginia militia who received grants of land as a reward for service in the war. It is possible to find southern furniture in the fine homes in that section of the state; little of it has found its way to the open market.

Of great interest is the Dunham Tavern Museum on Euclid Avenue in Cleveland. There is conjecture as to when the final structure was built, but it is known that Rufus and Jane Dunham, a young couple from Mansfield, Massachusetts, came to the Western Reserve in 1819 and settled the property in a log cabin. The north wing was built in 1824, and other wings were added later. It eventually served as a stagecoach stop on the old Buffalo-Cleveland-Detroit Road. It lived a

long and useful life watching the changes about it, and in 1941 the Society of Collectors, Inc., took it over to preserve it as an example of early living in that city. Today it is full of early Ohio memorabilia as well as furniture and artifacts from New England in keeping with the period. The fire frame in the parlor is believed to have been carved by Samuel McIntire, the noted artisan from Salem, Massachusetts.

The pioneers put up with incredible hardships in order to build a new world for themselves. One settler remarked that tall men and women were so thin that as they walked through the woods, they were followed by dogs, who thought they were "walking bones." Port Royal was one of the earliest settlements (1819) in Indiana, and Ladd's Tavern was one of the favorite stopping-off places. Mrs. Ladd was noted for being able to commandeer all types of beverage supplies in this backwoods area. One day a traveler arrived and ordered coffee. Having only half a cup of coffee left and half a cup of tea, she mixed the two and served it to the man. As he sipped it, he looked up at her saying, "If this is tea, bring me coffee; if this is coffee, bring me tea." After an explanation the good lady was forgiven her deed.

Cabinetmakers are listed in the growth records of the communities, but it is difficult to attribute work before 1830. Most of the furniture was influenced by the designs native to the new settlers from New England, so one must be very careful in determining the provenance of the early pieces found there. They could as easily have been brought there by wagon.

Although we know there were settlements in almost all areas east of the Mississippi, there are few records to determine positive attribution. People were more concerned with staying alive and making a living than keeping records. The future may hold many surprises for us when research uncovers facts about the furniture and other artifacts of these areas.

Perhaps no place exerted such an influence on furniture style as New York City during the early years of the nineteenth century. Cabinetmakers in the early part of the period seemed to conform to the basic Hepplewhite style, and the tapered leg was the rule, along with the incoming reeded and turned legs designed by Sheraton. In the wake of the American and French revolutions there was a close tie between the two countries, and trade grew at the expense of England. This was a time when New York finally shook its image as a conservative Dutch town and struck out on its own to create a new

image as the cosmopolitan center of the country. It served as the nation's capital and attracted the important personages of the times, many of whom decided to live there. The natural harbor grew in importance as the major link with Europe, and wealth abounded with America's growing dominance of the sea.

The death of George Washington in 1799 and the arrival of the new century brought new changes that affected all segments in the mode of living. No longer a second-class nation, America's wealthier citizens sought more than ever to duplicate and even better the old countries, and the new spirit brought with it new concepts in the arts and architecture. Practically all of the country with the exception of New York City went along with the change. For some reason New York's citizens preferred to be identified with the past and the influences of overseas designs.

Into the middle of all this moved a man who was to create a whole new style for acceptance—one based on French design, which eventually led to his deterioration as a great cabinetmaker: He was Duncan Phyfe. Duncan Phyfe was born in Scotland in 1768 and came to Albany, New York, early in his life. It is assumed that he learned the cabinetmaking trade in Scotland, since he entered the trade upon his arrival in Albany. Early in the 1790's he left to seek his fortune in New York City and opened a place of business on Partition Street. Later in the decade he established himself with such well-known clients as the Astor family, a contact that assured him all the business he could handle from others who wished his elegant work. He enlarged his premises to include two more buildings alongside his original, and at one time he employed up to one hundred men. His brother Lachlan was considered to be the best of his wood-carvers, and after the turn of the century he maintained a salesroom for the firm in Baltimore. Business was not confined to New York, as orders came in from Philadelphia, from old customers in the Capital District, and even from New England.

During the early years of his success Duncan Phyfe worked almost exclusively in the Sheraton style, and his fine reeded leg pieces are considered some of America's classics in early furniture. However, the French influence in New York became too obvious to ignore. Ladies were parading the streets in the latest fashions from Paris, and the increased trade with the new Republic brought with it all kinds of French goods which were considered by the wealthy to be far superior

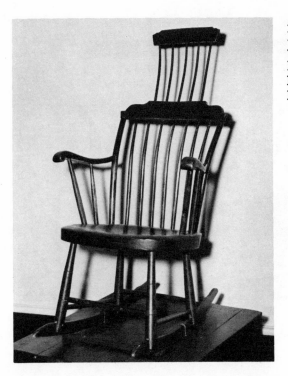

Armchair in style of Duncan Phyfe, about 1812. Mahogany with caned seat. Cooper-Hewitt Museum of Decorative Arts and Design, Smithsonian Institution, New York.

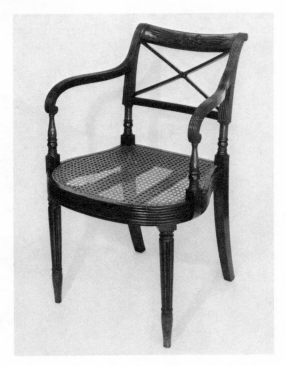

Rare Stepdown Windsor rocker with comb back. New England. Early nineteenth-century.

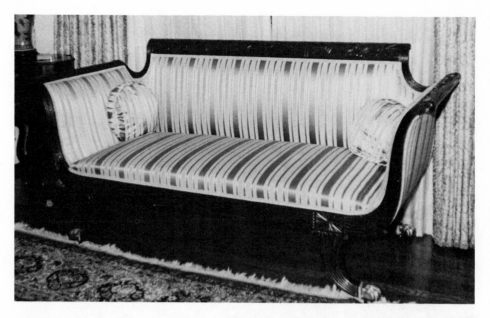

Phyfe-styled couch in mahogany with brass paw feet. Late Federal Period. Hammerslough Collection.

Late Duncan Phyfe couch in Empire style. Phyfe was one of the leaders of furniture making during the Federal Period, both in Albany and New York City. New York Historical Society.

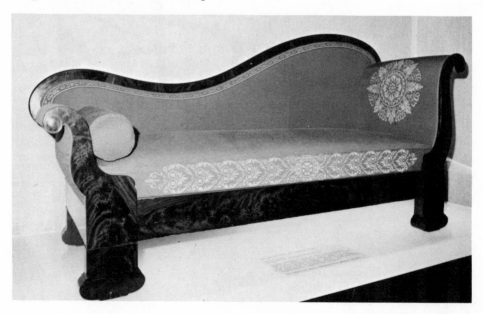

in style and manufacture than that of this country. Their demand for the graceful new furniture, which featured sweeping curved lines as opposed to the straight, architecturally correct forms, resulted in Phyfe's reexamination of his designs and the subsequent change to conform with the wishes of his well-heeled clients. This concession may have made him rich, but it cost him his greatness. He embarked on a course that ultimately terminated with the decline of his good taste in furniture design. Phyfe's early Empire work showed great originality and integrity, and he managed to keep his pieces light though strong. His straight lines practically disappeared, and invariably the lines that appear straight to the casual onlooker are imperceptibly curved. He mastered the art of making pieces look delicate and refined, but gradually his designs began to employ heavily carved, more massive proportions, which marked his decline.

Phyfe is identified with the pedestal base that bears his name to this day. Lyre-shaped decorations, reeded posts, and columns characterize many of his tables. His taller beds also feature reeded posts with extensive acanthus-leaf carving above the rails. Curule legs, which are found on many of his chairs, were borrowed from the design of an early Roman magistrate's chair. Some of his better pieces are equipped with brass feet, usually in the shape of an animal's paw.

Phyfe was a student of grained woods. Mahogany, either solid or veneer, seems to have been his favorite. Much of his work is decorated with carving. In addition, he was a master of veneer. His veneer work far outweighed his inlay work. He did not seem to like the broad expanse of wood in his sofa or chair rails and legs and most often would reed or flute them to break the monotony. His sewing tables were designed with the prevalent astragal design. His urn-carved pedestal bases, which are found on his card and drop-leaf tables, are perhaps the most original features of his work. His carving designs featured Prince of Wales feathers, drapery swags, oak leaves, cornucopias, leaves, wheat, and thunderbolts. The lion's foot was popular then, and rosettes of different styles were featured. Though rope or spiral-twist carving came into popularity, it was not commonly used by Phyfe.

Phyfe had a lasting influence on the cabinetmakers of his day. His styles have survived and are copied in reproductions offered by furniture-makers today. Phyfe's business survived until his death in 1854. Keeping pace with the demands of his clients, during this latter period

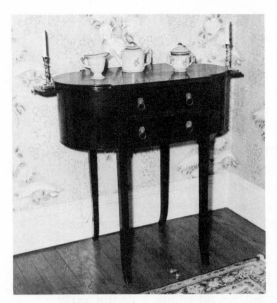
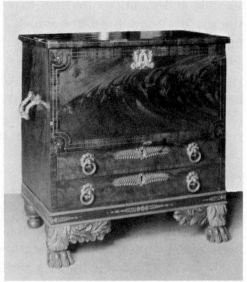

(Left) Astragal end work or sewing table with out-turned legs, front and rear; a style native to both New York and Boston. Circa 1810–1815. Mahogany with candle slides. Atop is a Lowestoft tea service. Hammerslough Collection. *(Right)* Small chest in the style of Charles Honoré Lannuier. Mahogany veneer, gilt bronze, brass, and stenciled decoration. First quarter nineteenth-century, New York. Cooper-Hewitt Museum of Decorative Arts and Design, Smithsonian Institution, New York.

he indulged in the fashions of the oncoming Victorian era. In the eyes of many, Phyfe diminished his greatness by turning out heavy furniture which was popular during the period of industrial expansion. Phyfe's death marked the end of an era of great craftsmen, hardly likely to be duplicated again.

Among Phyfe's contemporaries was Henry Lannuier, who came to New York City from France in the 1790's. Lannuier may have worked for Phyfe before opening his own establishment on Broad Street in 1805. The similarity between Lannuier's and Phyfe's work makes it almost impossible to tell one from the other at times, and consequently attribution of their unmarked pieces is rather risky. Fortunately, both worked in a period when furniture-labeling was common, and many labeled pieces have survived to serve as examples by which other pieces may be judged. Both Phyfe and Lannuier are known to have die-stamped their names to the underside of their fur-

niture. Lannuier made pieces for public buildings as well as for private homes, and he ranked as one of the better artisans of the period. He died in 1819 before the rather gross styling of the Empire pieces became the rule.

Another contemporary furniture-designer was John Gruez, who served as shop foreman for Lannuier and took over the business upon Lannuier's death. Also, there were Michael Allison, who maintained a shop on Vesey Street, and George Woodruff, who is listed as having worked with the Sheraton and Phyfe styles.

Another New York cabinetmaker of note was John Hewitt, 1777–1857. Born in England, he came to New York in 1796 and soon became involved with making steam engines. Hewitt participated in the first experiments conducted by Chancellor Robert Livingston, whose activities are covered in Chapter 8. Hewitt assisted in working out

(Left) Mahogany card table, circa 1825–1830. Squared mahogany top with veneered mahogany frieze supported by square, tapered mahogany-veneered column with spiral-carved base, resting on a rectangular-shaped plinth, supported by four carved outcurving legs, terminating in brass paw feet. Most likely New York. *(Right)* Fancy Sheraton-styled side chair. Maple and beech, red with gilt and two metal plaques. New York, possibly Thomas Ash. Circa 1820. The Metropolitan Museum of Art, New York; Rogers Fund, 1945.

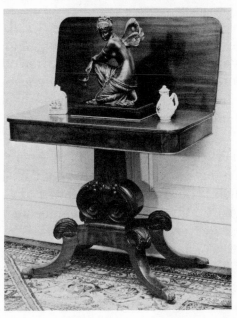 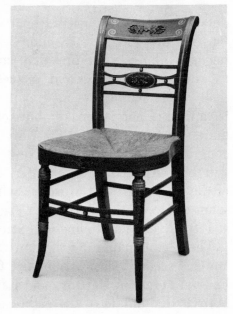

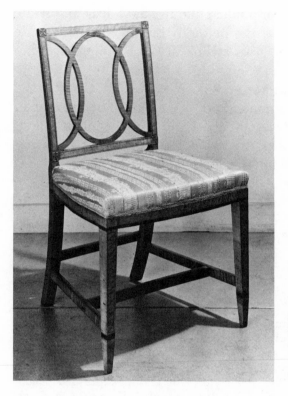

Side chair, once owned by Dor-
othy Q. Hancock, in the Hepple-
white-style dating circa 1795–
1810. Museum of Fine Arts, Bos-
ton.

details for a steam-powered boat which predated that of Robert Ful-
ton. By the end of the century he returned to cabinetmaking and
began working in the prevalent styles. He ended up as a follower of
the designs of Phyfe and incorporated Egyptian motifs to create
really fashionable pieces. Hewitt has usually been identified as a
Savannah (Georgia) maker, but actually he worked in New York, with
outlets in Savannah and St. Marys. His son, Abram, who was later a
congressman and mayor of New York City, married Peter Cooper's
daughter, Amelia. The daughters of this marriage were the founders
of the Cooper-Hewitt Museum, which is now the Cooper-Hewitt Mu-
seum of Decorative Arts and Design, Smithsonian Institution, located
at Fifth Avenue and Ninetieth Street in New York City.

The Chapin name is well known in Connecticut. Both Aaron Chapin
and his second cousin, Eliphalet Chapin, were working early in the
Federal Period in Hartford and East Windsor respectively. Both were
born at the middle of the eighteenth century, and it is believed that

they worked together at one time. Though Aaron Chapin lived throughout the period (he died in 1838), he did not turn out classic pieces, as did his cousin, Eliphalet. Aaron was a jack of all trades, making not only furniture but musical instruments and keys. Also, he served as a watch repairman. Eliphalet had fine training, and his work is on a par with that of his best contemporaries. His pieces were highly carved in the Philadelphia fashion but done with the lightness of New England design. Mahogany seemed to be the favorite wood used by both craftsmen, and both featured veneering and inlay. Aaron's son, Laertes, joined the business in 1807, and he carried on the trade after his father's death.

Other fine workers in the period included the firm of Kneeland and Adams in Hartford. This was a partnership of Samuel Kneeland and Lemuel Adams, which dissolved in 1795 when each went out on his own. Both made furniture for the old State House, some of which survives.

Inlaid tripod-based candlestand by Samuel Kneeland and Lemuel Adams, working in Hartford, Connecticut, 1792–1795. They were active cabinetmakers; perhaps their most famous work is furniture done for the State House at that time. Hammerslough Collection.

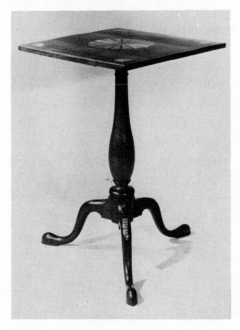

Others working in Connecticut were Aaron Roberts, of New Britain; Sanford and Nelson, of Hartford; and Benjamin Burnham, of Norwich.

Early in the 1820's a young man by the name of Lambert Hitchcock set up a factory in what is now Riverton, Connecticut, for the making of chair parts. These were shipped all over the country, which leads one to believe that the presently known Hitchcock style of chair originated in some area other than New England. About 1825 Lambert Hitchcock decided to enter the chair-making business himself and proceeded to establish a name that most furniture-collectors know. His famed pillowback side chair was first made with a rounded design, similar to one later used in Pennsylvania. Later the New England pillowback style was flattened out, which sets it apart from those made in other regions. The earliest ones were signed at the back of the seat, but it is possible that such signatures have been covered up with paint or removed by refinishing. There are so many variations of the Hitchcock style that one must be careful in buying if he intends to match them. The combinations of slats and spindles and their arrangements can confuse even the most seasoned buyer unless he has an excellent memory for detail. Others were designed with flat top rails, which lend themselves to stenciling. Most chairs with the scroll-front seat are attributed to Hitchcock. Boston rockers and settees were also part of his trade.

It is conceded that Newport, Rhode Island, contributed some of the finest cabinetmaking the country could claim; some feel it is the best. The Townsend and Goddard families were responsible for many years of service to the wealthy who resided there, and the pieces they turned out grace the finest American museums and restorations as well as homes of discriminating collectors. Daniel Goddard is the first recorded member of the families, and his two sons, John I and James, were to carry on after their father's death in 1764. James married Susanna Townsend, the daughter of Job Townsend, who died in 1765. Five of his sons had taken up the cabinetmaking trade, and the closeness of the families resulted in their working very much alike in design and style. Both families produced furniture-makers who worked well through the Federal Period, although they are best known for their eighteenth-century work, primarily Chippendale-inspired designs. The blockfront, thought to have originated with these families, is now credited to Job Coit, of Boston. The link to Newport

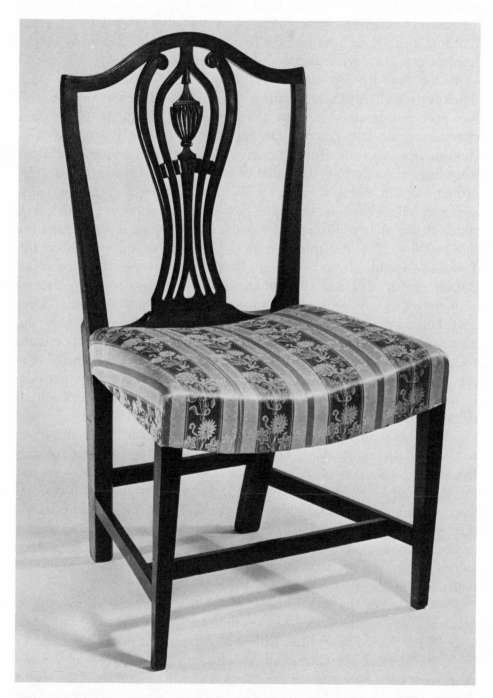

Hepplewhite side chair, Hartford, Connecticut, circa 1795, with pedestal back and serpentine top. Currier Gallery of Art, Manchester, New Hampshire.

75

was provided when one of the Coit daughters married a member of the Townsend family. The undercut talon on the ball-and-claw foot is credited to Newport, and the bracket foot with raised scroll carving on the front of it is considered native only to these families.

By the time the Federal Period arrived the Townsends and Goddards were well entrenched among the finest workmen in the country. Newport prospered at a time when the rest of Rhode Island was slumbering in slow growth. During the occupation of Newport by English troops in the Revolutionary War, several hundred buildings were burned or destroyed, probably taking with them the classic furnishings inside. Newport never fully recovered from this experience and was left behind in the rapid growth of other cities in this small state, although it continued to be a favorite summer resort area for the wealthy. The disruption caused by the war did not help the Townsend-Goddards, as they were Quakers and were caught between the ideologies of those who remained loyal to the Crown and those who regarded anyone who would not fight for liberty as being Loyalist. During this time little furniture-making was done, but after the conflict work began turning up again in the favored Chippendale style, only to be replaced with the incoming Hepplewhite and Sheraton. Thomas Goddard, the son of John I, worked in all three periods. It is difficult today to determine the maker of individual pieces, so alike was this family's work.

John Townsend, who was born in 1732 and died in 1809, also lived to see the changing styles. During the war he was captured by the British and taken to Middletown, Connecticut, where it is believed he continued his work until war's end, when he returned to Newport. Several members of this long-lived family contributed much work during the Federal Period. The favorite woods of both families seemed to be mahogany as the base with chestnut and pine as secondary woods. The elegant shell carvings on their pieces are a tribute to craftsmen of the first order.

Nowhere were the styles of Hepplewhite and Sheraton brought to greater fruition than in the northeastern section of Massachusetts and in New Hampshire. Although concessions might be made to those students of the Chippendale school in Philadelphia and Newport, none need be made for the cabinetry of the Federal Period. Both designs reached great heights at the hands of John and Thomas Seymour of Boston, and a host of others scattered up through the North

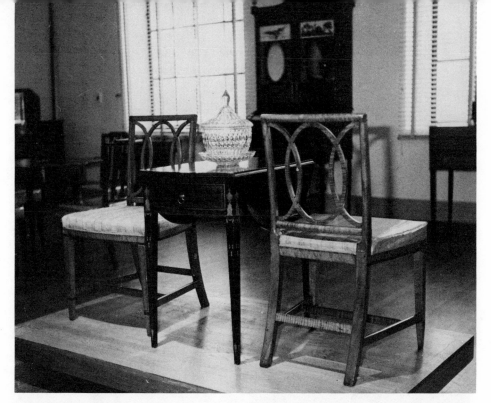

Pair of side chairs attributed to John Seymour, Boston, circa 1790. Maple, bird's-eye, and curly, with birch rails. Panels of bird's-eye veneer and bands of mahogany. Curly maple side and cross stretchers. Formerly owned by John Hancock. Cuban mahogany table is by Holmes Weaver of Newport, Rhode Island, 1790–1800, in tapered leg. Glass bowl and tray are Irish, circa 1800. Boston Museum of Fine Arts.

Shore into the Granite State. John Seymour came from England, and though he is recorded as having come from Portland, Maine, to Boston, it is felt that this was merely a stopping-off place on his voyage here with his wife. A craftsman trained in the English school, he brought with him firsthand knowledge of those ideas popular in England at the time. On his arrival he became acquainted with woods he had never seen before and began turning out furniture in such combinations of color and grain and with such graceful lines that it was no time before he was regarded as one of Boston's finest craftsmen. He made full use of the light mahoganies and cherry as his base woods and decorated his pieces with veneers of tiger and bird's-eye maple, satinwood, holly, and other fruitwoods. One notable characteristic of his work is the delicate style in which everything was made. His son, Thomas, joined the firm about 1800, worked with his father, and continued the business after his father's death.

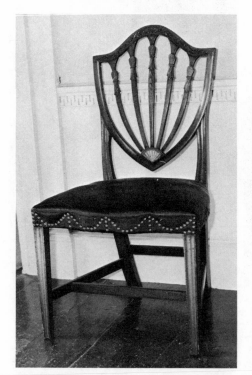 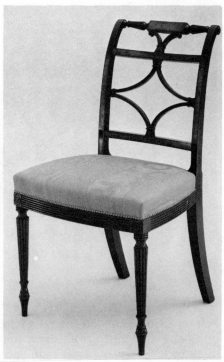

(Left) Hepplewhite-styled side chair. Mahogany, shield back, basket carving on top rail, leaf design on splats. Silver plate on back reads, "This chair was owned by Gov. John Hancock of Massachusetts in 1780. Presented by Eben Thayer to Wm. B. Dinsmore, 1883." Boston Museum of Fine Arts; gift of Madeline Dinsmore. *(Right)* Side chair in Sheraton style. Mahogany, attributed to John Seymour, Boston, circa 1800. Height 36", width 20½", depth 16". The Metropolitan Museum of Art, New York; gift of Mrs. Russell Sage, 1909.

Others who worked in the Boston area at the time were Major Benjamin Frothingham, who signed his pieces as being made in Charlestown, N.E., since so much of his work was done for export to as far away as Africa. He closed his shop at the time of the war and served with great distinction as an artillery officer under Washington. Charlestown is another community that was burned by the British, and much that would have been appreciated today was destroyed. After the war Frothingham returned and rebuilt his shop. He was one of the few craftsmen qualified to make the blockfront furniture designed by the Townsend-Goddards, and his pieces are often considered on a par with theirs. He took to the Hepplewhite styles,

(Below) Slant-top desk, by Benjamin Frothingham, Charlestown, Massachusetts, circa 1780–1800. Mahogany with satinwood. Currier Gallery of Art, Manchester, New Hampshire; gift of Mrs. Norwin S. Bean, 1967. (Right) Label on desk by Benjamin Frothingham. He made and shipped much furniture to the Caribbean and other parts of the world, so he signed his pieces "Charlestown, New England." It was used between 1734 and 1809. Engraving of label is signed by Nathaniel Hurd, of Boston (1729–1777), of the famous Hurd family of silvermakers. Currier Gallery of Art, Manchester, New Hampshire.

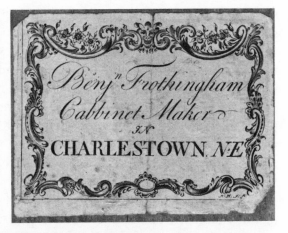

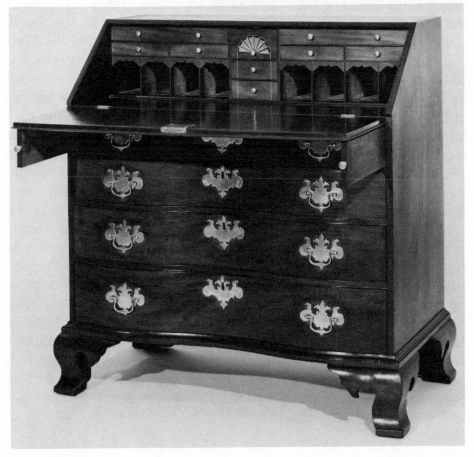

turning out classic pieces until his death in 1809. Some of his work is believed to have been carved by the famed Samuel McIntire of Salem.

Stephen Badlam worked in Dorchester until 1815, taking time out to serve in the Continental Army. His designs were in keeping with the times, and he is known to have made furniture in the Hepplewhite style in his later years. Most of his pieces were rather elaborate, and some are among the finest made in the country. Carving was believed to have been done by the Skillins brothers of Boston, who were noted in their own right. Again, this was a family of craftsmen that worked in several generations, doing much work for cabinetmakers as well as carving woodwork in homes and executing such large commissions as figureheads for ships. Some of their work was made for warships that were used during the Revolution. They were also employed by the noted architect Charles Bullfinch to carve the columns in front of the State House in Boston.

Salem, Massachusetts, the shire town of Essex County, was once one of the Commonwealth's most active ports. Located just north of Boston, it is the center of the North Shore section so often referred to in the attribution of antiques. This port was a window to the world, trading with the Orient, Africa, India, South America, and the West Indies, despite the fact that the harbor was far from the best on the coast—a vessel that drew more than twelve feet had to be unloaded on barges at a distance from the wharves, most of which were left dry at low water. Despite this, in 1816 Salem was rated to have the sixth largest amount of shipping tonnage in the country. Because of the fine quality of the ships built in Salem, her industry and commerce were sought from all parts of the world. Early in the nineteenth century there were sixteen hundred dwellings, eleven churches, a brick courthouse, three banks, an atheneum with more than five thousand books, a theater, and various other public buildings. Salem was the second town settled in New England, having been made a part of a purchase from the Plymouth Company in 1627 and 1628. John Endicott came from England with planters, servants, and tradesmen in 1628, and the following year eleven ships with fifteen hundred new settlers arrived. Many stayed in Salem, but others ended up in Boston, Charlestown, Dorchester, and other newly founded towns. The witchcraft problems first arose in the part of the town that is now Danvers, but the trials were held at the center of Salem. The famed General Israel Putnam is often referred to as a native of Salem, yet most history records him

as a son of Danvers, since this is where he lived before it became a separate community. One of the first acts of resistance to British authority took place here, when in 1774 troops were sent from Boston to commandeer some cannon. The citizens took up a drawbridge which made it more difficult for the soldiers to enter the city; once they had, the soldiers commandeered a boat in which to carry the cannon but later learned to their dismay that the colonists had slit the bottom. They left without the cannon.

There were several members of the Appleton family in Salem who were very active in furniture-making. Perhaps the most regarded is Nathaniel, who worked at the turn of the century. A William and Thomas Appleton, of the same period, are also listed. Attribution of the

Mahogany cupboard desk attributed to Nathaniel Appleton, Salem, Massachusetts, late eighteenth century. His work was in the style of Samuel McIntire, and he often used the master wood-carver to decorate his pieces. The desk descended in the Sawyer family, of Biddeford, Maine. It is presently in Saco, Maine.

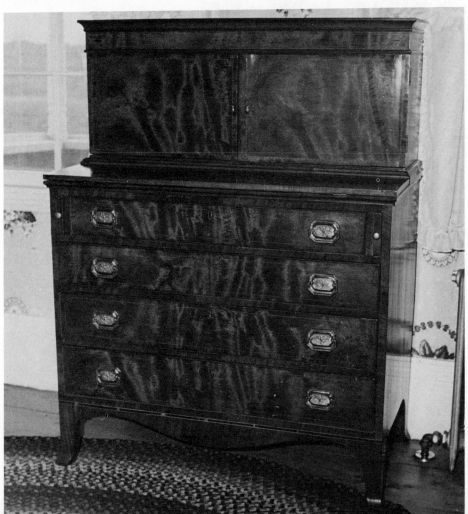

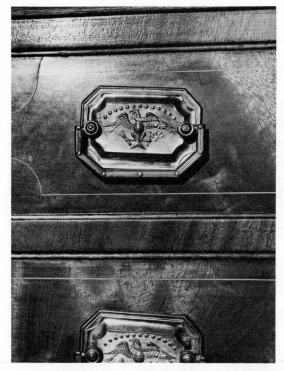

Attribution of the Appleton desk is helped by the elegant brasses which are stamped "H.J.," attributed to the partnership of Hamlin and Jones, pewterers and braziers who worked in Providence, Rhode Island. Hamlin was born in 1746 in Middleton, Connecticut. His partner in Providence was Gershom Jones. Chests of drawers have been found in Rhode Island with bails and brasses showing their touchmark.

Interesting inlay detail at top corner of desk reflects Appleton design.

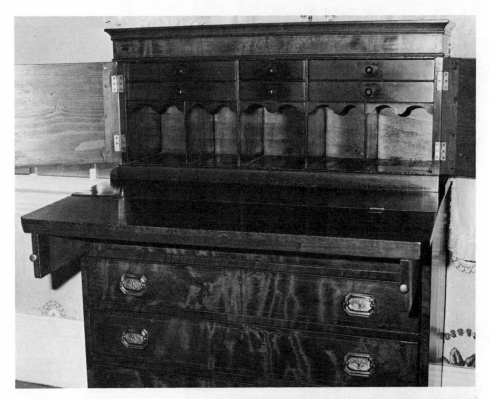

(Above) Unusual interior shows drawers at top with spacious pigeonholes. Front desk fall board appears very thick; this is because of molding to raise it to proper thickness at base of doors at top.

Though a fine craftsman made this desk, he erred slightly in the distances of inlay and keyholes—which is suspect—but both doors have been determined original to the piece.

83

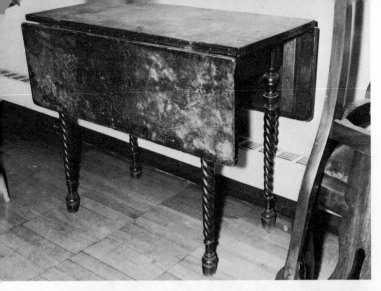

Typical Massachusetts country table, late in the period. Legs are mahogany, and top is pine. Note the heavy hoof feet, which are unusual for Massachusetts.

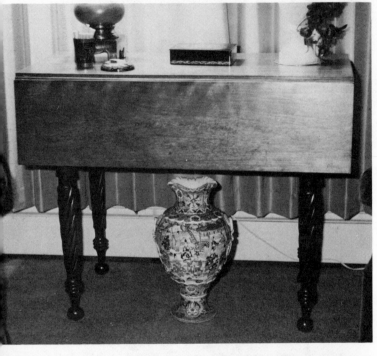

Late Federal drop-leaf table of birch with cherry legs. Length is 36", depth of leaf, 9". New England.

Late Federal drop-leaf table in cherry, found in Maine. Table length is 50"; depth of single board leaves, 19½"; top width is 18".

furniture made by each of the Appletons is difficult, since the work of the Salem cabinetmakers was very similar, and it is difficult to distinguish the origin of individual pieces if they are not properly labeled.

The name of William Hook is well known. He was born in 1777 and died in 1867. He is known for his water-leaf carving on corner posts and elaborate veneering and inlay. Other makers of the period were Edmund Johnson and Nehemiah Adams. Salem was a great town for exporting furniture to the world, so their work might be found anywhere in the world that was civilized at the time.

Little is known about William Lemon, who is said to have made the famous mahogany double chest that is in the Karolik Collection at the Boston Museum of Fine Arts. It is one of the most outstanding pieces of American furniture ever made. The carving is said to have

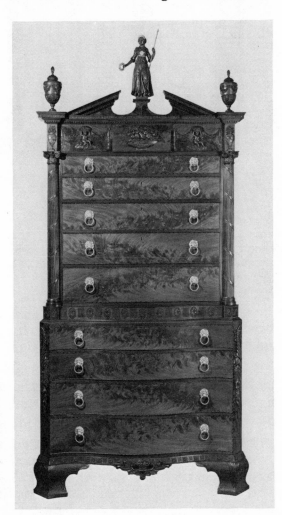

Famous Federal mahogany chest-on-chest, circa 1796, thought to have been made by William Lemon, although the intricate design and carving are attributed to Samuel McIntire, of Salem, Massachusetts. Karolik Collection, Boston Museum of Fine Arts.

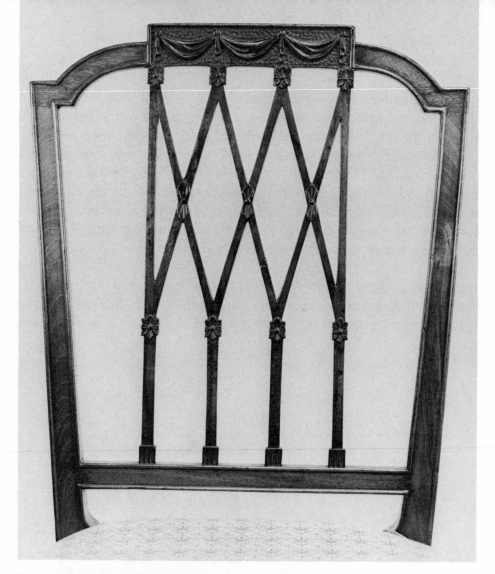

Detail of back of chair. Carving attributed to Samuel McIntire of Salem, Massachusetts, showing drapery swags and rosettes punched in detail.

been done by Samuel McIntire. This chest marks a complete departure from the dependence on English style, as the two craftsmen combined their talents to produce what one might truly call a native Federal piece. The carvings include baskets, urns, punchwork, cornucopias, figures, and fruit, along with elegant urn finials and a figure standing atop in the middle of the broken pediment. When found in Massachusetts in 1941, its drawers were being used for ripening pears.

Samuel McIntire was not only known for his wood carving and furniture-making but was also well regarded as an architect and

builder of homes. He is responsible for over twenty homes in Salem; fortunately, most of them still stand. He worked in the manner of the Adams, in that he designed not only the homes but also the furniture for them. He is known to have done much fire-frame and doorway carving for both himself and others, and his work on the furniture of so many other cabinetmakers shows the regard they had for him. He worked in both the Sheraton and the Hepplewhite styles, combining his talent for carving with graceful and light lines in the pieces. Much attribution to McIntire is made by comparison of his carving designs: He was known to have favored baskets of fruit, eagles, and sheaves of wheat. His favored woods were mahogany, contrasted with maple, birch, and/or satinwood veneer, which was the mode of that period in Salem and all along the North Shore through Portsmouth, New Hampshire.

(Left) Simple squared-back early Sheraton-styled side chair with tapered front legs. Note recessed cross stretcher. New Hampshire. At rear is fine plume inlaid fluted-leg tilt-top game table of the same period. Currier Gallery of Art, Manchester, New Hampshire. *(Right)* One of a pair of Sheraton-styled side chairs. Mahogany with satinwood veneers. Splat of four curved bars forms diamond-shaped opening. Inlay, carving, and reed molding. Forelegs curve out diagonally and are veneered with panels of satinwood. Height is 2' 11¾", seat 1' 4½" by 1' 6¾". Karolik Collection, Boston Museum of Fine Arts.

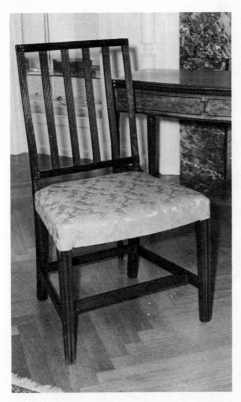
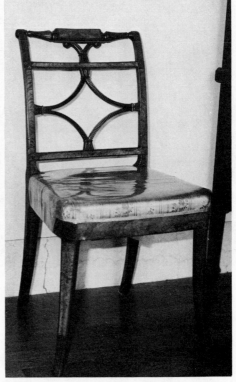

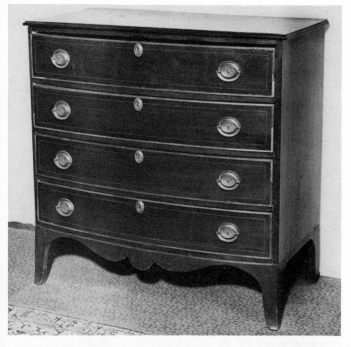

Bowfront bureau in mahogany, New England, circa 1780. Four-drawer chest with molded top. Each mahogany-veneered drawer is edge-and-line inlaid with fruitwood. The boldly scalloped apron curves into a slighty flared French bracket foot. Brasses are original with Federal symbol of the eagle.

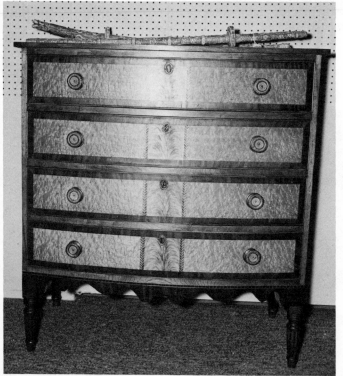

Four-drawer bowfront chest, Sheraton, New Hampshire, circa 1820. Case is of birch, mahogany-stained, with bird's-eye maple veneer on drawers. Mahogany banding on drawers. Note the legs are cut, as there should be at least 3" from the bottom turning to the floor.

88

The tradition of successive generations of a family carrying on a style of furniture was no better exemplified than by the members of the Dunlap family in New Hampshire. Major John Dunlap was born in Chester in 1746 and his brother, Lieutenant Samuel, in 1752. Both must have served apprenticeships to learn their trade, but it was not too long before their work was being recognized in central New Hampshire as being on a par with the finest at that time. The towns of Bedford, Goffstown, Henniker, and Salisbury were homes for future Dunlaps, and this remarkable family continued in the cabinetmaking business all through the Federal Period. Not only did they make furniture, but they are also known to have assisted in building churches and houses and in making pulpits and room paneling.

(Left) Four-drawer chest made of mahogany-stained birch, veneered with figured birch and bird's-eye maple. Made by Joseph Clark, of Greenland, New Hampshire, who had a cabinet shop in nearby Portsmouth. Inscribed under the top drawer in pencil is "Made by Howard's great-great grandfather Clark for Howard Clifton Avery, from Belle Avery. Made in Great Grandfather Joseph Clarks cabinet shop in Portsmouth about 1810. A part of Grandmother Mary Moody Clark Avery Trousseau in 1813. Belle Avery." Miss Clark inscribed this when she gave it to her nephew Howard. Joseph Clark moved to Wolfeboro in 1817 and is believed to have carried on his cabinetry work with his son Enoch. It is the first piece of drop-panel decorated furniture to be traced directly to a maker. *(Right)* Cupboard desk in mahogany-stained birch, with mahogany and birch veneers. It was also made by Joseph Clark. This is the second known drop-panel piece traced to its maker.

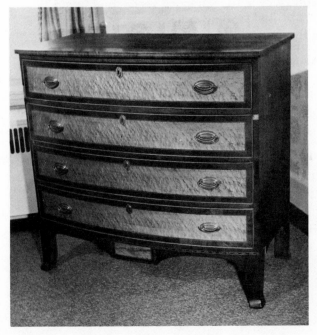

 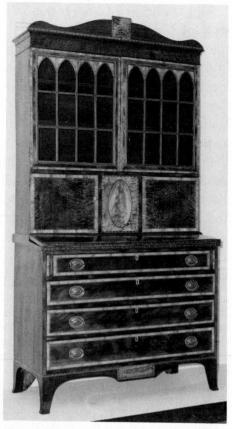

(Left) Elegant secretary made by the Seymours of Boston, early nineteenth-century. Case is mahogany with holly inlay. Hammerslough Collection. *(Right)* Ladies secretary and bookcase. Mahogany with mahogany veneer and inlaid maple decoration. Gothic arch doors and drop-panel indicate Portsmouth manufacture, most likely by Judkins and Senter, circa 1810. The top gallery does not appear to be original. Portsmouth furniture was not made with the raised panels in the manner of Salem and Boston. New Hampshire Historical Society, Concord.

In addition to continuing members in the family, there may have been as many as fifty-two men who worked for the Dunlaps in their trade over the years, and they must have assisted in making or completely made pieces in the Dunlap tradition that are directly attributed to the family. Since direct attribution to any particular maker is difficult, the pieces are generally referred to as having been made by a

member of the Dunlap Circle. One of the finest pieces in Dunlap tradition is a highboy with latticework top which was made by William Houston, an apprentice of Major John's, who signed the piece, now at the Winterthur Museum in Delaware. Although the bulk of the work was done in the latter part of the century, the cased pieces still featured bandy-legs and feet characteristic of both the Queen Anne and the Chippendale periods. A great change was seen after the turn of the century. Going from the high styles that would be associated more with city work, the Dunlaps began turning out the simpler pieces like candlestands, rocking chairs, pine-seat side chairs, worktables, washstands, dressing tables, and tilt-top game tables. These were done with both tapered and turned legs. Ladder-back chairs, a very basic country item, was also a product of Dunlap manufacture. The 1970 showing of Dunlap pieces at the Currier Gallery of Art in Manchester

(Left) New Hampshire worktable in birch with inscription in handwriting on drawer bottom: "This table was made by Enoch H. Clark before he was married, out of a birch tree that grew on the Clark farm in Wolfeboro about 1820. It was used in Sarah P. Clark's bedroom after their marriage in 1826. It was purchased from her estate by L. Maude Cate. This drawer was too bad to be used. Samuel Leavitt of Wolfeboro Falls refinished the table and made a new drawer, except for the old frame which had a new piece put in the lip edge where it was worn, 1894. The drawer pull came off a closet door in the house now occupied by the Wolfeboro Summer School. The house was called the Mooney Place. It was on the North Shore of Rust's Pond. L. Maude Cate." Elvira Avery. *(Right)* Tall writing desk with tapered Hepplewhite-styled legs, late eighteenth century. Owned by General John Stark, hero of the Revolution. In maple and pine. Manchester (New Hampshire) Historic Association.

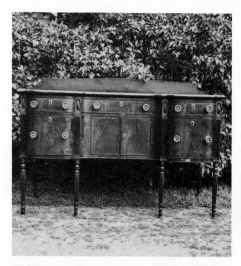

(Left) Awaiting its turn at an auction is this late Federal sideboard. In mahogany with pine as secondary wood. The impressive scroll back and oval fan carvings at the leg tops lend an air of dignity to the piece. Brasses are original. New England. (Right) Eighteenth-century invalid's chair with back missing. It could be lowered to form a cot. In maple and birch, well pegged. New England.

produced a catalog written by Charles Parsons, Dunlap historian, which is a complete guide to the activities and accomplishments of this family, along with many pictures of their work.

Another family with a long record of achievement in New Hampshire is that which lists John Gaines II, of Ipswich, Massachusetts, as its patriarch. He was the father of John III, who moved to Portsmouth in 1724 and opened a cabinetmaking shop. He is the most highly regarded of the Portsmouth makers. How much of his furniture remains undocumented in the Portsmouth area is a good subject of speculation, as he worked actively until the time of his death, 1743. He is responsible for the famous Portsmouth stairway balusters, which are done three to a step—one turned, one spiraled, and one fluted. This design was copied in most of the major houses built in Portsmouth until the time of the Federal Period. His son, George, was born in 1736 and died in 1808. After his father's death the cabinet shop was rented, and it is felt that George learned his trade under the new owners. Working well into the period, he must have been responsible for much of the fine furniture found in the better homes. He is known

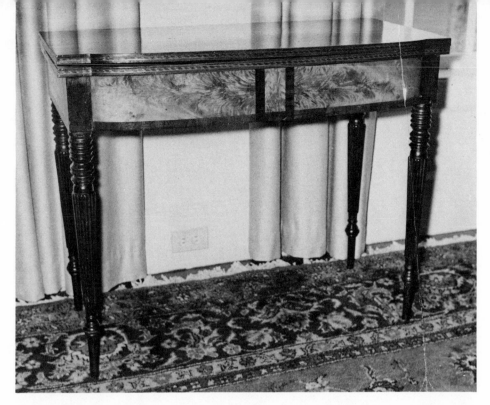

Early nineteenth-century card table with fluted legs, cherry, inlaid with plume veneer in satinwood. Massachusetts or Portsmouth, New Hampshire. Elvira Avery.

(Left) Impressive early Federal Hepplewhite-styled banquet table in mahogany with shield-back chairs. Though the style is reported to have originated in Baltimore, the table legs do not bear the familiar bellflower inlay of the southern pieces. It is on display at the Secretary's House, Greenfield Village, Henry Ford Museum at Dearborn, Michigan. The house, built by John Giddings, a prosperous merchant, was later sold to Joseph Pearson, who served many years as Secretary of State in New Hampshire. The house was moved from Exeter to the Ford Museum. (Right) "Martha Washington"–type armchair, circa 1800, New England. A very graceful example of this style.

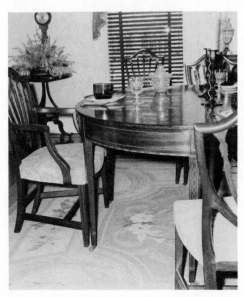
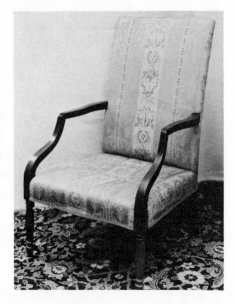

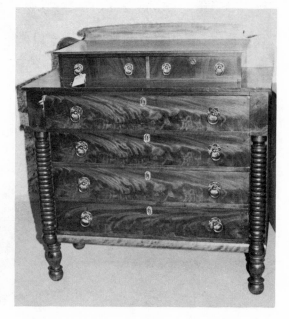

Late Federal Period chest, circa 1820–30. The flame graining of the mahogany veneer makes this quite desirable. The spool corners, raised drawers, scroll back, and overhanging top drawer are marks of the period.

to have done work in Chippendale style, but his other work is undocumented.

Another fine Portsmouth maker was Langley Boardman, who was born in 1760 and died in 1829. He was well established in his own shop by 1803 on Congress Street and employed many workmen. He is known to have worked in the Federal styles, leaning heavily on the designs of Hepplewhite and Sheraton and also joining those who began making Empire-styled pieces as the change was slowly being felt.

There are many other lesser makers whose contributions to the cabinetry in New Hampshire during the period were tremendous. The auctions, which are being held on old farms today, still turn up many of these pieces. During the Federal Period New Hampshire was fairly well settled all the way to the Canadian border, and every community had workmen who took care of the local furniture needs. Some of the characteristics of New Hampshire pieces include a fairly low center of gravity in cased pieces, made in the Dunlap tradition, spoon-handle carving in fans, the S scroll motif, flowered ogee molding, ball-and-claw feet with reverse taper in the ankles, dentil molding, and lattice-work galleries at the top. In the simpler furniture of the state one

Federal Period chest in cherry
with tiger maple veneer on the
drawers, of the type that would
have been made in the New York
State area. The legs are cut;
there should be at least 3″ from
the last turning to the floor.

should look for very high feet in the bracket-based pieces and wide
moldings at the tops of chests. Tiger maple was a popular wood, but a
lot of plainer birch was also used. In the Portsmouth area much was
done with veneering and inlay, utilizing much of the figured maples
and satinwood, linking this type of work with that done on the North
Shore of Massachusetts.

The many chests, desks, and secretaries that appear with drop ve-
neered panels at the bottom center have been the subject of much
research by the author. As of now, over ninety have been located and
photographed in the country; in homes, museums, shops, etc. . It is
felt that most were made in the Portsmouth, New Hampshire and
Salem, Massachusetts area. None has appeared with a Boston attri-
bution. Until 1971, no piece was documented to a maker until the
chest and desk pictured on page 89 were uncovered in Wolfeboro,
New Hampshire, with written documentation on a drawer bottom.
Others by Judkins and Senter of Portsmouth and Nathaniel Appleton
of Salem represent the only known makers at this time. Joseph Clark
lived in Greenland, New Hampshire, worked in Portsmouth and later
moved to Wolfeboro. The known pieces were handed down in his
daughter's family.

Chapter 3

Ceramics

The making of stoneware and other clay pieces is as old as history itself, and in America it was one of the first industries set up by the adventuring Pilgrims. There are few areas on the eastern seaboard where clay is not abundant. Clay is defined as a hydrous aluminum silicate, generally mixed with powdered feldspar, quartz, sand, iron, oxides, and various other minerals. Some people feel it has medicinal value, and for years pregnant women have eaten it—a practice still common in the South. Our concern is not for its therapeutic value, but rather for its functional value, which indeed has made it invaluable to all nations. It is a readily available raw material which requires little or no processing and is easy to shape and harden into vessels of all kinds.

Potters Hill in New York City was the site of a stoneware factory set up about 1735 by John Remmey, an immigrant from Germany. It was located near Fresh Water Pond at the rear of the City Hall. Remmey's stoneware factory signaled the beginning of one of the earliest industries in the colonies. It prospered as it passed through the hands of the Remmey family until its demise in 1820. Joseph Henry Remmey, a great-grandson of the founder, moved the business to South Amboy, New Jersey, in order to be close to clay deposits. During its long span of life this factory turned out some of the stoneware that is highly prized today. The bulk that remains as evidence was made after the revolution.

There were many other potters in the New York City area, and they should be mentioned, as most were quite active during the Federal Period. Earthenware and stoneware of this period are most interesting because colored decorations were incised on many pieces. Cobalt was most often used for the coloring, and the designs ranged from simple

crescents to flowers, animals, and simple sayings. Many were signed by their makers, especially after 1800, some not necessarily with their own names but with some other identifying symbol. When one sees the words "Manhattan Wells," the piece might well be attributed to either the Remmey family or the Crolius family. Both families set up their factories near these wells, which served the population for many years. Old records show the existence of a pottery owned by William and Peter Crolius as early as 1732, but it was not until 1742 that a map of the city showed the Remmey and Crolius Pottery as well as several others on Potters Hill. It is assumed the reference was to separate potteries, as there is no other evidence that the families were in partnership.

A huge stone reservoir was built near this site which supplied water under pressure through wooden pipes to the nearby area. As the city expanded on Manhattan Island, the reservoir was taken down, and both Potters Hill and Fresh Water Pond were leveled and filled. Clarkson Crolius moved his pottery to Bayard Street, and the firm operated there for some years, turning out pottery in a brown color rather than the usual gray stoneware. There is great similarity in the early Remmey and Crolius pieces, as shapes were similar and coloring

(Left) Gray stoneware crock, 1793–1815, by John Remmey III. Height 11³⁄₁₆″, diameter 8″. The New York Historical Society, New York. *(Right)* Pottery colander, heavy with brown glaze and yellow slip. Inscription, "Sally Bailer Her Cullender, 1781," divided by leafy designs. Boston Museum of Fine Arts.

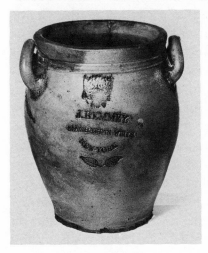
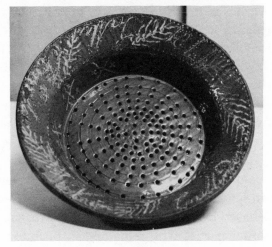

almost identical. Both used the address Manhattan Wells and New York, either impressed or inscribed. It has been suggested that the Remmey pieces were darker in color and heavier than the Crolius pieces. In any event both would command much the same interest and prices today. If "Manhattan Wells" alone is used, it is most often attributed to Clarkson Crolius, whereas "C. Crolius, Manufacturer, New York" is most likely his son, who had the same name. Both concerns turned out large numbers of crocks, jugs, cuspidors, mugs, pitchers, penny banks, salt boxes, and the like.

Works of other potters made during this period have turned up; little is known about some of them, and often that which is known is not enough to concern the collector, for insufficient work has turned up to create importance. Some of these are represented by pieces that might have a name and date or some other identifying feature such as: D. Morgan, N.Y. 1806; WK, 1788, NYC; Bill Howard, 1800, N.Y.; IJK, N.Y. March 4, 1798; John Johnson, Staten Island (about 1793–1806). Another with slightly more fame attached was Thomas Commeraw, who quite often marked his pieces only "Corlears Hook," an area at the East River end of Grand Street in New York. He worked there between 1802 and 1820. He used an incised and enameled crescent as a decoration.

New Jersey was a center of early pottery-making. The clay in the area of the Amboys was especially suited for the industry, and much was shipped and is still being shipped from that region to potters everywhere. As early as 1775 there is a recorded stoneware manufacturer, James Morgan, who was located in the village of Cheesequake, which is in Middlesex County. He served as a captain in the Continental Army but in later years was referred to as General Morgan as a token of esteem. During the war the British burned his pottery, but he reopened it, and it operated until about 1885. There are no markings that positively identify his pieces, but fragments dug at the site give some clue as to the decoration and manner in which they were dated. In 1805 James Morgan, Jacob Van Wickle, and Branch Green opened a pottery at South River Bridge, and their pieces may have had the marking "James Morgan & Co." Another pottery at Cheesequake was started by a Thomas Warne and later operated by his son-in-law, Joshua Letts. Letts worked there until 1815, when it was purchased by James Morgan. When Morgan died in 1822, it was bought by other parties who remained in business until 1830. Items made by the

earlier owners might bear the inscription "Liberty for Ev/Warne & Letts, 1807/S Amboy N. Jersey." Decorations might include bands of coggle-wheel decorations as well as incised and enameled crescents and holly leaves.

Other pieces marked "Made by Xerxes Prices/S. Amboy" were made at Roundabout, which is now Sayerville, as early as 1802. Some are marked only with his initials, XP, or only with a decoration resembling a three-bladed propellor.

Trenton, New Jersey, was also a center of ceramics-making for many years. The first recorded pottery in Trenton was that of Bernard Hanlen, dated 1778. It was the Stoneware Potting Manufactory at Trenton.

The reference on some stoneware marked "P.P. Sandford/Barbadoes Neck" is to P. P. Sandford, of Hackensack, which was once called Barbadoes Neck. He signed his pieces, which would date them into the

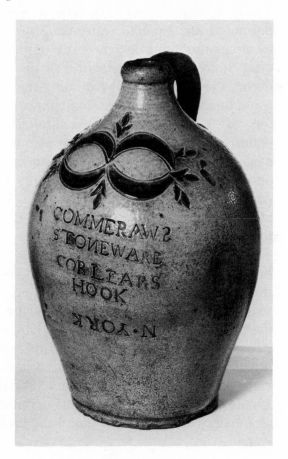

Gray stoneware jug, circa 1820, by Thomas Commeraw, New York City. Height 11¾", diameter 8". The New York Historical Society, New York.

latter part of the 1790's. Those pieces marked "IVS" can be attributed to Josiah Van Schoick, of Matawan, who is known to have worked during the first part of the nineteenth century.

Pennsylvania is rich in loam, and red clay lies just beneath this in abundance throughout the Commonwealth. The clay was easy to dig and easy to work and was broken up and softened by a rig, which used the power of horses to turn an upright post to which knives were attached. Most of the clay was turned on wheels, with those for right-handed people turning counterclockwise and those for left-handed, clockwise. Naturally, the simplest of shapes were made for the simplest of household containers and kitchen use, yet the charm of these pieces is so great that they are considered fine folk art. Sometimes larger items such as bowls and crocks might be molded. Unelaborate decorations were made by applying a simple slip glaze made of white clay and water with a goose quill or sometimes by merely trailing a design, pouring it from a cup or other container. The slip-decorated and sgraffito ware made in Pennsylvania during the eighteenth century and into the early part of the nineteenth is among the most desired yet most plentiful of our early ceramics work. Sgraffito decoration was created by dipping the clay body into the slip, which could be colored, and then scratching or incising the design so that the red clay beneath would show through. Much was done with brush painting, and figures of the popular tulip, doves, children, animals, eagles, and the like would be used for decoration in bright colors. Sponge decoration was created simply by dipping a cut sponge into colors, which would then be applied, leaving a stippled effect. The famed spatterware was decorated either by sponge or by spattering of the colors on the piece.

The early slip glaze was replaced by the salt glaze after the Revolution. At the end of firing a piece or pieces in a kiln, salt would be thrown into it, and as the salt vaporized almost instantly under the intense heat, it would be deposited on the pieces, forming a hard, clear finish. Once salt has been used in a kiln, no other glaze may be fired in it, as the residue makes it impossible for others to adhere to the clay body. The colored glazes came from the following metals: Green was made from oxide of copper; dark brown was made by adding manganese to red lead; and the most popular blue was provided by oxide of cobalt, which could withstand the high-temperature firing of stoneware.

Most of the early slip- and sgraffito-decorated pieces that have survived are dinner plates, pie plates, and smaller serving dishes. One type is the Poi-Schissel pie plate, used for raisin pies, called funeral pies. Unfortunately, many pieces like these ended up in the hen yards to feed the chickens; some of the best have been found in chicken coops and barns. However, many owners prized these pieces and used them as decorative items on their hutches, and good ones have survived. Many have remained in the hands of families, others have gone to museums and restorations, and collectors all over the country have created such a demand for them that the prices have soared. There are very few pieces of good quality that do not command more than one hundred dollars.

Many of the better makers have been cataloged. Among them is David Spinner, who worked in Bucks County about 1800. He liked to picture women and men on horseback, and soldiers. He inscribed his pieces in English, "David Spinner, Potter, his make," generally silhouetted in red against a light slip background. George Hubener

(Left) Pie plate, made by David Spinner, Pennsylvania German, Bucks County, circa 1800. Common clay. Sgraffito decoration. Philadelphia Museum of Art; given by John T. Morris. *(Right)* Pie plate, Pennsylvania German, Bucks County, made by Andrew Headman, dated 1808. Common clay. Philadelphia Museum of Art; given by John T. Morris.

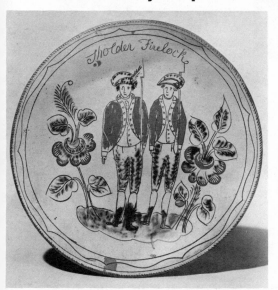 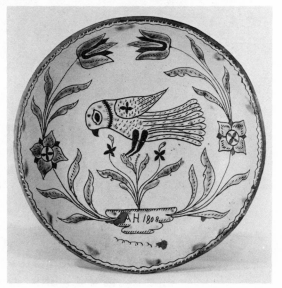

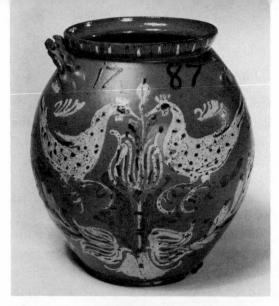

Pottery jar with slip decoration. Pennsylvania German, 1787. Possibly Christian Klinker. Philadelphia Museum of Art.

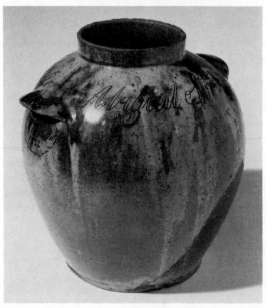

Pottery jar, lead glaze, sgraffito and slip, Pennsylvania German, from Vickers Pottery, Downington, 1822. Philadelphia Museum of Art.

worked in Montgomery County. He favored doves entwined, tulips, and peacocks and provided them with Germanic inscriptions and signed them "G.H." Christian Klinker worked in Bucks County in the 1770's and 1780's. He preferred tulips and floral forms and signed his pieces. Others of the period were Jacob Tavey, of Bucks County; John Leidy, of Montgomery County, who was working at the age of sixteen; John Nase, of Montgomery County; Johannes Neesz, of Montgomery County; and Andrew Headman, of Bucks County. Quite often pieces will turn up with little or no identifying writing other than

names and initials, such as the plate marked "John Monday, 1828" or the one marked "Andrew V., 1808," examples of whose work can be found in the Reading Public Museum, Reading, Pennsylvania.

Red clay is found just about anywhere, so one cannot make attribution to Pennsylvania on color alone. Slip and salt glazes were used by all the early potters in the period. The decoration of the Pennsylvania pieces is unique, and because of this bit of folk art, these pieces command the better prices. One cannot suggest any best place to buy them, as good-quality pieces are rare. Generally, one must wait for old farm auctions and the auction of collections in order to buy top-quality pieces.

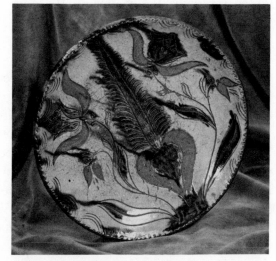

Pennsylvania redware plate, sgraffito-decorated, circa 1800–1830. William Penn Memorial Museum, Harrisburg, Pennsylvania.

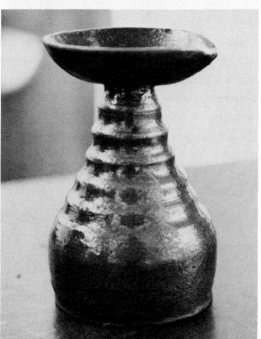

Simple red-clay grease lamp, Pennsylvania. Dr. David Bronstein, New Cumberland, Pennsylvania.

There were many brickyards in New England, as clay was abundant, and the Georgian designs of homes required bricks and other masonry products. By-products of many of these yards might be jugs, crocks, milk pans, butter crocks, and other simple forms that could be turned out quickly by potters and fired right along with the bricks. It is impossible to document how much of this was turned out and where, as little or none was marked. One particular area that contributed about 75 percent of the red brick that built eighteenth- and early nineteenth-century Boston was Gonic, New Hampshire. The town's original name was Squamanagonic, which means "river of clay." At one time there were thirty-five brickyards in operation, supplying the needs of much of New Hampshire and Massachusetts. A by-product of some of these plants was red-clay ware, which was simply slip-glazed. It is the coloring of the clays and the slips that makes this early ware quite important. Some pieces have turned up in greenish-yellowish colors, quite unlike the brick-red of most of the clays. The ware is referred to as Gonic clay and is collected when one is lucky enough to locate a piece coming out of an old farm or home during an auction. The best pieces date back to the late eighteenth and early nineteenth centuries.

Much more famous was the Norton pottery at Bennington, Vermont. The term "Bennington" is loosely applied to much ceramic work that was never made there. There were two potteries of note that share the fame of the community. One was opened in 1793 by Captain John Norton, a veteran of the Revolutionary War. Active during the Federal Period that followed, his pottery managed to survive all sorts of catastrophes and depressions until 1894, a hundred years later. Despite the tremendous amount of redware, stoneware, and graniteware turned out by this concern, it was but the contemporary of many other establishments, equally hard at work with mass-production techniques, making similar items. The term "Bennington" applied to the varicolored brown Rockingham ware is more often than not used incorrectly unless the piece is well marked or can be identified by its pattern.

Companion to Norton's pottery in the same village was a pottery opened by Christopher Webber Fenton and his partners in 1847. It was called Fenton, Hall and Company, but the pieces were marked "Fenton's Works, Bennington, Vermont." Since Fenton was linked with the Norton family by marriage, there has always been confusion

in attribution of pieces. Fenton is not of the Federal Period, so we will not dwell on his business success and the failure of his eventual United States Pottery Company, which expired in 1858. We cite him as the alternative to positive attribution of Bennington pieces. Fenton specialized in making more fancy and decorative wares and produced perhaps the finest Parian porcelains made in the United States.

Captain Norton, a native of Goshen, Connecticut, lived for a time in Williamstown, Massachusetts, and moved to Vermont before statehood was achieved. He took up farming and is known to have opened a distillery. Some feel that his entry into the pottery field was specifically to make jugs for his product. He began with redware and stoneware, and when his sons joined the business, he began to make brick. The sons, Luman and John, owned and operated the business between 1823 and 1827, when Luman took over sole proprietorship. His pieces are so marked, "L. Norton & Co." After 1830 the pottery grew and became an important factor in the economy of the community. There must be many pieces of unmarked early Norton pottery scattered throughout New England and New York. Captain John Norton died in 1828, just as this nation entered the threshold of the Machine Age. That his business survived until the latter part of the century is a tribute to his sons and those who followed.

The similarity of early stoneware and redware pieces throughout the whole country makes attribution difficult. If names are incised or painted on, or if decorations are native to an area, the chore is easier, but so much was made in identical fashion and of the same colored clays that it does little good to list potteries that appear in early histories or are advertised in early papers. Today most people are unaware of who did early nineteenth-century work. Old-timers of earlier generations who might have enlightened us have long since passed away. Once in a while the color of clay or of a slip decoration can help in attribution, but these instances are rare. In the annals of Brown Township, Morgan County, Pennsylvania, it is recorded that

> J. S. Kelley erected a pottery a short distance West, and Ball was his potter. They manufactured many excellent crocks, jars, jugs, etc., some of which may yet be seen in the neighborhood. Several thousand of these useful household articles were made annually, and found a ready sale for many miles around.

The history was published in 1884, at which time it is related that items from the pottery could still be found—and obviously identified. Now, almost a hundred years later, it would be interesting to locate a few pieces.

It is amazing that America lagged so far behind the rest of the civilized world in the making of fine chinas and porcelains. The rather feeble attempts during the eighteenth century deserve but passing recognition, as little worthwhile was accomplished by those who experimented with them. Actually, the English were quite late in their mastering of fine ceramic techniques (little was done there before 1720), yet their industries rose to such prominence during the latter part of the century that they all but dominated the china trade throughout the world. The English certainly dominated the buying habits of their colonies, allowing little but their own products to be sold there. The determination to keep the American colonies as customers rather than suppliers conspired to destroy the initiative to create such an industry here. What machinery and molds might have been used at that time most certainly were not made in America, which was dependent on England's good graces to supply them, and more often than not, they were not forthcoming.

Yet there were hardy souls who on their own attempted to duplicate the fine porcelains and chinas that came from England and the rest of the world. Trade with China was great, but much in the way of ceramics was shipped to America via England. Perhaps the colonists were actually content with what they received by regular channels of trade, but already the stirrings of independence inspired local craftsmen to go out on their own to better what was imported. Lack of adequate transportation, communication, and markets outside their immediate area kept most of these efforts to a small scale. The necessities, such as furniture, treenware, clothing, and farm tools, were more easily and competitively supplied by native makers, but when it came to the luxury items such as china, silver, pewter, fancy dress goods, jewelry, and fine glassware, America was not in much of a position to compete. The English withheld their supplies of raw materials as well as their know-how. America had the clay but neither the molding machinery nor the formulas to convert it into the desired items.

Andrew Duche, a native of Philadelphia, who was later to reside in New Windsor, South Carolina, and Savannah, Georgia, is credited as being the first maker of porcelain in America, although none of his

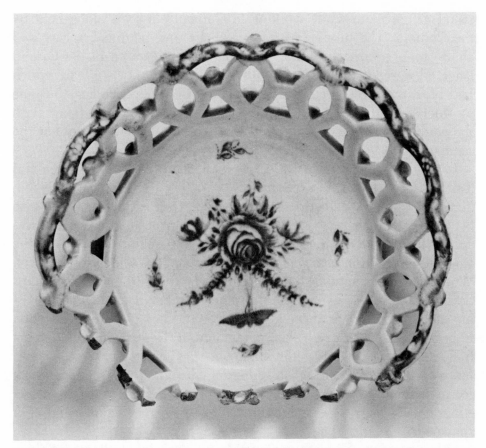

Pottery fruit basket by Bonnin and Morris, Philadelphia, 1770. The factory was set up to imitate the works of Bow and Worcester in England, but it has never been ascertained that porcelain was ever successfully made there. There are five known surviving pieces made by this firm. Philadelphia Museum of Art.

work has been found. He erected a pottery in 1738 to make porcelain and chinaware and advertised for workers and materials. He operated under a financial grant from the colony of Georgia and seems to have received encouragement from England to proceed with his work. This is in direct contrast to the feelings of the English later in the century who fought to forestall American manufacture in order to create dependence on English exports. One must remember that the English at the beginning of the century were still involved in primitive clay work, and it was not until 1709 that Johann Bottger discovered the

secret of porcelain while working in Germany—a secret long held by the Chinese. The proper mixture of kaolin and petuntse, a clay and china stone, produced porcelains equal to those found in the Orient. England was slow to catch up with even the early faience ware which had been produced for some time on the Continent, and at the time of Duche, England's own porcelain industry was in its infancy with the works at Bow, Worcester, and Chelsea being created at about the same time.

In 1743 Duche went to England. A year later Edward Heylyn and Thomas Frye received a patent for a method of making porcelain. Since the patent specified the using of Cherokee clay, which had also been used by Duche, there is feeling that Duche may have been responsible for the formula as well as for the real beginning of the English porcelain industry, which was destined to dominate the world. Whether Duche actually engaged in the porcelain-making business beyond experimenting with it is a subject for conjecture. No advertising of his product has turned up, and he did not give any indication in print that he was a porcelain-manufacturer. He died in Philadelphia in 1788. His discovery of the Cherokee clay proved of great importance to the fledgling English industry, and much was shipped there for manufacture. It is ironic that this was an American product, yet America was not able to capitalize on the great industry that it spawned.

Other potters who were responsible for short-lived efforts included a John Bartlam, who advertised in Charleston, South Carolina, that he had opened a pottery and china manufactory and solicited information on available clays he might buy. He was followed by Richard Champion, of Camden, South Carolina, who had moved there from Bristol, England, where he had operated his own plant. He died in 1791, leaving no evidence of any work he did there.

Perhaps the most successful early effort was that of Gouse Bonnin and George Anthony Morris, who erected a pottery in Philadelphia in the Southwark section. They advertised a finished product in 1771 and continued to turn out a product billed as American ware, blue and white ware, and enameled "china." Lacking necessary capital, they undertook a lottery to assist in their financing. In 1771 Morris left the firm, and in 1772 Bonnin announced he was quitting the business to return to England. The few surviving pieces made by this firm are not porcelain but white-glazed earthenware. They are marked

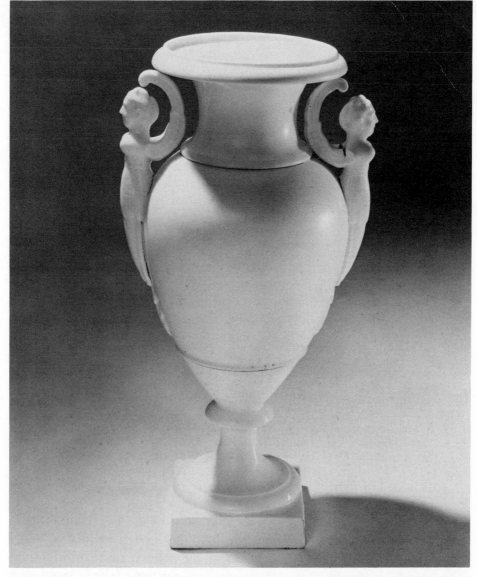

Porcelain vase, soft paste, made in New York by Dr. Henry Mead, 1816. Mead was one of the pioneers in porcelain-making, and this vase, which is made in two pieces, is bolted together. It is regarded as the earliest piece of porcelain made in this country that has survived. Philadelphia Museum of Art.

with a blue "P" on the bottom, most likely signifying Philadelphia.

Dr. Henry Mead, of New York, is responsible for the first true piece of porcelain made in this country. His obituary stated he opened his pottery in Jersey City. Though a successful physician and former alderman in New York City, he died destitute in 1843.

In 1825 the Jersey Porcelain and Earthenware Company was founded for the purpose of making porcelain and earthenware. One of

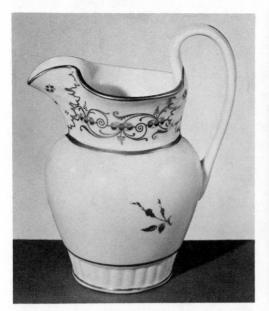 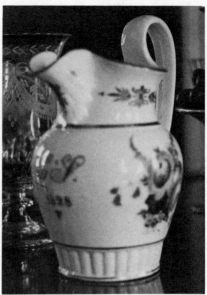

(Left) Porcelain pitcher by William Ellis Tucker, made by Tucker and Hulme China Manufacturing Company, Philadelphia, 1828. This was the finest of early American porcelains. Philadelphia Museum of Art. *(Right)* Porcelain pitcher by William Ellis Tucker, Philadelphia, decorated in gold with date, 1828. The American Museum in Britain, Bath, England.

the incorporators was George Dummer, who was an owner of the Jersey Glass Company, so there might have been some direct tie-in between the two firms. This firm must have been quite productive, as many of its wares were entered in competitions where they won prizes. Its fame was short-lived, however, and it closed its doors in 1828.

The most productive of America's early porcelain-making firms was that opened by William Ellis Tucker in 1826. He made his first porcelain the following year, and it was an instant success. His father had owned a china store on Market Street in Philadelphia, and as early as 1816 young Tucker was experimenting in a kiln built in the backyard. He finally succeeded in creating a fine porcelain, which in due time won awards. This was after he had purchased land on Chestnut Street and had built a new kiln there. He had entered into partnership with John N. Bird, and the business was called the Tucker and Bird China Factory.

This partnership was broken up because Bird was a minor and in ill health. Therefore, he would not have been able to work at the trade. In 1828 Tucker took on a new partner, John Hulme, and the factory was known by the name of Tucker and Hulme. Tucker appealed to President Andrew Jackson for funds with which to build a new factory in exchange for the secrets of his formula, which could then be used by all such firms to build a big china industry in the country. He failed in this attempt on two occasions. When Tucker died in 1832, he had as partner Alexander Hemphill. When Tucker's interest was sold at auction, Judge Joseph Hemphill, Alexander's father, bought it and took William Tucker's younger brother, Thomas, into the business to operate it. He operated it successfully until 1837, when it was rented to Thomas for about a year. It closed down in 1838.

Short-lived as it was, this concern managed to turn out a sizable output, which has resulted in some good collections. Identifying Tucker china is a chore even for experts who are versed in every

Garniture of three Tucker porcelain vases, Philadelphia, circa 1830. Governor's Mansion. William Penn Memorial Museum, Harrisburg, Pennsylvania.

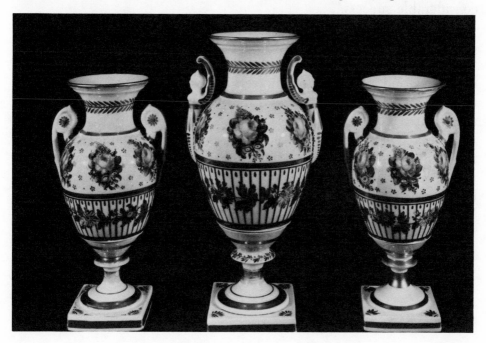

phase of its manufacture. There is good evidence that Tucker and Judge Hemphill had employed French artists and potters, possibly from Sèvres, France, and they turned out a product that can too easily be mistaken for true Sèvres. The first of it, prior to 1830, was mostly done in white with some gilding. Pictures in a sepia or brown color were the first decorations. Then elaborate pictures were painted on the porcelain. Few of the Tucker pieces were signed, as the trend was to allow the buying public to believe it was buying imported china, which was more highly regarded. Most of the marking was done on commemorative and presentation pieces and on specific orders from customers. That which went to the general trade, unmarked, is what gives the collector of today real problems in attribution.

It is interesting to note that there is no record of American porcelain exports during the Federal Period. However, the Tables of Commerce show that earthenware and stoneware were exported as follows: 1826, $1,958; 1827, $6,492; 1828, $5,595; 1829, $5,592; and 1830, $2,773. The ceramics effort was dismissed with one small paragraph in the report: "Earthenware of the coarser kinds has long been manufactured in various parts of the Union; and recently the finest qualities of china ware have been attempted and with considerable success."

One is amazed at the economy and industry then, when he compares ceramics with other products; in 1825 $25,162 worth of artificial flowers and jewelry was exported, along with $50,764 worth of umbrellas and parasols. There were more dollars' worth of billiard tables, vinegar, fire engines, and musical instruments shipped out of the country than ceramics.

It seems incredible that more was not achieved in ceramics in this fast-growing nation. As the population grew, there was greater need for functional and decorative ceramics, yet no one seemed able to compete in the open market with his wares and survive. History has not recorded the many undertakings in this manufacture that failed. At least, we can thank William Ellis Tucker for a look at good work of the times. It is unfortunate there were not a few more pioneers in this field who could have left us more to collect and enjoy.

Chapter 4

Glass

and Its

Makers

Records show that glass was first made in America in 1608 at the settlement in Jamestown, Virginia. News of the rich treasures to be found here spread throughout England, and men were inspired to come here to seek their fortunes. Perhaps, as we experience today, most stories were exaggerated by the time they were heard across the ocean, but this did not seem to deter those who had an adventurous spirit. The first glassworkers to come to Jamestown were Polish and Dutch settlers. The reports of fine silicas and vast forests with which to fire the melting pots were accurate, and glass items were soon being exported to England.

There must have been many glass-bead–making operations in the colonies. Glass beads were traded with the Indians in New York and New England up until about 1650, when suddenly the Indians realized they were receiving next to nothing in return for their furs, food, and goodwill. Prior to this time some artisans from Italy were imported to begin the making of fancier glass pieces and to enlarge the bead-making business; the colonists had discovered that the Indians were even willing to trade land for the beads. While this exchange of land for melted sand continued, there was great prosperity for the colonists. However, the Indians at last discovered themselves cheated, and the Jamestown massacre took place on March 22, 1622. Over three hundred persons were killed. Some say the glasshouse was destroyed, and others feel it may have been spared by the

113

Indians, but in any event, for all practical purposes, glass-making ceased then.

There was a Glassmakers Street listed in New York City in the middle of the century, but little is known of the workers there with the exception of a Johannes Smedes, who started in what was then called New Amsterdam. It is felt that by this time practically all housing had glass windowpanes for light, so there must have been production in just about every civilized area.

Casper Wistar, a brass-button maker who later turned his talents to glass, established a factory at Allaway Creek in New Jersey in 1739. This glass factory started the tradition of what we now call South Jersey glass. The business thrived under the direction of Casper's son, Richard Wistar, until the time of the revolution. It disintegrated in 1781.

Henry William Stiegel, an immigrant from Germany, settled in the Lancaster County area of Pennsylvania and took up ironmongering as his trade. He married the boss's daughter and was soon in charge of the Elizabeth Furnace, named after his wife. With several partners he acquired land that was later named as the community of Manheim and opened a glassworks in 1765. He lived a rather colorful life and finally ended in debtor's prison in 1774, but not until he had left a great contribution to the industry with the work he and his men turned out.

The third big name in eighteenth-century glass was John Frederick Amelung, who opened his works in New Bremen, Maryland, in 1787. He imported many workers from Bohemia, but the work they turned out was not good enough to compete with the foreign glass that could be made and delivered more cheaply in Europe. His business survived only until 1794, but it earned him a place in the hall of fame of glassmakers.

In 1696 a tax was levied on glass windows in England, and it was not repealed until 1851. Escaping this tax brought sickness and death to many people, since many homes were bricked up, creating bad air inside along with other unsanitary conditions. Much English windowpane glass was shipped to the colonies, but the expense of it limited its use to the wealthy.

American glassmakers were still making panes by what is known as the spinning process. A large bubble of glass would be blown and then attached to a pontil rod. The blowpipe would be broken off,

(*Left*) Covered tumbler, free-blown of slightly grayish glass with copper-wheel engraved decoration showing Tobias and the Angel (from the apocryphal book of Tobit) and the inscription "Happy is he who is blessed with Virtuous Children. Carolina Lucia Amelung. 1788." Made at the New Bremen Glass Manufactory of John Frederick Amelung, New Bremen, Maryland, as a gift for Amelung's wife. Height with cover 27.6 cm. Corning Museum of Glass, Corning, New York. (*Right*) Goblet, clear, colorless glass; engraved with the arms of Pennsylvania; said to have been presented to Thomas Mifflin, Governor of Pennsylvania. New Bremen, Maryland (near Frederick); New Bremen Glass Manufactory, John Frederick Amelung, proprietor, 1784–circa 1791. The Metropolitan Museum of Art, New York; Rogers Fund, 1937.

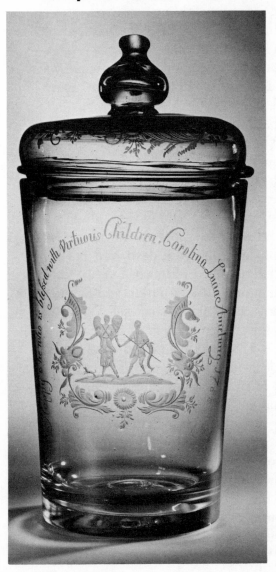 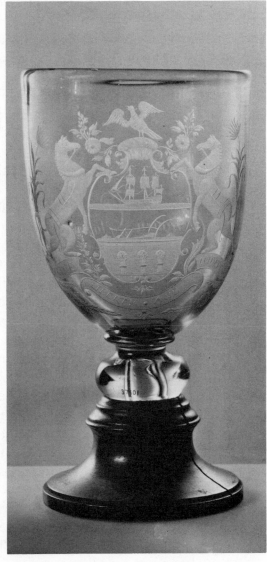

leaving a hole at that end. Then the molten metal was spun by the rod, widening the hole, and after the whole mass was enlarged into a flat shape, it was laid flat to cool. The pontil rod was broken off, and at this point it left what we know as the bull's-eye, prized by collectors today. The rest of the sheet was sliced to different pane sizes. Another method of making panes was to spin a bubble of glass until it assumed a cylindrical shape, slit it down one side, and roll out the glass, allowing it to cool and later slicing it into panes. The term crown glass applies to the raised point where the rod is broken; it is much like the bull's-eye but is raised more, resembling a crown.

In the mid-eighteenth century the French perfected a method of molding glass by pouring it into a mold and rolling it in very large sizes. This radical change in glassmaking resulted in better windows and mirrors, and the French had a corner on this market for many years until their secret was learned.

By the time the Federal Period had begun, quality glass was available in the colonies but at a price. The native glassworkers knew there were equivalent silicas and plenty of wood and coal to fire the pots, but no one had yet come up with a solution on how to remain in business in the face of foreign competition. A Bostonian, Robert Hewes, set up a glassworks in Temple, New Hampshire, in 1780, utilizing the services of deserting Hessian soldiers as workers. His first plant burned, and in the second his pots were destroyed by the winter weather. Little is known of the glass he produced.

In 1783 Hewes was hired by William and Elisha Pitkin and Samuel Bishop, proprietors of a glassworks that had been set up near Hartford, Connecticut. He failed as the superintendent of these works, but the company was reorganized in 1788 and continued throughout the Federal Period to make glass bottles, demijohns, and flasks to take care of the growing liquor trade. Their flasks are among the most desired by collectors today. The name "Pitkin" has been applied to a pattern-molded style for which the plant was famous. There is question as to whether this plant was the first to make them, but the name has long been credited for this style.

An early New York State glassworks was built at Peterborough and another one near Albany in the 1780's. The former operated until 1830, making the glass necessities of the day with some success. The latter went through several reorganizations until it was finally named the Albany Glass House. This went out of business in 1815, as it had used up all its nearby fuel.

Bad luck seemed to plague many of the early glassworks. Even in Pennsylvania, which gave birth to many noted works, the story was the same: organization, then lack of good pot clays, lack of a good supply of silica and fuel, poor management, then reorganization, and then, possibly, some measure of success. The New Geneva Glass Works in western Pennsylvania and the later Pittsburgh Glass Works were two of the most famous companies that had their troubles. Perhaps it was the desire of the colonists to aid their own industry by not purchasing what was imported from abroad, especially from England, that helped the glassworks to survive at all. But human nature won out, and soon the more desirable imports caused financial harm to local efforts. Also, as with most industry, the communities were so small that it was impossible for a large operation to survive on its local trade. Shipment to other areas in the country was necessary for survival. Shipping such a fragile commodity over rough roads in crude wagons was risky business and necessitated small quantities. And shipment by water was impossible for many.

As the nation grew, roads improved, and Europe became involved in military matters, the infant glass industry in America finally achieved a firm footing. The introduction of glassmaking to the

Left: Blown and engraved wineglass, owned by the Dickson family, of Pittsburgh, circa 1817. Engraving shows primitive simplicity. Right: Blown and engraved glass, circa 1830. Note heaviness of stem and redundant engraving.

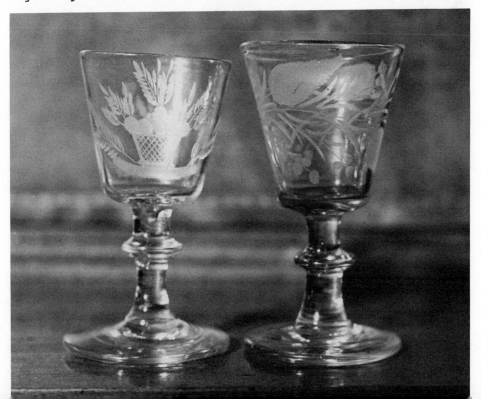

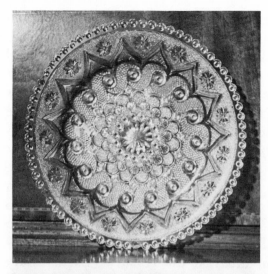

Midwestern lacy glass dish. Bull's-eye serrations, scrolled eye motif. Shells and circle surrounding a rayed center. Pittsburgh area, circa 1830.

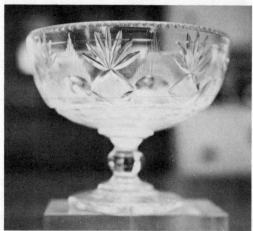

Small clear cut-glass Pittsburgh compote on knop stem with a rayed base. Rim cut on the outside with five scallops. Bowl cut in a single row of large strawberry diamonds and fans alternating with roundels surmounted by a rayed pyramid. Fourteen short panels below this row. Lowell Innes.

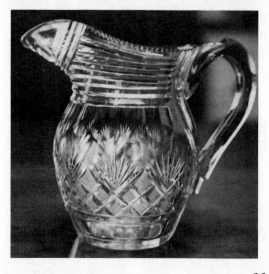

Clear glass quart pitcher in strawberry, diamond, and fan pattern. Rim notched. Prismatic bands around the neck of the pitcher. Vertical prismatic cutting on each side of the end of the handle and under the lip. Eleven prismatic panels below the circular prismatic cutting and eleven square panels around the base. Deep thumb latch at the top of handle. Probably American, but could be English, circa 1830. Height to top of lip. 7⅝"; diameter of base, 3⅝". Lowell Innes.

Pittsburgh area heralded greater production there than in any other section of the country. It was not long before huge plants were erected in western Pennsylvania, Ohio, and West Virginia, which were to dominate glassmaking in this country for years to come.

One man who exerted a great influence upon the growth of glassmaking in Pittsburgh was an Englishman, Benjamin Bakewell, who came to this country and first set up shop in Pittsburgh in 1807 as a glass importer. Commercial problems with the English and the French caused this business to fail, and after a short spell in New York in another unsuccessful glass-importing venture, he returned to Pittsburgh, eventually getting involved in the Pittsburgh Flint Glass Works, where he remained until his death in 1844. The business went through a couple of name changes, from Bakewell to Page and Bakewell and thence to Bakewell, Pears and Company, reflecting the entrance of a partner and other members of the family into the business. Other flint-

(Left) Fifteen-diamond nursing bottle, made at Mantua-Kent factory, Ohio, circa 1821. The rediscovered and redug plant is being moved to the Hale Homestead in Summit County; it will be rebuilt, and glass will be made in exactly the way it was made then. Jabe Tartar. *(Right)* Unusual clear pattern mold glass vase on short straight stem—pontil polished. Sixteen rib mold slightly swirled to form thin gadrooning on lower part of bowl. Sixteen straight ribs to wide flaring rim. Midwestern, circa 1830.

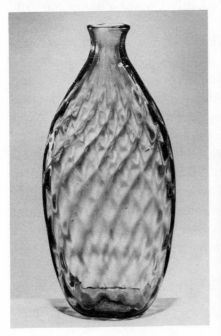
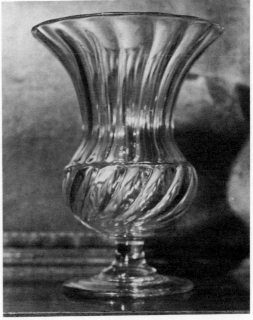

glass firms set up in the Pittsburgh area were the Stourbridge Glass Works; the Fort Pitt Glass Works, started by Robert Curling; and the Union Flint Glass Works, started by William McCully and John Hay.

In 1829 the Wheeling Flint Glass Works came into being in Wheeling, West Virginia, which was later to become a big center for glassmaking.

For collectors the other great center for glassmaking was New England. In 1787 the indefatigable Robert Hewes started another venture, the Boston Crown Glass Company, locating its works at the foot of present-day Essex Street, practically at the site of the South Station. The business prospered to the extent that another firm was started by the group in Chelmsford in 1802. The Boston effort ceased production in 1827. The Chelmsford operation was taken over by another group, and this burned in 1829. A branch plant was set up in Suncook, New Hampshire, presumably for the making of window glass, but this was not too successful, and it went out of operation in 1850. The blown aquamarine pieces made there rank high as collectibles today.

Another Englishman, Thomas Caines (also spelled Cains), came to this country in 1812 and encouraged the management of the Boston Crown Glass Company to enter flint-glass production and to build a new plant in South Boston. When this firm encountered difficulties, Caines left and started his own place of business, the Phoenix Glass Works, in 1824. It closed in 1870. Early Caines glass is rare and most often quite difficult to document.

In 1814 the Boston Porcelain and Glass Company was formed with headquarters in Cambridge and embarked on a rather unsuccessful venture which culminated in the sale of the properties to new owners in 1817. This resulted in the formation of the New England Glass Company, which was destined to be the longest lived of the New England firms and one that was responsible for a prodigious output. Under the leadership of Deming Jarves the company prospered. He was the son of John Jackson Jarves, of Boston, who had emigrated from England in 1787. He advertised as a cabinetmaker with a shop on Newbury Street. Deming was born in 1791 and dealt in such varied interests as dry goods and crockery ware. He was the clerk of the Boston Porcelain and Glass Company at the time it was taken over by him and his associates.

Jarves might well be referred to as the Henry Ford of glassmaking,

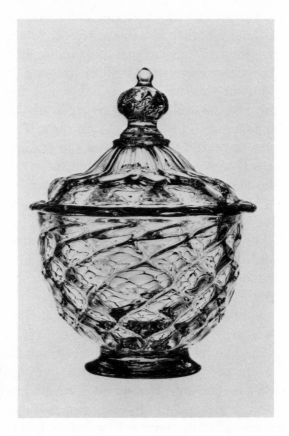

Covered bowl of the type made
by William Henry Stiegel in
Manheim, Pennsylvania, early
in the 1770's.

as he sought more rapid production techniques and was the first
to master mass production on a basis not known in the industry.
Steam power was added to make cutting easier and quicker, and he
hired the best men available. The plant had twenty-four glass-cutting
mills and two flint furnaces in addition to a lead furnace, which
assured a steady supply of the flux needed. So great was the expansion
and reception of the products that the firm soon began exporting
its wares to the world. Jarves hired James Barnes as engineer, under
whose supervision much of the equipment and furnaces was designed.
Barnes was destined to become one of the principals in a firm that
took over an ailing glassworks in Wheeling, West Virginia, which later
became Hobbs, Brockunier and Company.

For a while the New England Glass Company dominated the scene, making all sorts of tableware, decanters, casters, lamps, and decorative items. Their cut glass was on a par with that produced anywhere. The firm entered the field of pressing glass a year after the first was done in this manner at Bakewell's factory in Pittsburgh. Perhaps the first pressed items were knobs of all sorts, which soon made their appearance on furniture of all sorts. The company continued in business until 1888, when under the management of Edward D. Libbey it was moved to Toledo, Ohio, where it continues to operate under the name of the Libbey Glass Company.

Another name in Federal Period glass is that of John Gilliland. With partners he was instrumental in creating the Bloomingdale Flint Glass Works, which was located on Manhattan Island. He sold out to his partners in 1822. The business survived until 1840, making a good-quality glass under the leadership of one of the original owners, Richard Fisher.

Gilliland was not idle—he formed John L. Gilliland and Company in nearby Brooklyn in 1823, often referred to as the Brooklyn Flint Glass Works. He was a skilled glassmaker, and under his supervision the plant went on to win great recognition for its work. Years later, after he had sold to new owners, the business was moved to Corning, New York, and became known as the Corning Glass Works.

In 1824 the Jersey City Glass Company was formed under the leadership of George Dummer. In addition to the blowing and cutting of glass (he had as many as thirty-two steam-driven cutting wheels), he entered the field of pressing, and during the life-span of the company great amounts of glass, little of which can be documented today, were turned out.

Perhaps the most fascinating and productive story in glassmaking was written by Deming Jarves, who was so instrumental in forming the New England Glass Company. Jarves was a great sportsman, who enjoyed hunting and fishing, and Cape Cod was one of his favorite retreats. In the spring of 1824, while on a trip to Sandwich to pursue his favorite sports, he selected a spot for the erection of a new glassworks. The tall pine trees were huge at the base (some said they were "round as barrels"), and he saw here an unlimited supply of fuel for the glass pots. He sent his agent, Mr. Dame, to the area, where he quietly bargained for many thousands of acres of land—some say as many as forty thousand. In the spring of 1825

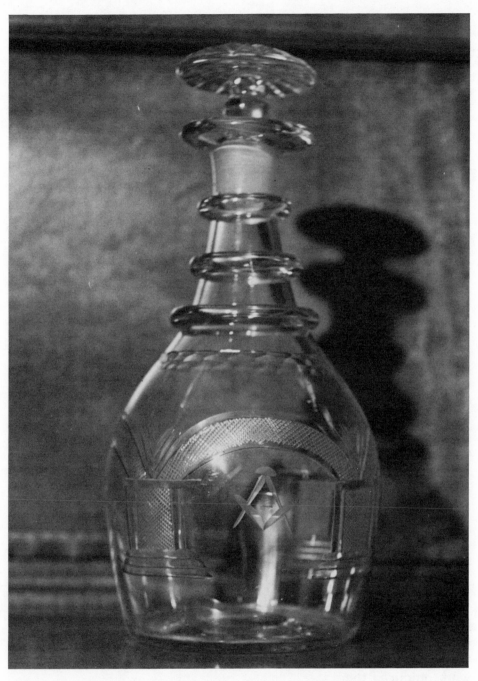

Cut and engraved Masonic decanter, initialed GWH. Pittsburgh area, circa 1825. This was made when the New England Glass Company was in its infancy, and the Boston and Sandwich Glass Company first went into business.

Jarves arranged a meeting with the citizens of the community and outlined his plan to erect a glassworks there. He cited the high wages—two dollars a day—that they would be paid, the availability of wood for the furnaces and silica for the pots, the proximity of the ocean, where a dock could be built to accommodate freighters traveling the world, and the acres of marsh grass that could conveniently be used for packing the fragile product. On April 19, 1825, ground was broken for the venture, and a small furnace of eight pots along with the necessary tools and equipment was built. Fifteen tenement houses were quickly erected as homes for the workers, and then a butcher shop, a store, and a barn for his teams of oxen. The first pot of glass was melted from nearby sand on July 4, 1825, but evidently the salty content made an inferior product, which prompted a search for better material. It was found in the Berkshire Mountains in western Massachusetts and was hauled for many years by ox team from there to Sandwich. Three thousand cords of wood were cut each year to fire the pots. The wood would be dried in front of the roaring pot fires until it was browned and ready for burning itself. Fifty yoke of oxen were kept busy year round just hauling the firewood.

A carpenter, Enoch Robinson, conceived the idea of pouring hot glass into molds, instead of blowing it into them, and then pressing a properly made plunger into the mold, thus forming the piece. Jarves was quick to seize on this technique and later adapted it to machine pressing. This was done early in 1827, and by April of that year a machine to handle the work was perfected. The first tumbler was formed in it on April 20. It was preserved until the Philadelphia Centennial of 1876, when it was taken from its case to be examined and was dropped—one of our most historic pieces of glass was destroyed. Although other glassmakers in Pittsburgh were pressing knobs in the 1820's, it fell upon Jarves's ingenuity to apply the technique to larger pieces. The molds were elegantly shaped with designs and patterns of all kinds, and the famous lacy glass made its appearance, perhaps the best known of the Sandwich efforts. The Boston and Sandwich Glass Company was a company to be reckoned with in the glass industry, and awards soon came its way for the quality work produced there.

Jarves shipped his glass by water to Boston in his own ship *Polly*,

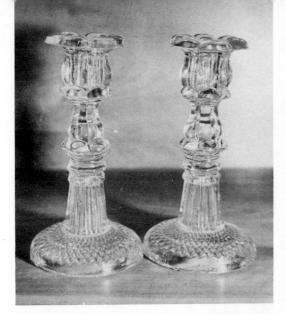

(Left) Rare Sandwich glass candlesticks, circa 1830. Petal tops with variant of ribbed and diamond-patterned base. Barlow Collection. *(Right)* Closeup of early Sandwich candlestick, showing wafer, or lozenge, which joined base to candleholder top. Barlow Collection.

(Below) Early lacy work footed salt, possibly Boston and Sandwich Glass Company, circa 1830. Barlow Collection. *(Right)* Diamond quilted pattern decanters; Boston and Sandwich Glass Company; pre-1830. Barlow Collection.

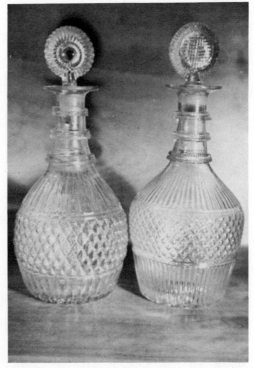

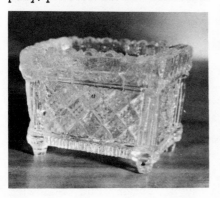

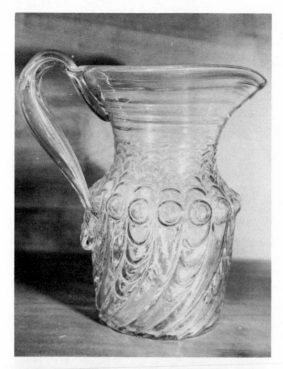

Blown molded hollow-handle pitcher, originally a bottle, with top opened and shaped. Peacock eye pattern. Boston and Sandwich Glass Company, circa 1830. Barlow Collection.

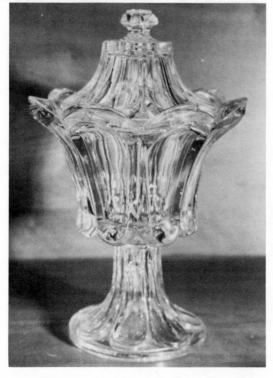

Molded covered dish, loop design, Boston and Sandwich Glass Company, circa 1830. Barlow Collection.

where it was transferred to other ships bound all over the world. In later years some was shipped even to Russia, and much of it went around the coast of South America to be sold in California. The company survived all types of depressions and panics but was unable to survive labor strife, the cause of its closing on January 2, 1888. Orders still came in to the company three years after it had gone out of business. An order from Russia specified eighty thousand dollars' worth of lamps alone. Others came from Australia and South Africa, so well was the name known. There were several attempts to revive the works, but all failed. Eventually the buildings were sold to George Henderson, the founder of the Dorchester Pottery Company in Dorchester, Massachusetts, who wanted the huge applewood drying boards for use in his pottery kilns.

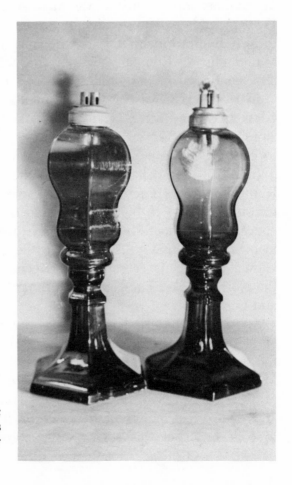

Whale-oil lamps in amethyst; Boston and Sandwich Glass Company, circa 1830. Barlow Collection.

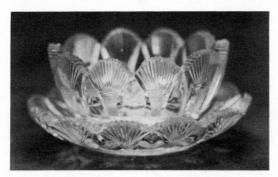

Clear cut oval master salt on heavy rayed base. Ten cut sheaves of wheat forming bowl and top rim. Height 2"; top 3⅞" by 2⅞"; base 2⅜" by 1⁷⁄₁₆". Matching tray for the salt, twelve sheaves of wheat. Height 1"; top 4¹⁵⁄₁₆" by 3⅞"; base 2¾" by 1¹⁵⁄₁₆". Massachusetts, circa 1830. Lowell Innes.

In the course of his career it should be noted that Jarves was responsible for the creation of the Mt. Washington Glass Works in South Boston, having created it for his son, George, in 1837. One of his workers was the first of the famous Libbey family of glassmakers, William Libbey, who became owner in 1866 and moved the company to New Bedford in 1869. Later the company joined with the Pairpoint Manufacturing Company, which specialized in silver, and together they continued in the glass, silver, and ceramics business until 1958.

In 1858 Jarves was responsible for the formation of the Cape Cod Glass Company after leaving the management of the Boston and Sandwich firm. This firm prospered under his magic touch, only to close at the time of his death in 1869.

In 1815 John Elliott and Nathaniel Sprague opened the New Hampshire Glass Factory in Keene, which was located deep in the forests that were to fuel the pots and near a good silica supply. The concern was successful, although it went through many changes in ownership. Finally, it burned to the ground in 1855. It had been known through its career as the Keene Window Glass Factory and the North Works. The company primarily made window glass, flasks, and bottles.

Another Keene glasshouse was formed in 1815 with the partnership of Henry Schoolcraft and Timothy Twitchell, who were responsible for the Marlboro Street Works. Here, the famous Keene flasks—the Masonic, sunburst, and historicals—were blown under the ownership of Justus Perry, who acquired the plant in 1817. The dark amber and deep green colors of these crude flasks are what endear them to collectors. Yet this coloring stems from the kind of silica used.

Some work was done in clear and aquamarine, but less of this is recognizable. The plant finally closed in 1850 because of a lack of nearby fuel for its pots.

Among the lesser known but important glassworks was the Vermont Glass Factory, which was established near Lake Dunmore in Salisbury township. Lawrence Schoolcraft was awarded the superintendent's position at the Vermont Glass Factory and began work there when it opened for business in 1813. Schoolcraft had emigrated from England and worked at the Hamilton Glass Works near Albany, New York. Later he managed the Oneida Glass Factory at Vernon, New York. A branch of the Vermont Glass Factory was built in East Middlebury, Vermont, but the company never gained a firm financial footing. In 1815 fire destroyed the main branch of the window-glass

Pressed glass salts of this type made by the Boston and Sandwich Glass Company as early as 1827 were very popular and made extensively into the 1840's.

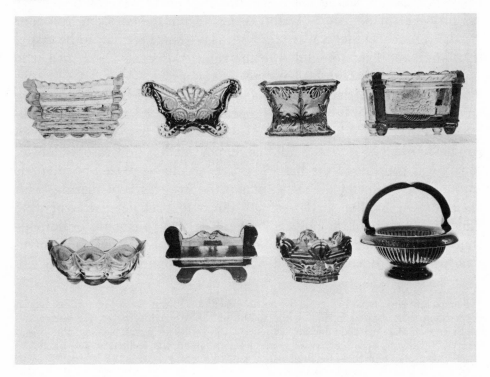

factory, and after loss of the Middlebury property due to attachments, Schoolcraft's concern ceased business in 1817.[1]

The problem of documenting glass is a plague to historians. The quality of flint glasses and the manner in which early blown and pattern glass was made were so similar that it is almost impossible to document them. When mechanical pressing came into being, one factory could copy the work of another simply by preparing a mold from an original piece. Most students of glass are very careful in attribution, and unless a piece is really documented by writing or by a specific mode of manufacture that characterized a particular concern, they will not hazard positive identification. Recent seminars on glass have featured lecturers who show glass pieces simultaneously on two screens, pointing out the exact similarities of design and quality yet stressing that the items are the products of two different concerns, which are documented.

Terminology of an early glassworks is interesting. A stated number of glass pieces constituted a "move"; so many moves constituted a "day's work"; so many men constituted a "shop," and the head man was known as a gaffer. The making of a furnace for melting glass is basically simple but very exacting. Some were built as wide as fifty feet in diameter. At the center of an arched room, the floor of the furnace, or siege, was laid with clay. This clay had to be a special kind, and it was pounded to the right consistency by a man who would stamp on it with his bare feet.

All the work of shaping the pots had to be done by hand with the room kept constantly warm and moist. It might take up to six weeks to build one pot. When finished, the pots would be baked in an oven to be hardened. It was said that a pot made and seasoned seven years was considered the best. The pots would be placed at intervals around the center of the siege, where the fire was kept roaring, with heat drawn by the suction of air ducts to each one, drawing the smoke past and out the huge chimney. Replacing a cracked or burned-out pot was a hazardous operation, as the fires were not shut down; the work was done at great danger and discomfort to the men.

[1] Schoolcraft later served as geologist on an expedition to the West. He also headed an expedition that resulted in finding the source of the Mississippi River. He became an authority on the American Indian, served as a government agent, dealing with tribes in the Northwest, and later wrote many treatises about the Indians which today are highly respected references for students.

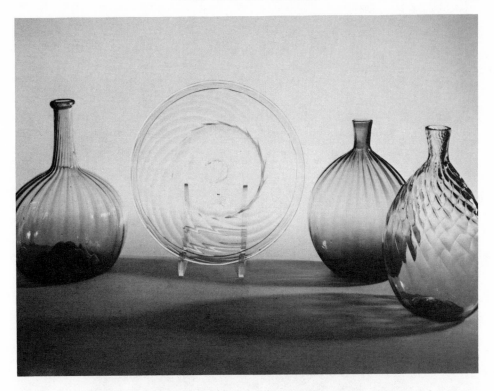

Early nineteenth-century blown glass, from the Ohio region. Glass of this type was blown in many states in various colors.

The mixture of silicas and flux generally took place behind closed doors, but actually there must have been few production secrets, since so much of the glassware looks alike. The ingredients of a mixture usually included sand, possibly ash, saltpeter, and nitrate of soda. The addition of lead gives glass its brilliance and weight. It takes a mixture sixteen hours to melt, and it is imperative that an even heat be maintained. In the center of each pot floated a clear ring of metal, and it was from this center that glass was drawn to be worked. If there were any impurities in the mixture, they would rise to the surface and float at the outer perimeter of this ring. One necessity of a good glassworks was its own fire department, since many of the works were located far away from town, deep in a woods in order to maintain a constant fuel supply.

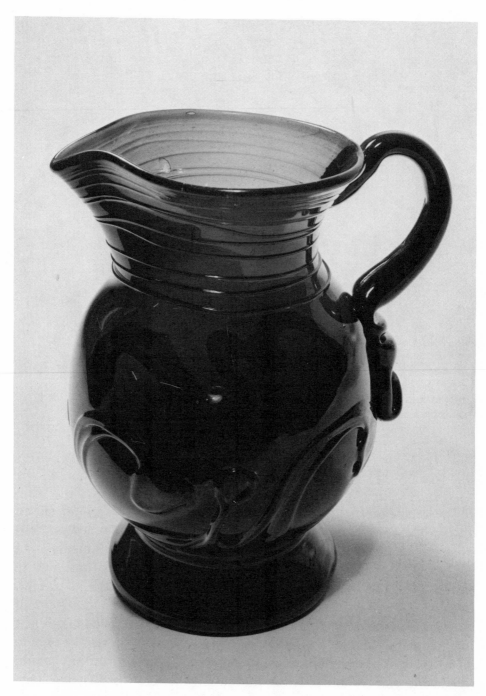

The lily pad design in glass is known to have originated in southern New Jersey early in the nineteenth-century. Pitchers of this type were also made in New York State, Vermont, and New Hampshire.

132

To give one an idea of early glass prices, we cite those quoted by Benjamin Bakewell for the report made by the Committee on Manufactures in 1828:

> In 1808, we sold common flint half-pint tumblers at two dollars per dozen; after the currency of the state became settled, we sold them at one dollar per dozen; and now we sell them at about eighty-one cents per dozen. Plain quart decanters, which in 1808, we sold at six dollars per dozen, we now sell at two dollars and twenty-five cents. Wine glasses in 1808, were one dollar and fifty cents per dozen, and they are now seventy-five cents per dozen.[2]

Another report gives an interesting account of the amount of glass manufactured: "1826, $44,557; 1827, $59,307; 1828, $51,452; 1829, $49,900; and 1830, $60,280." [3] Since this represented the sum total of the country, it becomes evident that manufacturers were at that time suffering from foreign competition, which was gradually being overcome by the time of the latter date. Glassware is listed as being chiefly imported from Great Britain, France, and the Hanse towns.

[2] John Howard Hinton, *The History and Topography of the United States* (Boston: Samuel Walker, 1834), II, 168.
[3] *Ibid.*, p. 190.

Chapter 5

Pewter,

Silver,

and Other Metals

The search for natural resources resulted in the discovery of almost everything needed for American industry with the exception of tin. Since tin made up about nine-tenths of the composition of pewter, it was only natural that in the early part of the period makers had difficulty in turning out the product. In England, however, the tin mines at Cornwall were among the most productive in the world. Consequently, the English managed to dominate the pewter market for many years by withholding tin from the colonies. Other metals used to make up the remaining 10 percent of the mixture were zinc, lead, antimony, and even copper. Harder pewter was made with the addition of brass, and in the eighteenth century this would most often be used in church communion services, where there was much wear and tear.

Pewterers guilds were formed as early as the fourteenth century in England, and some report even earlier in France. Workers were classified as to makers of "sadware," which included plates, dishes, and chargers; "holloware," which included pots, bowls, mugs, flagons, and other vessels that would hold liquids; and "triflers," who turned out the whimsy objects—medals, toys, and even salt casters. A touchmark was required on all the items turned out by members of the guilds, which is a help to us today in identification. Regulations were established as to content of metal and size and weight of the pieces, so quality was kept high. Offenders were severely dealt with.

Much pewter came over with the settlers who followed the early colonists. Fortunately, when a piece was worn or damaged, it could be melted, and a new piece cast from it. Unfortunately, it did away with much of the early production—pieces that would be welcome additions to many collections today. The early settlers must have contented themselves with woodenware or treenware for household use, and those who could afford new pewter items must have been among the wealthy. Even at the middle of the eighteenth century pewter items were quite expensive and in some cases as costly as the more plentiful silver.

There are two methods of making pewter pieces: One is to pour the pewter into molds, fashioned out of gunmetal or in some cases brass; the other method is to "spin" it, or shape pieces on a lathe, applying the proper tools against the soft metal. Molds were quite expensive to make and own, and local pewterers did not enjoy the benefits of the guild members in England, who could borrow molds from the guild itself. Here the worker had to make his own or shape his piece by spinning and hammering. Needless to say, the work done here during the eighteenth century was very plain, with very little decoration. Chasing and incising, methods used to embellish silver, were used with pewter, but they tended to weaken the metal.

Impressive pewter communion service by Johann Christopher Heyne, 1754–1780, of Lancaster, Pennsylvania. Ranked as one of the nation's top pewterers, his two large flagons, bowl, chalice, and plates are among the earliest of marked American pewter. In a rural church in central Pennsylvania.

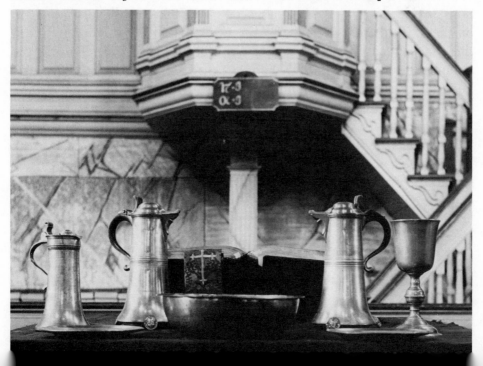

The craftsmen who used these techniques needed to be very careful.

By the time of the Federal Period a small core of fine pewterers had developed, and it is their work that dominates the collectible market now. Members of the Will family, who worked in Philadelphia, New York, and Albany; Johann Christopher Heyne, of Lancaster; Peter Young, of Albany; and Frederick Basset, of New York and Hartford, are but a few of those who remain in the forefront today. The advent of the war brought another tragedy—that of melting down pewter vessels to make bullets for the Continental Army. One can only speculate as to how much was destroyed in this manner. The Revolutionary War heralded a return to wooden trenchers and plates, and there is many a hollowed-out wooden bowl that has survived that period—a grim reminder of what it replaced. Household items were not alone in being melted down; some houses had roofs of lead which were sacrificed to the cause, and perhaps the most notable item broken up and tossed into the caldron was the statue of King George III, which was torn from its mountings in New York City on July 9 and hurled back at the British troops in the form of bullets.

Tankards were a popular item and still are today. Many made by the fine pewterers of this period are today worth more than one thousand dollars. America's first brewery was erected in New York City in 1633 to satisfy the thirst of the Dutch colonists. Beer and wine were made just about everywhere, and rum was popular in New England, which enjoyed a growing trade with the islands in the Caribbean bringing sugar back to its ports for conversion into the "king's grog." One of the firms, Caldwells, which began operations in Newburyport, Massachusetts, in 1790, is still very much in business. Tankards were made for women as well as for men, and this may or may not account for the differences in size. During the temperance movements that were popular at the end of the Federal Period many tankards found their way to the melting pots or the dump.

The pewterers who worked before the Revolution had one thing in common—the shortage of metal made it necessary for them to work at this trade on a part-time basis. Under the circumstances, it is remarkable that so much was turned out. William Will, who is considered by many to be the dean of American pewterers, served as a lieutenant-colonel in the war, and with the noted artist Charles

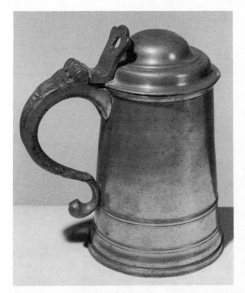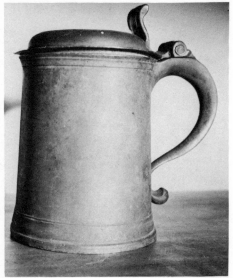

(Left) Tankard, pewter, made by William Will, Philadelphia, 1785–1797. Philadelphia Museum of Art; given by Mrs. William D. Frishmuth. *(Right)* Tankard by Henry Will, member of a famous family of pewterers who worked in New York State and Pennsylvania. In New York City at the beginning of the Federal Period, he moved, 1775–1783, to Albany. He later returned to New York, where he died in 1793. His work is rare and desirable. This is probably a piece from the Albany area, as it resembles the work of Peter Young, who worked next to Will there.

Wilson Peale he served on a committee that confiscated the personal goods of traitors. He served as high sheriff for Philadelphia and also as commissioner of salt for the Continental Army. As a pewterer he turned out work for wealthy families in the Philadelphia area and was called on by many churches to make their communion services. His brother, Henry, was just as talented and was responsible for a full range of pewter items that are today among the top collectibles. He worked in New York City before the Revolution, and when war broke out, headed north to Albany, where he worked in a shop with another great craftsman, Peter Young. Each influenced the other's work enough so that today surface examination would prove pieces difficult to document. The touchmarks of the makers are the positive clue to identification.

Another pewterer and Revolutionary War hero was Richard Austin, of Charlestown, Massachusetts. He served under Washington and

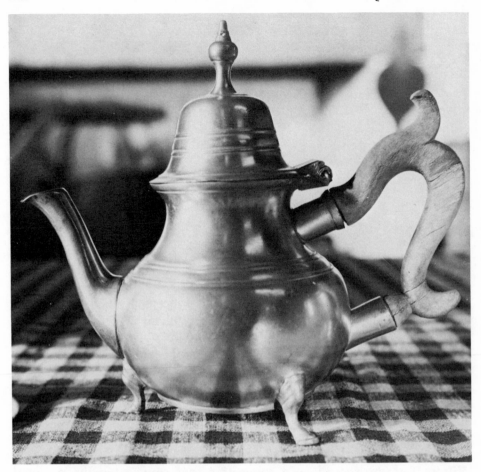

Pear-shaped footed pewter teapot by William Will, of Philadelphia, 1764–1798. Very rare. Hershey Museum, Hershey, Pennsylvania.

attained the rank of captain. In 1800 he was appointed the sealer of weights and measures for the city of Boston and also served as one of its assayers. Austin's pewter communion sets are still found carefully preserved in churches. He is a favorite among New England collectors.

The post-Revolutionary period brought an immense change in the fortunes of pewter-workers, and large establishments were set up to take care of the country's needs. The Danforth and Boardman families in Connecticut dominated the scene as they began to mass-produce pewter items in an unrivaled quantity, and members of the

family were working as late as the middle of the nineteenth century. The Yale family, of Meriden, Connecticut, was also prolific, as was the Melville family in Rhode Island. Israel Trask, of Beverly, Massachusetts, and Roswell Gleason, of Dorchester, contributed much to the output, with the latter employing up to two hundred workmen in his shop at one time. The Dunhams and the Porters, of Westbrook, Maine, made most of the later pewter found in the northern section of New England.

Supplies of tin became more plentiful after the War of 1812, and we began trading freely with the rest of the world, except for a brief period in the late 1820's when much was restricted both in imports and exports. This was a period of adjustment as the influence of newly created machinery began to be felt and as increased production created the problem of finding more consumers. The pewter trade thrived, however, as tin was permitted as a raw material from England, and much was shipped here from South America from mines that had been worked for centuries by the Aztecs and Incas.

During the middle of the eighteenth century a harder pewter metal was developed—it was called Britannia. It was more easily spun on the lathes, and it resisted denting and heat much better than the original metal. It was not generally used in this country until the

(*Left*) Porringer, pewter, by David Melville, Newport, Rhode Island, 1755–1793, a member of a family of fine pewterers. (*Right*) Melville's well-preserved touch-mark is shown on the bottom of a plate.

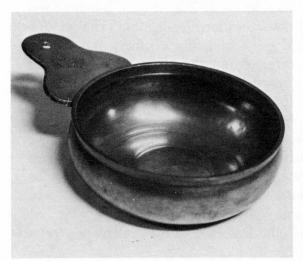

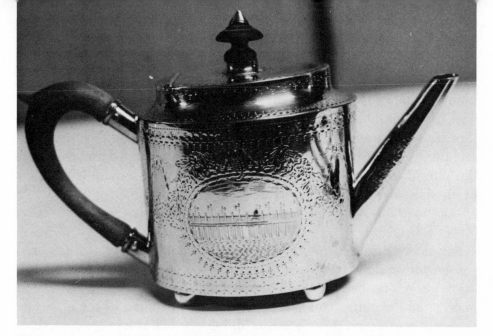

Silver teapot by Zachariah Brigden, Boston, 1734–1787. Elliptical with concave shoulder. Engraved and bright cut bands and medallions, joined by garlands. In one is the Charles River Bridge; in the other, in script, is: "Presented to/ Capt. David Wood/ by the proprietors of/ CHARLES RIVER BRIDGE/ in testimony of their entire approbation/ of his faithful services/ as a special Director of that Work,/ begun AD 1785/ and perfected A.D. 1786." Boston Museum of Fine Arts; gift of Miss Penelope Noyes.

beginning of the nineteenth century and, with the age of mechanization, became the standard product. Purists feel it brought with it a decline in the quality, design, and construction of the product. The earlier pockmarked pewter has greater appeal because of its patina and fine handicraft. Some of the work on the later pieces was done by hand—for example, the soldering on of lids, spouts, handles, and legs—and this is what makes the later pieces collectible. The production of pewter gradually died off during the century, and by the 1870's mass production of pewter ceased altogether. In recent years there has been a revival of interest in making pewter reproductions. One rule must be observed: If the word "pewter" appears anywhere in the marking of an item, it is too new to be a good collectible. Early pewter made in this country is quite well marked with the initials, name, or other touchmark of the maker. Unmarked items may be either English or American, and most rules for judging one from the other are loaded with exceptions—so much so that one can never be sure of the provenance of an unmarked piece.

Silver-workers suffered much the same fate as their fellow pewterers

in experiencing a shortage of metal. Work in silver has always been reserved for the very rich, since it has always been a costly commodity and was even more so in eighteenth- and early-nineteenth-century America. Not much was written or known about early American silver and silver-workers until the turn of this century. In 1906 the Boston Museum of Fine Arts staged an exhibition that was at the time the finest exhibit of silver ever seen in this country. Much of the silver was thought to be of English manufacture; no one suspected that American craftsmen could turn out such elegant pieces.

Communion pieces were used for their functional value. People did

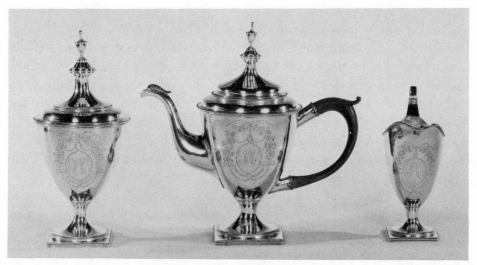

(Above) Three-piece silver tea set by John Germon, working in Philadelphia about 1785. The pieces in earlier tea services did not necessarily match. This set represents work of the highest style and order. Hammerslough Collection, Wadsworth Atheneum, Hartford, Connecticut. *(Below)* Four-piece silver tea set by William Thompson, New York, working 1810. Inscription: "Tea Set Presented by the Vestry of/ St. Michael's Church, Charleston, S.C. 1810," on teapot and waste bowl. Also, script monogram, "NMB," stands for Bishop Nathaniel Bowen. Hammerslough Collection, Wadsworth Atheneum, Hartford, Connecticut.

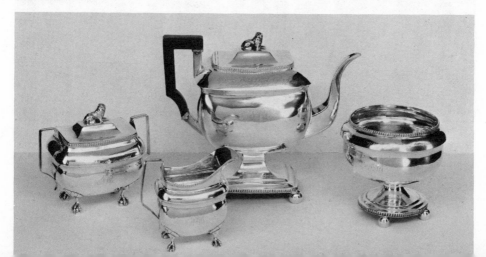

not regard them as historic treasures which should be well preserved. That so many communion services were sold is an indication that the churches felt they were improving on them with the purchase of new solid silver or plate. Occasionally, these services were relegated to hidden storage places in churches, and from time to time a discovery is made of boxes of pieces long in disuse. When one church was re-modeled, its silver service was stored in an area that was entirely built over to hold a new pulpit. It was only uncovered when another remodeling took place. New interest has been expressed in the historic, antique value of such pieces, and many churches have loaned or given their pieces to local museums, where they may be stored and exhibited safely.

The Boston Museum had another exhibit of American silver in 1911, featuring pieces made for churches. That same year the Metropolitan Museum of Art in New York held an exhibition of silver by New York makers, which was deemed a great success. After these exhibitions the collecting of American silver gained prominence, and important collections were donated to museums. Also, American silversmiths earned the esteem previously accorded to the English craftsmen. In the catalog printed for the 1906 show at the Boston Museum of Fine Arts Mr. R. T. Haines Halsey writes:

The silver is of the period when the ancient geometrical shapes held sway among craftsmen; when purity of form, sense of proportion and perfection of line were preferred

Silver tea service by John Owen, Philadelphia, circa 1800. To replace lost one, creamer was made by Bigelow-Kennard.

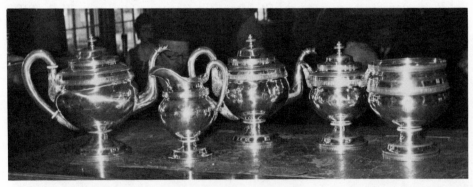

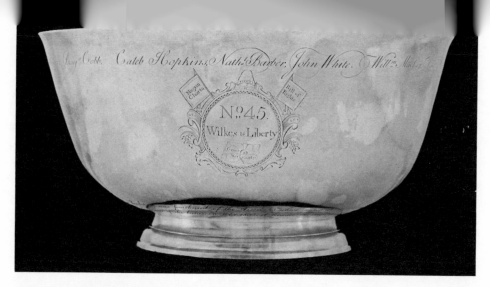

Historic Sons of Liberty bowl, made by Paul Revere in 1768. It was commissioned by the members of the Sons of Liberty in memory of the courage shown by the Massachusetts House of Representatives. Boston Museum of Fine Arts; Frances Bartlett Fund.

to elaborateness of design; when dignity and solidity were considered superior to bulk, and when the beautiful white metal was allowed to take its colors from its surroundings, rather than be made the medium for the display of skill by workers in metal. The early American silver, as in the case of our early American architecture and furniture, is thoroughly characteristic of the taste and life of the period in America. Simple in design and substantial in weight, it reflects the classic mental attitude of the people. Social conditions here warranted no attempt to imitate the magnificent baronial silver made in England, illustrations of which are to be found in all English books on plate.

Early inventories use the word "plate" in reference to silver made then, but this is not to be confused with the term as applied to Sheffield plate or the later electroplated pieces. Sheffield plate originated in England in the middle of the eighteenth century as a less expensive way to make silver pieces. A sheet of copper was sandwiched between two layers of silver, and the sheets were bound to one another by rolling under pressure. As with the electroplated pieces which appeared in the 1840's, the silver could wear, showing the copper beneath.

Perhaps the most important piece of silver in the country is the historic Sons of Liberty bowl, which was made by Paul Revere. It is

exhibited at the Museum of Fine Arts in Boston. Commissioned by fifteen members of this patriotic organization, it has their names inscribed on one side. The other side is inscribed:

> To the Memory of the glorious NINETY-TWO: Members of the Honbl. House of Representatives of the Massachusetts Bay, who, undaunted by the insolent Menaces of Villains in Power, from a strict regard to Conscience, and the LIBERTIES of their Constituents, on the 30th of June 1768, voted NOT TO RESCIND.

The reference is to the defiance shown by the Massachusetts House of Representatives in 1768, which protested the Stamp Act along with other oppressive measures against self-government. The House had sent a letter of protest to London and later sent another to the other colonies urging united action against the British policies then enacted. The English demanded the letter be rescinded, but by a vote of ninety-two to seventeen, it was voted to let it stand. This was the first act to arouse the colonies to pursue independence, and the courage of the Massachusetts men spurred others to praise them in writings and in song. A member of Parliament, John Wilkes, was cast into prison in England for attempting to encourage greater independence within the colonies. While he was there, the bowl was made. It was kept at John Marston's tavern, known as the Bunch of Grapes, on what is now State Street in Boston. Inscribed on it is "No. 45," which represents the forty-fifth issue of his paper, the *North Briton*, in which Wilkes attacked the infringement of the rights of the colonists and resulted in his being in prison. The torn parchment, inscribed "Generall Warrants," refers to the illegal warrant issued by the king to search his home and confiscate some of his private papers. The flags, labeled "Magna Charta" and "Bill of Rights," had reference to Wilkes's fight for constitutional government for the colonies. Also inscribed on the bowl are the names of the members of the MacKay family through whose hands it passed until it reached the museum.

At the time of King John, about 1300, a group of German immigrants well versed in silver-working was employed to set the standards for purity of silver in coins. They were referred to as the Easterlings, but by the time a statute was passed in 1343 to set the standards, only the word "Sterling" was used. The term was not commonly marked on

silver until the nineteenth century, and at that, most after the middle of the century. The English formed various goldsmiths and silver-smiths guilds as early as the twelfth century, but it was not until 1479 that a law was passed that established the letter-marking system by which we can date any piece found so marked to within a span of twenty years. A leopard's head, which gradually evolved into a lion's head and body, along with the maker's touchmark, became the standard. Many years later the head of the reigning monarch was also impressed into the piece.

The American silversmiths were not bound to any rules, and some even attempted to mark their pieces "London" to make American purchasers feel they were getting a superior product. Fortunately,

(Left) Silver tankard by William Gilbert, New York, circa 1775. A characteristic New York tankard with straight tapering sides and molded base. Flat cover with high shoulder and broad rim. Scroll thumbpiece, molded drop on hinge. Double-scroll handle, lozenge at lower joining. Script monogram "GWS" in bright cut medallion on front. Marked on bottom, "GILBERT" in capitals and "N. York" script in rectangles. Height 7¾". Boston Museum of Fine Arts; on loan from Mrs. E. S. Webster. *(Right)* Silver tankard by Joseph Anthony, Philadelphia, 1762–1814. There were several Anthonys working in silver in Philadelphia at the same time. Inscription reads: "Presented by John Penn Jun. & John Penn Esq. to W. Charles Jarvis as a Respectful acknowledgement of his services, 1788." Philadelphia Museum of Art.

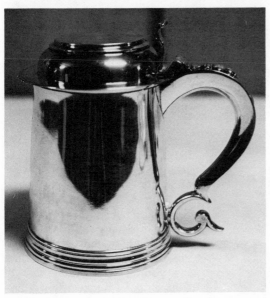
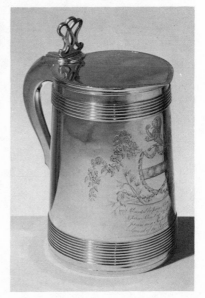

many makers took pride in their work and marked their pieces. Most good-quality early American silver can be identified. However, some marks have worn off the English pieces, and American marks may have been substituted. Also, some pieces have been made over, and unscrupulous people have been known to cut out an authentic touch-mark from a relatively inexpensive spoon and insert it into the base of a more expensive pot, providing a false name as to its maker. Hence, it is now mandatory for one interested in buying early silver to seek out reputable dealers, or competent advisers.

Simple vases or urns may have turned up years later with lid, handle, spout, and feet added to create a coffeepot or teapot. When the temperance movement took hold, quite often tankards were remodeled into teapots by being notched at the top rim and having a spout added. Some of these have been remade to their original state, and it is difficult to detect the work. Knowledgeable dealers often blow their hot breath on suspected places of repair—the mist that collects on the piece can turn up places where repairs, replacements, and soldering have occurred.

It is possible that some church silver was not made originally for ecclesiastical purposes. A party might have moved from England to

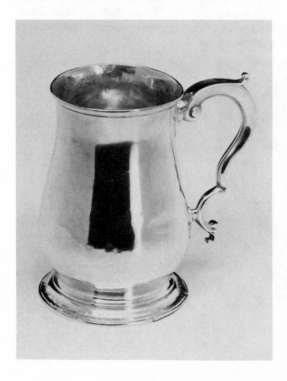

Silver cann by Enos Reeves, 1753–1807, Charleston, South Carolina. Bulbous body, molded foot and rim, double-scrolled, crested handle with slight hook on end. Reeves was an officer in the Continental Army, and his silver is very scarce. He was apprenticed to his uncle, Steven Reeves, a Philadelphia silversmith, during the year 1774. Hammerslough Collection, Wadsworth Atheneum, Hartford, Connecticut.

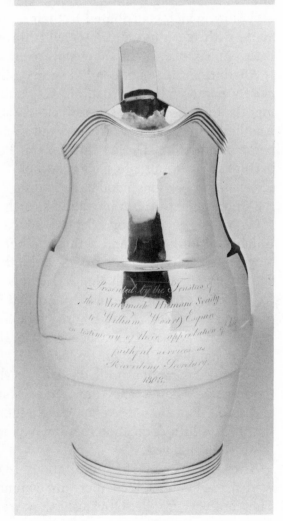

A rarity in American silver is this folding cup by John H. Connor, circa 1830, New York. Round body in three sections, flaring rim, and round spread foot. "FBB Jr." on body in florate oval. Hammerslough Collection. Wadsworth Atheneum, Hartford, Connecticut.

Silver presentation pitcher by Ebeneezer Moulton, Boston, 1768–1824. Engraving: "Presented by the Trustees of/ the Merrimack Humane Society/ to William Woart Esquire/ in testimony of their approbation of his faithful services as/ Recording Secretary/ 1808." Hammerslough Collection, Wadsworth Atheneum, Hartford, Connecticut.

147

these shores, bringing with them a silver goblet which could have been a family piece. Upon association with a church here, they may have been inclined to present it to the church for use as a communion goblet and might have had it inscribed. This would not necessarily diminish its value.

Forks, spoons, and knives as we know them in table services are relatively recent in comparison to other forms of silver. Though spoons were known for centuries, they were large and mostly used for serving. The smaller spoons as we know them did not appear until the end of the seventeenth century, and table knives and forks did not come into general use until the Georgian period in England during the second quarter of the eighteenth century. General acceptance of forks was very slow, which contributed to their scarcity today. At first they were made with two tines and later with three; the four-tined forks made their appearance in the nineteenth century.

All during the eighteenth century silver designs in the colonies closely paralleled those made in England. One reason for this "copying" is that America was still closely tied to the mother country. Another is that many workers served their apprenticeships in England before emigrating. During the Federal Period there was a radical departure from the ornate Georgian look that was still popular abroad. Excellent proportions, good taste, and simplicity might best characterize the American effort. Earlier workers, such as Benjamin Burt, of Boston; Myer Myers, of New York; Samuel Williamson, of Philadelphia; Lewis Buichle, of Baltimore; and William Whetcroft, of Annapolis and Baltimore, gave way to such workers as Nathaniel Vernon, of Charleston, South Carolina; William Smith Nichols, of Newport, Rhode Island; John Easton, Jr., of Nantucket; and Daniel Van Voorhis, of Philadelphia and New York City, whose work has only recently gained high regard. There was a time when nineteenth-century silver was not considered significant enough to collect. However, one must realize that many workers, active until the end of the Federal Period, made all their work by hand. They must be reckoned with as some of our best craftsmen. The aura of age may make the earlier pieces more valuable, but there is little indication that the makers were any more skilled than those who followed.

After the War of 1812 until about 1840, lightweight silver spoons were made in abundance; these are commonly referred to as coin silver. They are very fragile. Obviously they were not used for heavy eating

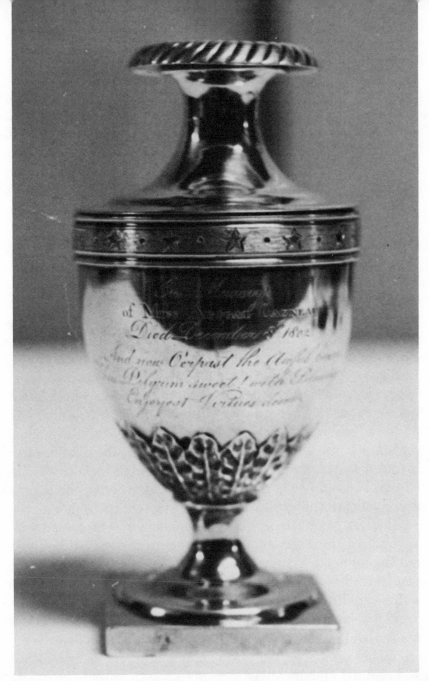

Memorial urn, silver, by Robert Evans, Boston, 1768–1812. Lower part, egg-shaped bowl, repoussé acanthus leaves around bottom, on splayed foot and square plinth, molded rim with stars and dots. Removable upper section with concave sides and flaring, everted gadroon rim. Engraved on body in script: "In Memory of Miss Abigal Cazneau/ Died December 8th 1802/ And now O'erpast the Awful bound/ Thou Pilgrim sweet! with Blessings crown'd/ Enjoyst Virtues doom." On other side: "Born July 27/1769." Marked "EVANS" in serrated rectangle on plinth. Boston Museum of Fine Arts; gift of George Blaney, Alice B. Holmes, and Marguerite B. MacLean.

tasks, and one suspects they were used for tea and coffee and light desserts. The notion that these were made by hammering out a large silver coin into a spoon shape should be taken lightly. Such production would denude the mint. I suppose it would be possible for a person to create a spoon in this manner, but this is an unlikely method to use for mass production. The coin designation refers to the silver content, which was exactly that of the coinage of the time, about nine parts to one part alloy.

It appears that American silver-workers resisted the change to fancy designs, unlike furniture-makers, and continued to use traditional lines with minor innovations, after the earlier, radical changes were made immediately following the revolution. The Federal style of silver is still duplicated today, a tribute to its classic beauty. The coffee and tea sets were often of oval or octagonal shape, with flat bases, vertical sides, and straight tapering spouts. Paul Revere and Zachariah Brigden, both of Boston, were pioneers in making the pieces in this fashion. The taller coffeepots and chocolate pots were plain in concept and not as harshly decorated with repoussé, or chased, as were the foreign pieces.

With the advent of the Machine Age, about 1830, and the method of electroplating in the 1840's there was a decline in the quality of work and in the demands made by the public. A new society was being formed which could not afford, nor necessarily wanted, the expensive efforts of handcraftsmen still working, and the cheaper mass-produced silver and silver-plated items flooded the country. The accent was on quantity, not quality, and another of America's cherished collectibles suffered the fate of changing times and tastes.

Several excellent books have been written about early American silver; these are listed in the Bibliography. Familiarization with names, cities, and touchmarks is very important if one is to collect this precious commodity. Until such books were written much fine silver lay dormant in homes until after the turn of this century. Greater recognition of it has resulted in more silver finding its way into trade channels. In the Introduction to his second volume on American silver, Philip Hammerslough writes:

> Shortly after the first book on my collection of silver went to press, it seemed to me that fine new pieces of silver began to mysteriously appear. As all dyed-in-the-wool collectors will agree, it was impossible for me to turn down a number of

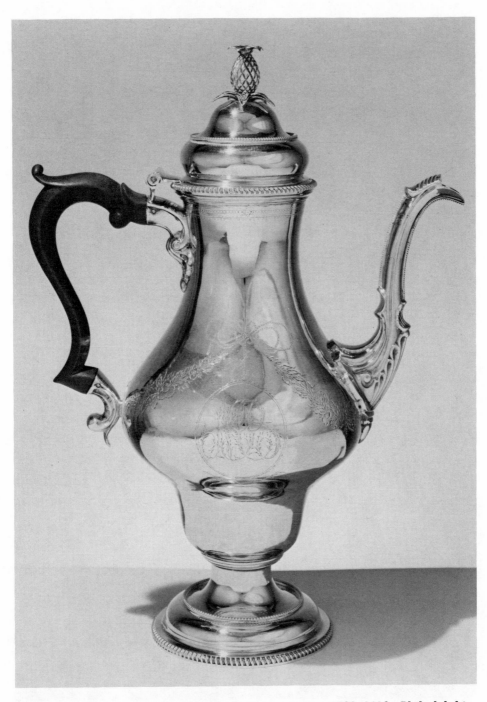

Coffeepot, silver, made by Joseph Lownes, active 1780–1816, Philadelphia. Height 14⅝″. Philadelphia Museum of Art; given by Mr. and Mrs. Percival E. Foerderer.

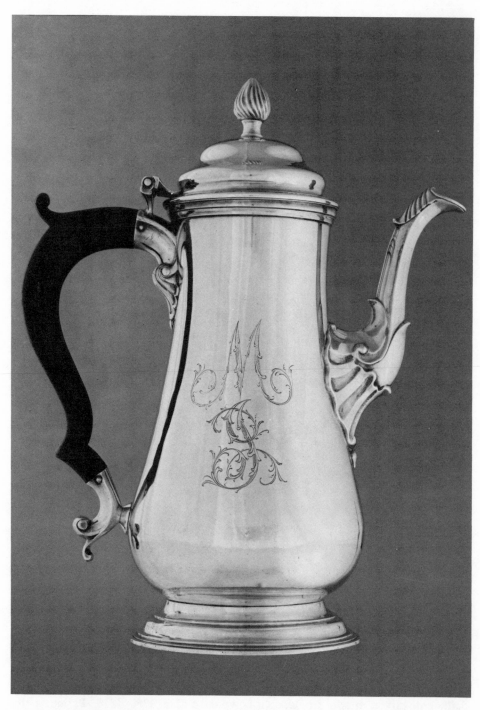

Coffee pot by Joseph Bruff, Easton, Maryland. Made between 1730 and 1785. Baltimore Museum of Art.

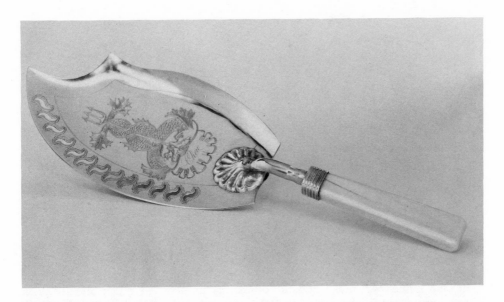

Fish slice, silver, by John W. Forbes, New York, working 1802. Flat blade
with curved pointed tip; elaborate engraving on face. Ivory holder. Engraved
"Chew" on face of blade. Chew was the purser on the ship *Constitution*.
Hammerslough Collection, Wadsworth Atheneum, Hartford, Connecticut.

Pair of candlesnuffers, silver, by John C. McClymon, working 1805, New
York, with his name in capitals on the snuffer plate. Hammerslough Collection.
Wadsworth Atheneum, Hartford, Connecticut.

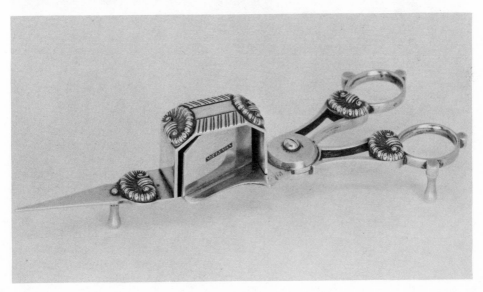

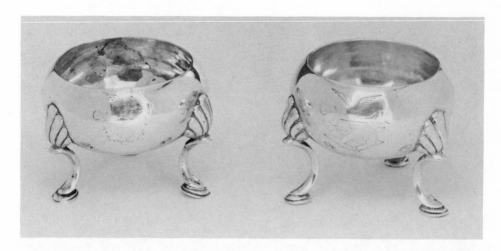

Pair of open salts, silver, by Andrew Billings, Poughkeepsie, New York, 1743–1808. Shells at tops of legs and hoof feet are unusual. Engraving is unidentified. One is marked "AB," and the other has unrecorded mark of Billings in a small rectangle. Hammerslough Collection, Wadsworth Atheneum, Hartford, Connecticut.

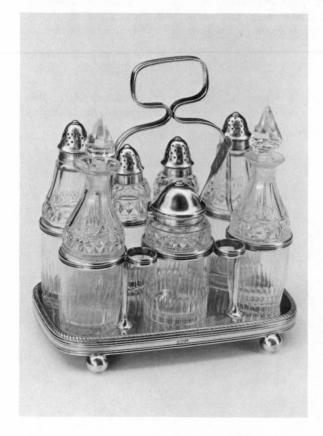

Caster set, silver, by George Riggs, 1777–1864, Georgetown, District of Columbia, and Baltimore. Seven original bottles, five with silver tops. Hammerslough Collection, Wadsworth Atheneum, Hartford, Connecticut.

154

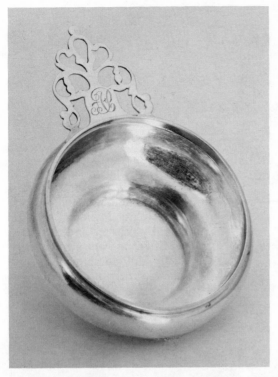

(Left) Porringer, silver, by Nathaniel Vernon, 1777–1843, Charleston, South Carolina. Circular bowl, keyhole handle. Initials "IAC" on handle. Hammerslough Collection, Wadsworth Atheneum, Hartford, Connecticut. (Below) Dish cross, silver, by Standish Barry, Baltimore, 1763–1844. Inverted pearshaped spirit lamp bisected by two movable arms, adjustable shell supports, and feet at the termination of arms. Dish crosses are very rare in American silver. Hammerslough Collection, Wadsworth Atheneum, Hartford, Connecticut.

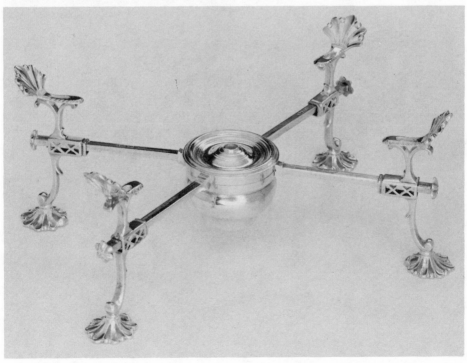

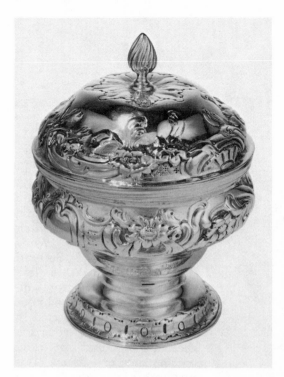

(Left) Sugar bowl, silver, made by Edward Milne, active 1757–1813, Philadelphia. Height 5¾". Philadelphia Museum of Art; given by Walter Jeffords. (Below) Silver tea box by Anthony Rasch, Philadelphia and New Orleans, early nineteenth century, circa 1825. City Art Museum, St. Louis, Missouri.

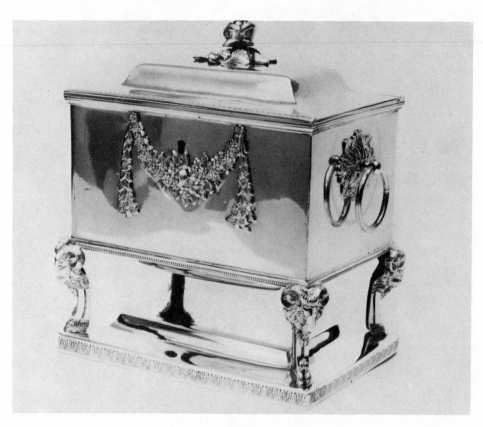

these outstanding items. I rather hope that after this second
volume is published, I will not be offered any additional
pieces of silver. However, this is not a very deep-rooted hope,
and I rather suspect that some of my close dealer friends will
not take me too seriously.[1]

Mr. Hammerslough's superb collection of early American silver may
be seen at the Wadsworth Atheneum in Hartford, Connecticut.

The collecting of other basic metals, pieces of the Federal Period,
such as brass, copper, tin, and iron, is rather hazardous. One difficulty
is documenting the age and origin of these pieces. These metals are
subject to reproduction in handmade fashion even today, and with a
little age and patina applied in one fashion or another it becomes very
difficult to be positive in attribution. It is most likely that any brass
items of quality surviving from the Federal Period were made in
England or another foreign country. Some retired shipmates are known
to have located along dock areas at American seaports in order to make
necessary items for sailing vessels. However, little is recorded of their
work. When one examines the ship artifacts of the period, he is con-
fronted with English binnacles, compasses, barometers, sextants, and
lanterns. Most are stamped by their makers. Some ship items were sold
by local chandlers, but more often these were of foreign manufacture.
Seemingly, most of the dockside work was in repair, not manufacture.

Most of the fireplace equipment in use at the time came from En-
gland and European countries, although there are instances of native
concerns, such as the Hunneman enterprises in Roxbury, Massachu-
setts. William Hunneman was an apprentice of Paul Revere, and after
leaving his employ Hunneman opened his own shop and foundry. He
made not only fireplace equipment, but firefighting equipment, and his
steam pumpers were a familiar sight on many New England streets.
Hunneman brass pieces are well marked, and most are still found in
New England. He worked up until about 1850.

Paul Revere himself worked until 1818 and was responsible for
much brass and copper work. He engraved plates for printing, and his
famous work of the Boston Massacre has been reproduced many times.
The Metropolitan Museum in New York has a pair of brass andirons
with his mark. The legs are cabriole with ball-and-claw feet, and they

[1] Philip Hammerslough, *American Silver* (privately printed, 1960–1970), Vol. II, Intro-
duction.

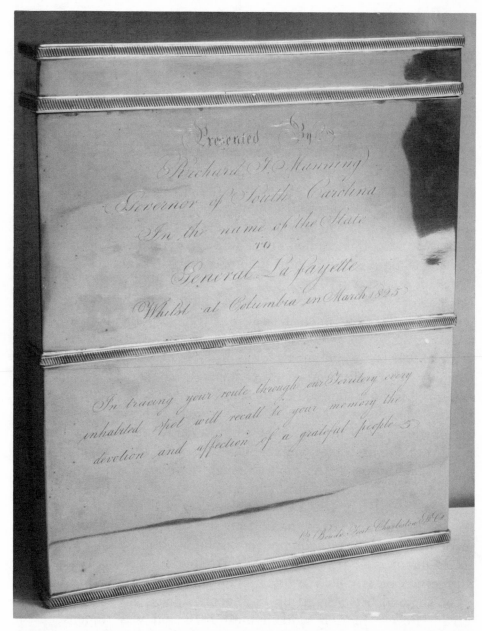

Silver map case by Louis Boudo, Charleston, South Carolina, circa 1825. Its inscription: "Presented by Richard G. Manning, Governor of South Carolina in the name of the State to General Lafayette whilst at Columbia in March 1825. In tracing your route through our Territory every inhabited spot will recall to your memory the devotion and affection of a grateful people." It is signed at the bottom right, "Ls. Boudo. Fecit Charlestown, S.C." Metropolitan Museum of Art, New York; bequest of A. T. Clearwater, 1933.

158

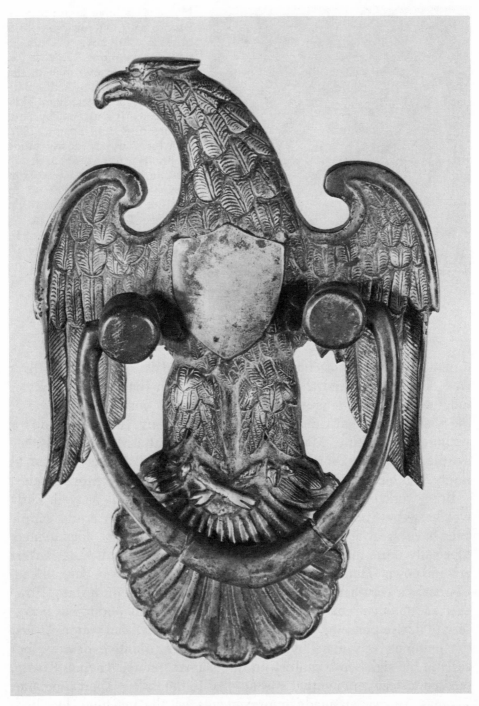

Brass eagle door-knocker, found in Massachusetts. Height 9″, width 5½″. Circa 1800–1810. Shelburne Museum, Shelburne, Vermont.

159

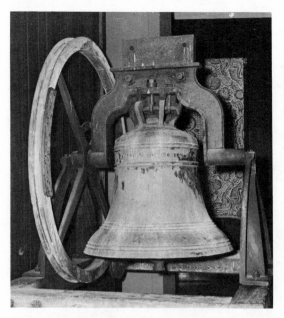

Many of us have heard of Paul Revere bells, but few have been able to get close enough to actually see one. This is on display at the entrance of the Merrimack Valley Textile Museum in North Andover, Massachusetts. It was cast by Paul Revere and Son, Boston, 1807, with the 7 upside down. Made originally for a church in Castine, Maine, it was later brought to North Andover to ring out the work hours at the Stevens Textile Mill. It remained there until 1961, when it was donated to the museum.

terminate in a bulbous column with reeded finials. His work in bells is well documented, and there is many a church that tolls its services today with a Revere-made bell. One rests in the belfry of the tower at the Shaker Colony at Canterbury, New Hampshire. Another, made for a church in Castine, Maine, may be seen at the Merrimack Valley Textile Museum in North Andover, Massachusetts. This is unusual, as rarely does one get this close up to a well-marked, Revere tower-bell.

Brass-workers most often worked with copper and tin as well. Early weather vanes were a product of this effort, and the very crude, simple ones have great appeal today as folk art. Many are not documented, especially those made in the Federal Period, and usually the makers are unknown. Hence, most of them are still relatively low priced. Copper is a very basic metal and can be found in its pure state. However, most copper comes from deep within the earth, and it was necessary to devise pumping systems to free the tunnels from water. At first the pumping was done by hand with rather primitive devices, but early in the eighteenth century an Englishman, named Thomas Savery, devised a steam engine that was applied to the task. A short time later Thomas Newcomen made improvements on the machine, but both machines consumed huge volumes of coal. The government allowed

the mine-owners free duty on their coal to assist in their use, but it was not until James Watt perfected the steam engine, reducing the fuel intake, that deep-mining was made practical. Pure zinc was refined as calamine, and this was mixed with copper to form brass. Bronze is a mixture of copper and tin.

The term "ormolu," used in connection with much Empire design, has actual reference to a French-inspired "ground gold." However, much of what we call "ormolu" is actually brass, or a poor man's gold. Bronze doré is a bronze that has been finished with a burnished gold. The best of both types of work came from France and England. There is little evidence that much of this work was done in America except by the finest makers. The use of such decorative devices is best applied to furniture of the period.

Among the rarities in brass are whale-oil lamps. They are fairly common in glass, tin, and pewter, but few seem to have been made of brass. Soldering a seam in a brass font with lead solder is quite a chal-

Peacock weather vane, lead and copper, 36½" long and 16" high. Circa 1800. Shelburne Museum, Shelburne, Vermont.

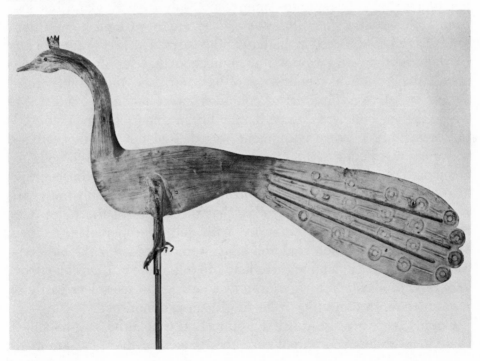

lenge to a fine craftsman, as the solder shows plainly against his work. In contrast, the solder blends in with the color of pewter and tin and can hardly be noticed. Those who did make them in brass concentrated on spinning the fonts and joining them under pressure in a manner that made them leakproof. Needless to say, this was a time-consuming technique, not indulged by the majority. There were some excellent examples of such whale-oil lamps made in Newburyport, Rhode Island, with delicately shaped fonts, molded pillars and dolphin handles, and spun bases. Others were made in plainer fashion. Not too many have survived.

Brass chandeliers were popular in the wealthy homes. These were made to hold candles, and some were later modified to hold whale-oil or camphene burners. Most likely these were made in England. The workmanship on them is very fine, and the item is so popular yet scarce as an original that reproductions are being turned out to satisfy the demand.

Many long-handled brass warming-pans are available, but most of these are of English manufacture. Their value is determined by condition and the interest of the punched-work designs on the cover. Brass candlesticks are plentiful, but the aged ones are more likely of foreign manufacture. Many came to America not only from England but also from Holland, and since this was a mass-produced item, many thousands have found their way here over the years. The fact that few pairs reach three figures in value is an indication that supply exceeds demand. Reproduction over the years has destroyed the confidence in age. Very few food utensils or containers were made of brass. Little was made for tableware, since the acidity in some foods reacted with the metal. Much horse equipment was decked out in brass, all the way from the hames to the bits and buckles. Old brass sleigh bells are common, but most found today would have been made in this century. The helmet-shaped coal scuttles, made in both copper and brass, are being so widely reproduced today that the values of the older ones have dropped. Some are equipped with delft-blue porcelain handles and openly exhibit their soldered joints in the manner of the old ones. Today, shops in England and Holland are full of them. Items like doorknockers, candlesnuffers, kettles, and lamps lend themselves easily to reproduction, so the fun of collecting them is diminished.

Copper items are also easily reproduced. It is not advisable to collect these items unless you do not care about age, and the items are mod-

erately priced. It is inadvisable to use copper items for cooking unless they are well tinned, since copper reacts with food and produces a disagreeable taste. Old, huge, copper applebutter kettles from Pennsylvania make wonderful woodboxes but should not be used for cooking unless tinned. Very few brass and copper pieces date back to the early nineteenth century. Most of those found are from the twentieth century. There is much copper and brass flooding America's markets today, coming from North Africa. Perhaps the women there have finally given up polishing and cleaning these hard-to-keep-clean vessels, selling them off in favor of stainless steel and Teflon. As a result, most copper and brass is at a low ebb in price and value today, regardless of period.

Dealing in tin items can be rewarding today, but little or none of these items can be traced to the Federal Period. Tin is a relatively perishable metal, and unless well protected with paint or another coating, it will rust out quickly. Tin, as we know it in sheets, is actually tin-plated rolled steel, and once the protection of the coating is gone, the thin steel beneath will deteriorate rapidly. Most of the tin-decorated items that have come so much into favor recently are products of this century.

Iron is still being wrought in the manner it has for centuries, so documentation of iron items can be a fragile exercise unless there is written proof of existence. Perhaps the most important antique iron piece that can be documented is the stove plate. Most furnaces in existence at that time molded their names into the pieces they cast. To

Forty-eight-hole tin candle mold, a rarity for its size. Typical of those used for candlemaking during the period. Dr. David Bronstein, New Cumberland, Pennsylvania.

(Left) Tin fluid lamp on stand, circa 1830. 8½″ high; pan diameter 7½″. Pennsylvania. William Penn Memorial Museum, Harrisburg, Pennsylvania. *(Below)* Pisces weather vane, sheet iron and iron rod, late eighteenth century. Shelburne Museum, Shelburne, Vermont.

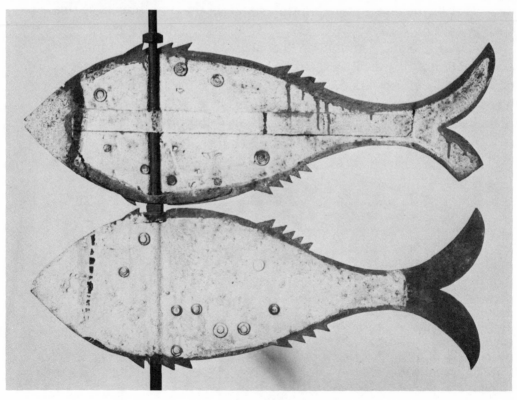

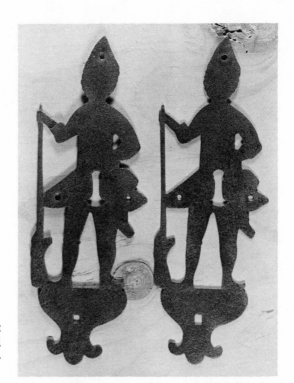

Wrought-iron escutcheon, circa 1800. William Penn Memorial Museum, Harrisburg, Pennsylvania.

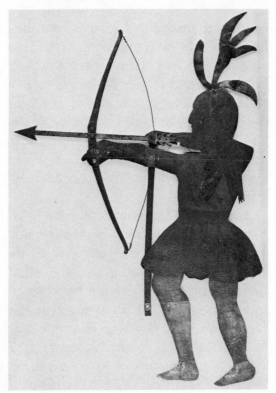

Indian archer weather vane, silhouette in sheet iron, painted. 5' high. Circa 1810. Shelburne Museum, Shelburne, Vermont.

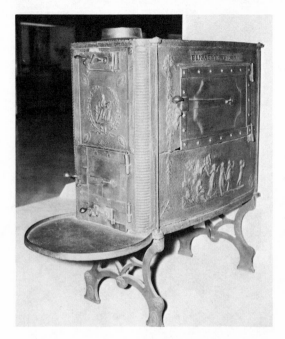

An early logwood, or better-known "schoolhouse," iron stove from the Elizabeth Furnace, near Manheim, Pennsylvania. It was the custom of early foundries to mold decorations and their names into the stove plate. This furnace was once owned by Baron William Stiegel, of Stiegel glass fame. William Penn Memorial Museum, Harrisburg, Pennsylvania.

enumerate the many furnaces operating up to and during the Federal Period would take many pages, as iron was one of the readily available commodities, found almost anywhere. Notable are the Cornwall, Pottstown, and Hopewell forges in Pennsylvania, which were responsible for turning out much of the cannon and accouterments of war during the revolution. The Cornwall Furnace restoration is outstanding and should be visited. The mines nearby, from which ore was taken during the war, are still in operation. Washington and Lafayette visited Cornwall during the war and witnessed the making of cannon and shot.

Another manufacturer of note was the Honorable Hugh J. Orr, Esq., who came from Scotland and settled in East Bridgewater, Massachusetts. He was engaged in the manufacture of firearms just before the revolution. When the war began, he developed the technique of producing cannon by boring a solid casting, which speeded up construction. His ironworks was also responsible for many types of farm tools. Mr. Orr was instrumental in the introduction of cotton-spinning machinery in this country. The first machines for carding, roving, and spinning cotton, made in the United States, were constructed at his works in East Bridgewater.

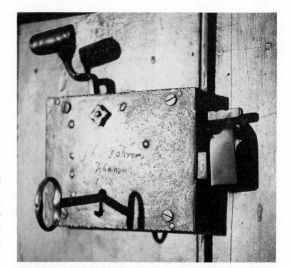

Iron lock by John Rohrer, of Lebanon, Pennsylvania, dated 1803. On front door of the Bindnagles Evangelical Lutheran Church in Palmyra, Pennsylvania.

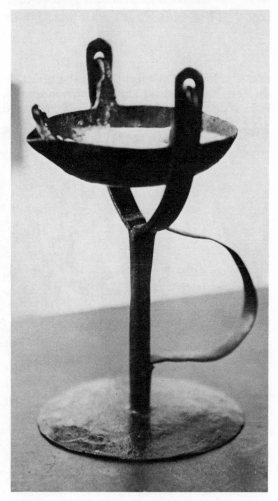

Iron grease lamp, Pennsylvania. Dr. David Bronstein, New Cumberland, Pennsylvania.

167

During the Revolutionary War the Hudson River was the most vital link connecting the Mohawk Valley and the Great Lakes, as well as serving as the ideal corridor for the moving of troops. The British were especially interested in it, as they planned to use it to flank New England with their forces to cut off men and supplies. Washington heard of the preparations of the enemy, who were planning to sail up the Hudson, take West Point, and dominate the river. He decided to do something about it, and a contract was let to the Sterling Orange Works, which was just southwest of Sloatsburg, New York. It was for a chain that could be stretched across the river to bar the passage of ships.

The Sterling Works was under the leadership of Peter Townsend, who had succeeded in making steel there in 1776. It had been organized in 1751, and New York's first ship anchor was made there in 1753.

Fourteen links of history; part of the great chain that was stretched across the Hudson River during the Revolutionary War to stop the British. Courtesy U. S. Military Academy, West Point, New York (U. S. Army photograph).

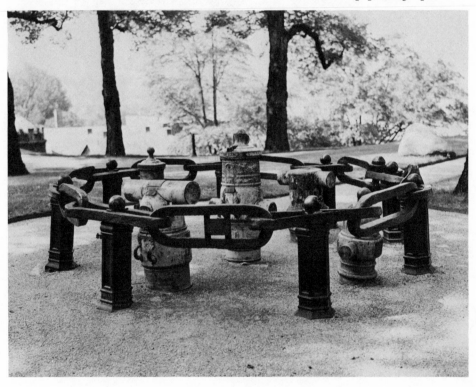

The links for the chain were made of bar iron, and each one weighed about 150 pounds. The entire chain is estimated to weigh 186 tons. Townsend's men worked day and night, completing it in six weeks. Ox carts that came from Connecticut were used to haul the links in place to the shore of the Hudson, where they were assembled on its banks. Each link was about three feet in length, and every one hundred feet a clevis was used to join each section. The chain was stretched from West Point to Constitution Island shortly before April 30, 1778. It was buoyed by large logs which were pointed to allow freer passage of the tide. It did its work well and stopped the British from using the river until it was removed in 1783.

Fourteen links of this Sterling chain along with a clevis and swivel are on permanent display at the United States Military Academy at West Point, New York. By today's standards they represent the most primitive of barriers, but they were part of a military strategy that paid off. This is perhaps some of the most historic iron preserved. Other links and parts must lie elsewhere, perhaps at the bottom of the river or in homes and on farms where they may have been taken as souvenirs.

Actually, this was not the first chain to be stretched across the Hudson. One was brought from Lake Champlain as early as 1776, but when it arrived, it was found to be too short. Another was forged in Poughkeepsie and was stretched between Fort Montgomery and Anthony's Nose in November, 1776, but this was not sturdy enough, and its links gave way. It was strengthened and put in place again about March 23, 1777. The British captured it on October 7, 1777, and sent it to Gibraltar to be used there. One wonders at its eventual fate, or if it still survives.

Chapter 6

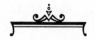

Timepieces

No one knows when the first clock with a gear or wheel mechanism was made, but records prove the existence of some in the thirteenth century in England and the fourteenth century in France.[1] The earliest clocks had no dials; they were generally built into towers of churches as a simple striking mechanism to toll the hours. The Egyptians were making clocks as early as the thirteenth century B.C. As early clockmaking developed, it was not unusual to construct clocks in which figures of people, skeletons, animals, etc., performed while striking the time. There is a clock in Rouen that still keeps excellent time today, though it was made in 1389. This was a predecessor of the fancy clocks that were made to show the time, the days of the week, and the phases of the moon.

By the turn of the seventeenth century every home that could afford one bought a clock. These household clocks were referred to as birdcage, lantern, or bedpost clocks. Some were shelf pieces; others hung on the wall. The clocks with the very visible hanging pendulums were introduced during the mid-seventeenth century, following the appearance of the "dumbbell" and "balance wheel." They were called wag-on-wall clocks. It would appear that very few of these early timepieces came to America with the settlers. Those that are here now were most likely brought over by dealers and tourists during this past century.

The father of English watchmaking was Thomas Tompion. Many of his pieces are still running today. Tompion and a group of fine craftsmen are responsible for elevating the art of watch- and clockmaking; they made timepieces dependable, reasonably accurate, and with

[1] F. J. Britten, *Britten's Old Clocks and Watches and Their Makers* (New York: Bonanza Books, 1956), p. 4.

170

greater longevity. Many clocks and watches that were made in both England and America during the eighteenth century have survived well, still faithfully serving in thousands of homes. These pieces were excellent buys in their time, and they still are. Very few items of such a mechanical nature have survived so well; although many seem primitive in appearance, their inner works were designed much as they are today and perhaps have more life left in them than some of our present-day production.

Clockmaking in America generally fell under the influence of the English clockmakers. Another influence was that of the German, Swiss, and Dutch population in Pennsylvania, who continued to produce mechanisms with which they were most familiar. Though they appeared in many inventories and estate accounts, it is unlikely that any were made in this country prior to the beginning of the eighteenth century. The first clockmakers were perhaps no more skilled than men in other trades, such as smithing, tin-knocking, and gunmaking. Since works, dials, and finials were sent from England, the local makers were initially no more than assemblers. The Pennsylvanians followed in the footsteps of their European counterparts and fashioned their weights from iron. The New Englanders, who had less iron at hand, were inclined to make weights out of sheet metal, soldering it into the shape of cans and filling the "cans" with available material, such as beach sand, lead shot, or metal scraps. In the latter part of the seventeenth century the tall clock came into being. The weights had a long drop to the base and could power the mechanism for eight days. Minute hands and second hands appeared, and by the beginning of the eighteenth century the clock as we know it today was a reality.

Though there were makers early in the eighteenth century, it was not until the Federal Period that clockmaking became a big business in America. According to records, many tower clocks were installed prior to the Revolution; however, there is not enough evidence to say who made them or whether the craftsmen were Americans. Gawen Brown, of Boston, is one of America's earliest makers. He is known to have made and installed the tower clock in the Old South Church, on Washington Street, in Boston, where it remains to this day. Other early makers are Elisha Purington, of Kensington, New Hampshire, who invented a brass gear-cutting machine in the middle of the eighteenth century; Benjamin Chandlee, who lived in both Philadelphia and Maryland in the early part of the century; the Cheney family, of Hartford,

Connecticut; Thomas Claggett, of Newport, Rhode Island; members of the Mulliken family in the Boston area; and Reuben Ingraham, of Preston, Connecticut.

A discussion of those clockmakers active during the Federal Period, as well as a complete recap of those before, would require a volume by itself. The more famous makers who cast an indelible mark on America's clockmaking industry include Simon and Aaron Willard and their descendants, who worked in the Boston area, and their many apprentices, such as Lemuel Curtis, Elnathan Taber, Levi and Abel Hutchins, and Daniel Munroe. In Pennsylvania there were Christian Eby; Jacob Hostetter; Matthias Baldwin, of Philadelphia, who started work as a watchmaker and ended up making locomotives; Jacob Carver; members of the Heilig family, including Nolen and Curtis, who made dials and tools; Thomas Voight; Daniel Rose; and the Solliday family, of Bucks County.

Although the making of smaller, inexpensive clocks by such men as Simon Willard began before the Revolution and continued until shortly thereafter, it was not until after the turn of the century that mass production became a reality. Eli Terry was among the first to use water machine power. The technology of design had been mastered; it was merely a step to produce the product rapidly and inexpensively, so that every family might own one. Until this time, clocks as a rule were made to order for customers, and a tall clock might cost a hundred dollars. When Terry brought out an inexpensive, accurate shelf-clock to sell for about ten dollars, its acceptance was so immediate that he is credited with becoming the first maker to produce them for sale in advance of orders. At one time he was in partnership with Silas Hoadley and Seth Thomas, two other important makers, who later formed their own companies. Perhaps the most noted design, featured by all three, was the pillar and scroll, which was first made by Terry and later by the others under license.

Despite the prominence of clockmakers elsewhere, Connecticut became the hotbed of manufacture; perhaps more well-known and successful makers settled there than anywhere else in the country. The production by the makers in Connecticut was so great that many often made only the works, which were peddled from town to town, where they might be assembled locally in a case made by a local cabinetmaker. Some of the makers featured wooden works, which were at first an answer to the more expensive brass, but these were not reliable in

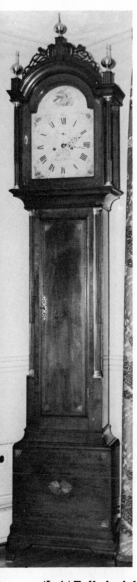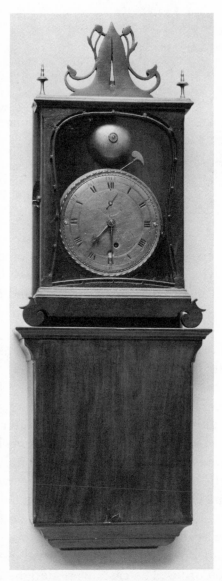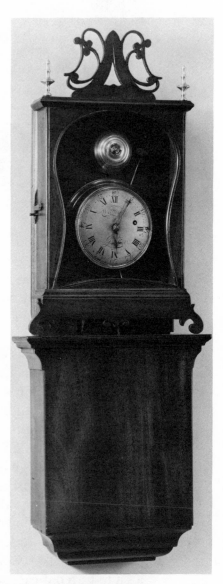

(Left) Tall clock by the master maker Simon Willard, of Roxbury, Massachusetts. In a private collection; we show it as an example of one of the ultimates in clock-collecting. It was made during the Federal Period. *(Center)* Wall clock, mahogany case, made at Roxbury, Massachusetts, by Aaron Willard, 1757–1844. Dated between 1780 and 1790, it is 23" high, 9" wide, and 3" deep. The Sylmaris Collection, the Metropolitan Museum of Art, New York; gift of George Coe Graves, 1930. *(Right)* Very similar to the wall clock made by Aaron Willard is this one, in mahogany, by Simon Willard, with the location of Grafton (Massachusetts) inscribed on its face. This dates between 1770 and 1780. The Sylmaris Collection, the Metropolitan Museum of Art, New York; gift of George Coe Graves, 1930.

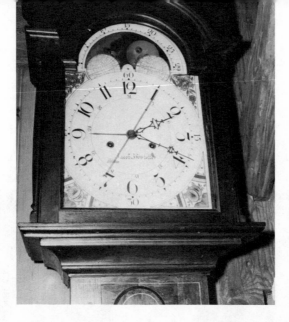

Face of tall clock by Jacob Hostetter, 1754–1831. Hostetter worked first in Hanover, York County, Pennsylvania, after having learned the trade from Richard Chester. In 1825 he moved to New Lisbon, Ohio, where he continued his work. Note the unusual full-sweep second hand. The case is made of walnut.

their timekeeping and eventually lost favor. Many of the clocks with wooden works have survived. Silas Hoadley must have made hundreds of them, since they continually turn up at auctions and in shops. However, their acceptance is considerably less than that of the early brass mechanisms.

The banjo clock is one of the most renowned products of the period. Its invention is generally credited to the Willards. They were made not only by the Willards but also by their apprentices. The banjo clock marked the appearance of the first classically designed wall clock. These first timepieces did not strike the hour, but later ones were designed with a second weight to drive the striking mechanism exactly on the hour. The girandole design, created by Lemuel Curtis, greatly improved their aesthetic appearance. Few of these were made, and consequently their value is often estimated to exceed five figures today.

The tall clock, however, was considered to be the epitome of ownership, and great work was done in designing the works as well as the cases. The maker would often employ the best cabinetmakers in his area to turn out cases on order. The cases were designed after the lines of the furniture in vogue at the time. The last great period of clockmaking was the latter part of the Federal Period; the cases for the clocks made at that time show the Sheraton influence. The basic design is that of a case that would range from five feet, known as the dwarf, or grandmother, clock, to those that might stand nine feet or taller. The case was topped with a "bonnet hood," made of three plinths joined by fretwork, and finials in either brass or wood. The corner posts on the case are reeded, and the case bottom features a bracket or boot-

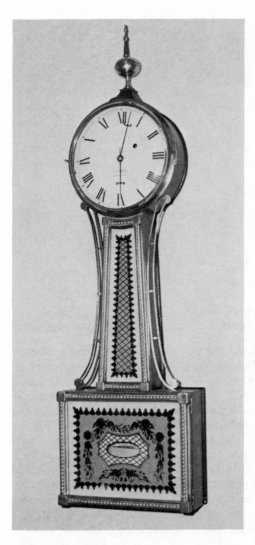

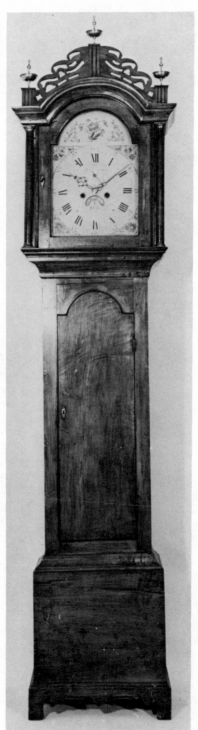

(Above) Banjo clock by Elnathan Taber, Roxbury, Massachusetts, 1786–1854. Regarded by Simon Willard as his best apprentice, Taber made all types and had privilege of marking "S. Willard's Patent" on his banjo clocks. Willard sold him all his tools along with his business and goodwill. (Right) Tall clock. Case made by James Dinsmore, Hopkinton, New Hampshire, circa 1800. Cherry case in inlaid with 12" enamel dial. The Metropolitan Museum of Art, New York; Rogers Fund, 1943.

175

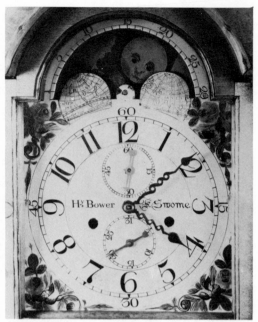

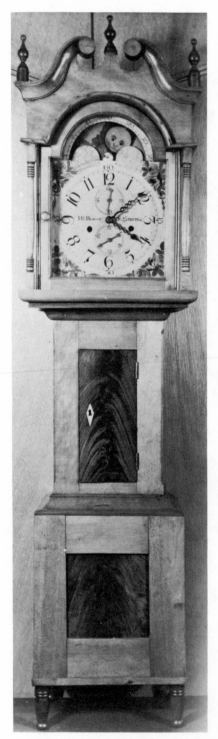

(Left) Dwarf tall clock by Henry Bower, Philadelphia, first quarter of the nineteenth century. Nicknamed the grandmother's clock, they were built in proportion to the larger ones, generally not attaining a height over four feet. They were made by many fine clocksmiths. William Penn Memorial Museum, Harrisburg, Pennsylvania. (Above) Face detail showing moon dial of the dwarf tall clock by Henry Bower, Philadelphia, first quarter of the nineteenth century. Note the second hand and the calendar dial.

jack design. Many are embellished with veneer and inlay. Country clocks featured maple, birch, and pine as woods, and the more elegant city clocks were created with cherry, mahogany, and walnut. Many of the country clocks in Pennsylvania and the South are in cherry and walnut, as the woods were plentiful in those areas, but the designs are much plainer than their city counterparts. Early tall clocks occasionally featured glass-paneled doors. However, the crude pendulums and weights were not things of beauty and were usually covered up with solid doors. If a clock with a glass door is found, one should check the construction of the door to make sure that it is original, since many have been added subsequently. Glass doors are perfectly acceptable, although solid doors remain more popular.

Many New England clocks have works and dials that were made in England during the Federal Period but assembled in America with native-made pendulums and weights. These may be classed as native-made clocks as long as they are installed with American cases. Osborne's Manufactory in Birmingham must have shipped many to the States, as they are well stamped on the clock plates and have turned

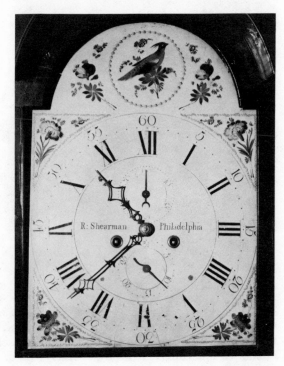

Clockworks by Robert Shearman, active 1799–1804, Philadelphia. In Chippendale tall case, mahogany, height 2 m. Philadelphia Museum of Art; bequest of Elizabeth Gilkison Purves.

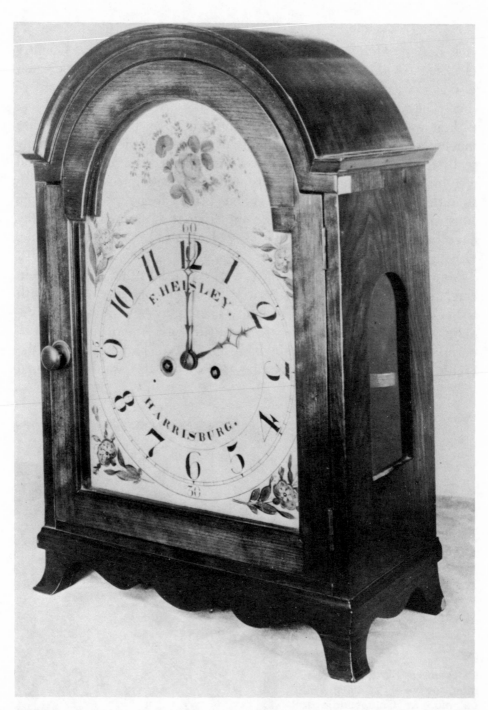

Mantel clock by Frederick Heisley, 1759–1839. Born in Frederick, Maryland, he served in the Revolutionary War. Worked in Lancaster, Harrisburg, and Pittsburgh. This clock made while in Harrisburg, circa 1800. William Penn Memorial Museum, Harrisburg, Pennsylvania.

up in many tall clocks signed by New England makers. The tall clock survived until about the middle of the nineteenth century, eventually giving way to the less expensive, convenient mantel and shelf clocks that poured out of Connecticut by the thousands.

The Empire Period brought a change in clock-case styles. Garish carvings, large rounded columns, and ogee frames became popular. Mantel clocks evolved from well-proportioned designs into fancy gingerbread styles, which prevailed in the latter part of the century. Style seemed to be the last thing in the minds of the makers. Mass production was their aim, and they were willing to put their works into anything that would sell. The weight-driven mechanisms gave way to improved spring-wind systems and the eight-day movement was compressed into smaller and smaller space. The promise of a clock for every home, no matter its social level, was made a reality by the Connecticut clockmakers.

William Gilbert, Elias Ingraham, George Mitchell, and Joseph Ives were among the clockmakers to set up shop in Bristol and start very successful businesses. In addition, the Forestville Manufacturing Company, Chauncey Jerome, John Birge, and Elisha Brewster joined with these and others to create new clock businesses and enlarge on those already started. Clocks were sold from peddler's wagons throughout the country. In one instance Tennessee was up in arms as to how much money was leaving the state for purchases of Connecticut clocks, and in 1820 a petition was placed before the legislature to impose a duty on this trade.

A rather remarkable reversal of trade was evidenced by the interest shown in American clockmaking by European nations. The first shipments of clocks were confiscated and paid for by British Customs, but later they were allowed entry. Connecticut clock mechanisms soon began appearing in European cases, and in some instances the finished product was shipped right back to America. This represented the first mass production of any item by this country and set the stage for America to eventually dominate almost every country in the production of consumer products.

Chapter 7

Religious Sects

and Their Contribution

to the Period

It is well known that many emigrants came to America in search of religious freedom. Perhaps nowhere in the world has such freedom been enjoyed and protected as in America with its doctrine of the separation of church and state. In 1662 when Flushing, New York, was governed by Peter Stuyvesant, it was stipulated that all worship would be held within the framework of the Dutch Reformed Church and that those who opposed this order would be punished. Many Quakers, however, moved to the Flushing area and were soon holding services in the huge kitchen of the house owned by John Bowne. Stuyvesant respected Bowne's position in the community, but after having warned him many times about breaking the rules of worship, Stuyvesant had Bowne arrested and returned to the British Isles. The document known as the Flushing Remonstrance, signed by Bowne's religious friends and neighbors, protested the restriction on worship. This further enraged Stuyvesant, who had some of the protesters imprisoned. Meanwhile, Bowne found his way back to Holland, where he petitioned for a hearing before the West India Company under whose charter Stuyvesant ruled. The governor was reprimanded by the company with this statement: "In this case, some connivance should be made at least, and in all events, people's conscience should not be forced by anyone but remain free in itself, as long as he is modest and behaves in a lawful manner, and therefore does not disturb others or oppose the government." Upon this declaration, freedom of worship was established in America. Bowne returned to Flushing within nineteen months, arriving March 30, 1664. To perpetuate the memory of this man, the Bowne House Historical So-

ciety restored and dedicated his home in 1945, three hundred years to the day after the original charter was granted to Flushing.

The success of Bowne and the Remonstrance opened the doors to sects of all kinds, and in they came all through the seventeenth and eighteenth centuries. We shall concern ourselves with those who had an impact on colonial life during the Federal Period.

There was a great concentration of Quakers in the eastern half of Pennsylvania at the time of the Revolutionary War, with many of them engaged as successful tradesmen and merchants. To attempt to evaluate their contribution to the artifacts we collect today is a Her-

Unusual yarn winder, perhaps as sturdy a one as will be seen. Bowne House, Long Island.

culean task. Many of the finest craftsmen belonged to this sect, and many of their contributions were being copied by non-Quakers as well. To label a piece "Quaker," such as we might label a piece "Shaker" or "Zoar," is not in order, since the Quakers worked in no specific style, but rather in the prevailing styles of the day. Many other religious sects, however, were known for specific styles and methods of making, and collecting their crafts is popular today.

Perhaps the best known of these sects is the Shakers. On May 6, 1774, Mother Ann Lee and her small band of believers docked in New York, from where they scattered in different directions in order to earn a living. The only one with money was a John Hocknell, who went upriver to Albany, where he leased land in perpetuity from the estate of Stephen Van Rensselaer. After he returned to England to bring back friends and members of his family, Mother Ann went north to visit with other Shakers on the property. By 1776 after the return of Hocknell, a settlement was formed on his property. From here missionaries went out into all parts of the country in order to help set up new colonies and spread the gospel of the Shakers. Colonies were established as follows: Mt. Lebanon, New York; Watervliet, New York; Harvard, Massachusetts; Enfield, Connecticut; Hancock and Tyringham, Massachusetts; Canterbury, New Hampshire; Shirley, Massachusetts; Enfield, New Hampshire; Alfred and Sabbathday Lake, Maine. Of those first settlements only two remain as homes for practicing Shakers: those at Canterbury, New Hampshire, and Sabbathday Lake, Maine. Other colonies, such as those in Hancock, Massachusetts, and Pleasant Hill, Kentucky, have been restored and are open to the general public.

The Shakers were an industrious people and are now well known for their inventions, including the clothespin, dish strainer, hand washing-machine, circular saw, and flour-sifter. They improved on such items as the stereoscope viewer by making one that collapsed completely so it could be carried about easily. They were great gardeners, and some communities specialized in the growing and preparation of herbs, which were shipped all over the world. The tools they used in the field were devised by themselves. Since there was much red clay at Mt. Lebanon, they made smoking pipes. Credited with being the originators of the metal pen, they made steel, brass, and silver pens, some with handles of wood and tin, which would close telescopically.

The famous Dorothy Shaker cape was made from French broadcloth

Shaker dish drainer. This inventive sect not only designed the first drainer of this type but also made it so it could be folded to be put out of the way. New England.

Shaker wooden colander. Made out of pine, it was crude but effective. New England.

Shaker wool-washer, New England. This would be placed in a rushing stream, full of wool, and the fibers were cleaned for later use.

and originated in Canterbury; those that have survived are so strong and well made they could be worn today. In Kentucky the Shakers grew mulberry trees in order to raise silkworms so they might spin their own silk. The first permanent-press cloth was made by putting layers of cloth between chemically treated papers and pressing them in a Shaker-invented press, producing cloth with a shiny surface on one side and dull on the other. Flat brooms were first made at Watervliet in 1798 from broom corn, which still grows in that area. As early as 1809 basketmaking was a huge industry. Poplar trees were cut when frozen into twenty-four-inch lengths, put through a Shaker-invented plane, sliced into thin strips, and fashioned into baskets. Other inventions include the screw propellor, the disk harrow and threshing machine, the apple-parer, swifts, and even machinery that turned out the first tongue-and-groove boards. Little wonder, then, that people have singled out the Shaker items for collecting today. It is difficult to ascertain the exact period in which their items were made, as the styles changed little, if any, and few were marked to aid in documentation.

All the Shaker colonies made their own furniture, much in the same austere yet comfortable style. Native woods were used, and the cabinetry was of the finest. At Mt. Lebanon chairs were a specialty, and many of the ladder-back design were numbered on the top rung showing their size. These numbers are helpful in attribution. The styles in furniture, especially the chests, chairs, and tables, are in the style of the Federal Period. We must remember that many country craftsmen, not exposed to the latest drawing books and guides, worked with the design that was pleasing, functional, and quite often easy to make with the simpler tools at hand. At least one museum in Europe, the American Museum at Bath, England, displays a full room of Shaker items.

Another religious sect early on the American scene is that of the Amish. This Dutch sect, originally called the Omish, fled during the Spanish occupation of their homeland to Switzerland, Germany, and Russia. During the eighteenth century they migrated to Pennsylvania, settling as far inland as Lancaster, for here they found familiar limestone soil. After the revolution the sect spread out and can now be found in several Midwestern states as well as in Canada.

Along with the Amish during this period came the Moravians, the Dunkards, the Mennonites, the Schwenkfelders, and the German Piet-

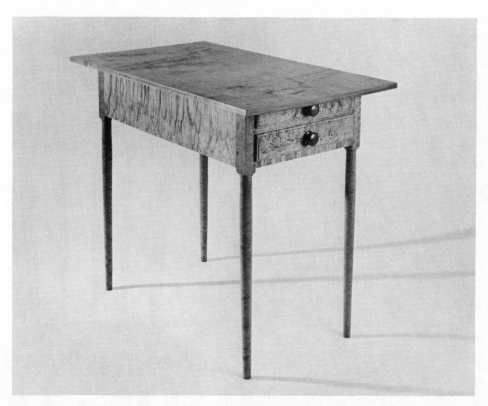

(*Above*) Shaker table, attributed to the Shaker community, Canterbury, New Hampshire. Curly and bird's-eye maple. Currier Gallery of Art, Manchester, New Hampshire. (*Below*) Unusual early nineteenth-century tiger-maple drop-leaf table. Shaker, probably Canterbury, New Hampshire. Legs turned with the grain give it a striking look. Bud Thompson, Canterbury Shaker Museum, New Hampshire.

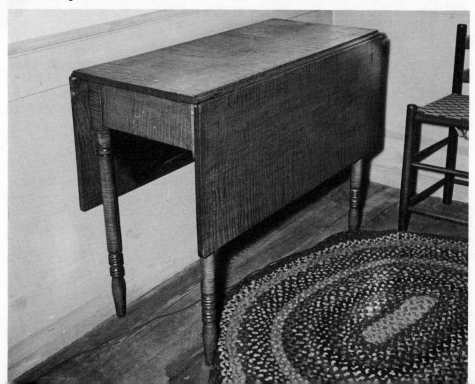

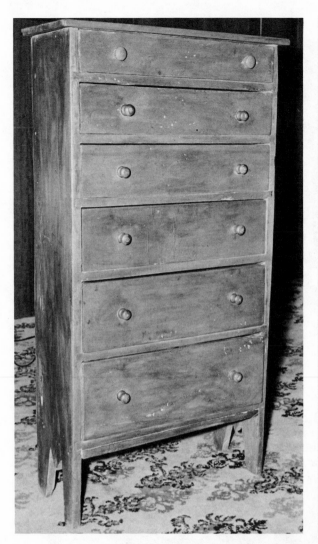 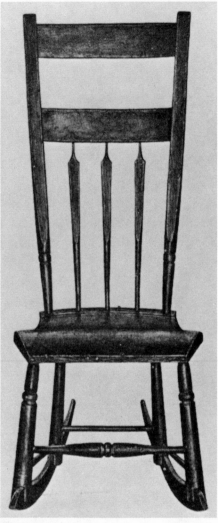

(Left) Early Shaker chest found in New Hampshire. In simple pine with boot-jack leg and clothespin pulls. Probably Canterbury, New Hampshire. Country Antiques, Loudon, New Hampshire. *(Right)* Rocking chair made at Lebanon, Ohio, about 1825. Thought to be a product of the Shaker community. Arrow-back design, painted black. Jabe Tartar.

(Opposite page) Child's drawer chest, maker unknown, Lebanon County, Pennsylvania, 1825–1835. Height 13″, width 19¼″, depth 11″. Pine, grained painted. Child's rocking chair, maker unknown, Lebanon County, 1825–1835. Height 22¾″, width 12¼″, depth 11½″. Pine, grained painted. William Penn Memorial Museum, Harrisburg, Pennsylvania.

ists, who founded the Ephrata Cloister. Little is recorded in the way of artifacts made by these settlers for their use. Most items fall into a loose collectible category and turn up at country auctions today; for example, dough boxes, kasts, sawbuck tables, cherry cupboards, painted dower chests, and long benches. Most country pieces made in mid-Pennsylvania have completely foreign designs, since they were often made by newly arrived immigrants who simply plied their trade in the manner they had at home. Some pieces ended up with distinctive names, such as the Moravian chair, which has a heavy plank seat, splayed legs, and a solid back, often with a heart or tulip cutout. The larger ones were made for men; the smaller ones for ladies. Pine, walnut, and cherry were most often used for tables and for chests of all types. The heaviness of the legs almost instantly marks these Pennsylvanian pieces, which were built solidly to last forever. The proportions of these pieces are not so graceful as those found elsewhere, and their immense sizes prevent their being used in the smaller homes of New England and along the eastern coast.

In the latter part of the eighteenth century some of the tall kasts, or cupboards, were the only real storage pieces used in the home. Those without the painted decorations but with some detail and carving are the rarest. Some are found with inlay, along with dates and names carved into them. Different counties are noted for different details. For example, Lancaster County is known for pieces made of either softwood or hardwood with carving and detail along with folk-art painted motifs; Dauphin County for those done in high floral motifs; Berks County, for pieces with the unicorn design; Lebanon County, for painted tulips done in panels; Lehigh and Montgomery counties,

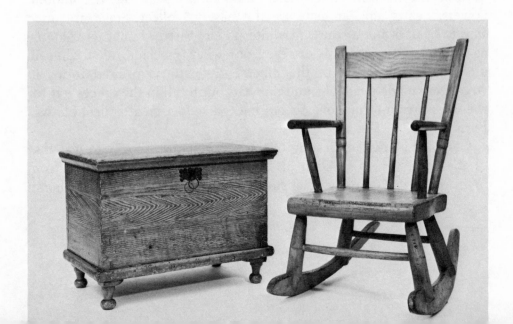

for their geometric-designed pieces. Furniture was painted in just about every state, mostly by members of the family or by itinerant artists, but nowhere was this art practiced as much as it was in Pennsylvania; much of it was done by members of the above-mentioned religious sects.

The cloister at Ephrata, Pennsylvania, was set up by Conrad Beissel in 1732. Today the original cluster of buildings built in medieval style has been restored. Here, German Pietists, both men and women, sought to serve God by leading lives of austere self-denial and pious simplicity. The Brothers and Sisters slept on board benches hardly wide enough to accommodate their bodies. Doorways were made very low in height so that all would have to bow in reverence to God as they passed through them.

Furniture, baskets, candles, paper, and other items were made here, but little has survived that can be documented. Perhaps the printing done here might still be found, as at one time the largest press in America was used to print the huge twelve-hundred-page *Martyrs Mirror* for the Mennonites. Recently a prayer book printed in German on this press turned up at a bookstall at a marketplace in Pennsylvania.

Some of the finest folk art that one can collect—that of the fractur, or manuscript illumination work and calligraphy—was made here. Most of these documents are of family records, including birth, wedding, death, and baptismal certificates. Not even the Revolutionary War interrupted the making of these documents, which have turned up in museums and private collections dated throughout the war. There are a few rules in the collecting of fractur. (Most of these documents are no larger than eighteen by fourteen inches.) The best ones are colored with illuminated paints, often made from a mixture of whiskey, varnish, and colors. Those found with angels, children, flowers, hearts, and animals are the best to collect. Some are done simply in dark ink against off-white paper—these are not as valuable as the colored ones. This art died out when mechanization came in after the first quarter of the nineteenth century; printed forms in color were made available, and one had but to fill in the spaces left for the necessary information. An era had passed—a great collectible was born.

One of the most interesting of the communalistic societies was that of the Zoar, set up in Ohio in 1817 by a group of Separatists from Württemberg, Germany. Pietism was a new force in the Lutheran

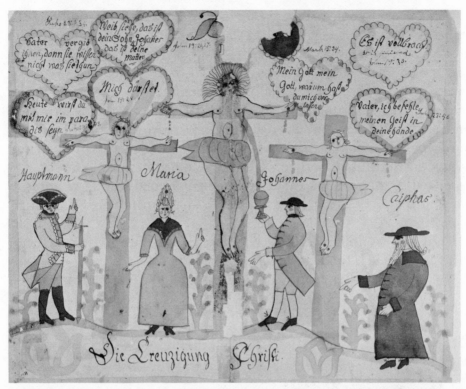

Colored pen-and-ink sketch, "Christ Crucified." The seven hearts represent
the last words (Luke 23:24, John 19:26–27, Luke, 23:43, John 19:28, Mark
15:34, John 19:30). Colors: black, red, yellow, and ochre. Size 16″ by 13″.
Circa 1800. Pennsylvania Farm Museum, Lancaster, Pennsylvania.

Church in the seventeenth century, and this demanded a more rigorous
moral life. In the eighteenth century groups no longer able to live in
Germany under such rigid tenets separated from the main body of
the church but were then considered outcasts even in their own
country. Eventually, Zoars, who had survived intolerable living condi-
tions, set sail for the New World and landed in Philadelphia. Many
were taken into Quaker homes as indentured servants. Others took to
industry and saved what money they could. Through the help of a
friendly Quaker they were able to buy a 5,500-acre tract of land
on the Tuscarawas River in Tuscarawas County, Ohio. It was given
the name of Zoar, which in biblical times was a place sought as a
refuge by Lot from the evils of Sodom—a refuge from the evils of
the world.

The leader, Joseph Bäumeler, went with a group in the fall of 1817 to build homes and clear land in order that others might follow the next year. Fortunately, there were many fields, where the Indians had grown their crops, and much timber, which could be used for construction. The Zoars were so industrious that the mortgage on the property was fully paid by 1830. At first the community operated under a free society, but after the first few years it was felt that new measures would have to be taken to insure its success. Communal living was instituted, and for a brief period after 1822 celibacy was practiced so that women could be freed from childbearing in order to work in the fields. This was lifted in 1830 as an unsuccessful experiment.

Until its dissolution on March 10, 1898, this village, named Zoar, contributed much to the economy of Ohio. In 1825 the canal was built to link the Ohio River with Lake Erie, and it passed right through

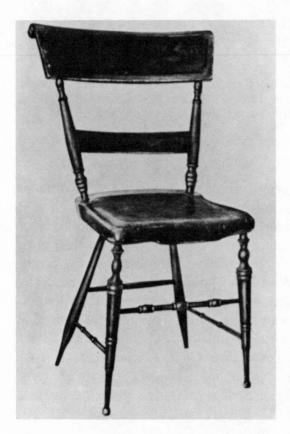

Plank-bottom side chair, circa 1830, from the Zoar community, Ohio. Gold, red, and green decorations. Jabe Tartar.

Zoar. The inhabitants even assisted in the digging of the canal and were paid by the state for their work. Buildings were set up for all facets of commerce, including a furniture shop, a planing mill, a flour mill, a community foundry for iron and tin, and machine and blacksmith shops for tools, plows, and wagons. There was much clay on the property, so tile, pottery, and other ceramics were made. The clothing made there was excellent and sturdy, and the quilts and coverlets were the equal of any.

The Ohio Historical Society is acquiring homes and buildings in the community in order to preserve it as an interesting part of the heritage of the state. It is known that much in the way of artifacts was sold by the Zoars to improve their economy; hence the interest in collecting pieces from there. The furniture is very austere, as might be expected, yet the coverlets are gay and colorful. Zoar stoves were excellent heaters, and many must have been scattered around the countryside. How much of it is pre-1830 is subject to speculation, but all the early homes must have quickly been equipped with the necessities, and it was prior to this time that the greatest growth of the community was experienced. In any event, collecting Zoar is a byword in Ohio, and others interested are beginning to learn the characteristics of the pieces so they may identify them when they turn up for sale in neighboring states. The styles are similar to those found in the rest of the country—late Sheraton and early Empire. More native styles have rigid proportions and what would be termed country fashion.

Chapter 8

Other Artisans

and

Their Work

Except for the wealthy, very few people of the Federal Period gave much thought to the beautification of their homes. They were too busy eking out an existence in territories that still contained unfriendly Indians and were met by all the challenges of nature in their attempts to travel, locate a suitable spot, build a simple log hut, and clear land on which to grow their necessities. Just to locate near a good water supply presented a problem in itself, and the farther west they went, the greater the problem.

The dowser came into his own during this period, and hardly anyone would locate on a piece of land until it had a thorough examination under a forked stick in the hands of an experienced "water witch." Many dowsers were women and were quite successful in their tasks. Favorite woods for the forked sticks were the fruit-woods, willow, alders, and even birch. The technique had been advanced so that it was (and still is) possible to determine the depth of the supply of water located.

A dowser walks with his stick twisted under pressure in the palms of both hands and searches until the pull of water forces the point downward. Marking this point, he searches further for other evidence of an accumulation of underground water, and he marks this point. He will continue this procedure until he locates the path of the underground stream of water; the other pockets of water are located, and

by pacing from pocket to pocket he can tell the depth. Those who live in the country are accustomed to city people buying land for summer homes. Until they purchase land they scoff at the dowser. After buying they realize the responsibility of locating water and the futility of just poking holes in the rocky soil, and consequently, they eagerly turn to the dowsers to help them out. I have never seen one miss yet. Consider the pioneer who had to dig his well by hand with the crudest of tools, and you can consider the importance of the dowser to him.

As the early homes were improved, the walls and ceilings became plastered, and soon they were painted and decorated with colorful pictures or designs. Many an itinerant painter received his food and lodging for his work and left an indelible imprint for us to enjoy. Some did not confine their work to the walls, decorating furniture and utensils as well.

During the early part of the Federal Period America was fast developing a group of talented portrait artists, and we are fortunate that they were able to picture some national heroes in order that we might know what they looked like. Other artists worked in painting miniatures; among them was the inventor of the steamboat, Robert Fulton, who gave up his early artwork to concentrate on engineering. Charles Willson Peale, 1741–1827, was the titular head of a talented family of painters, which left its imprint on American art as late as 1885.

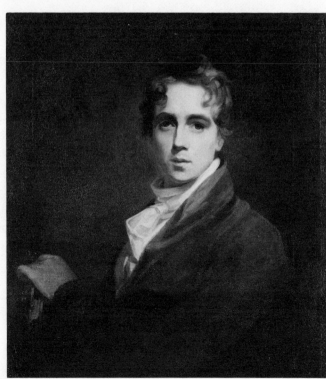

Thomas Sully, 1783–1872, at one time the leading portrait painter in Philadelphia. This is a self-portrait done in 1808. Oil. Philadelphia Museum of Art; collection of Mr. and Mrs. Wharton Sinkler.

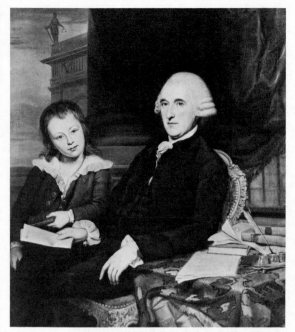 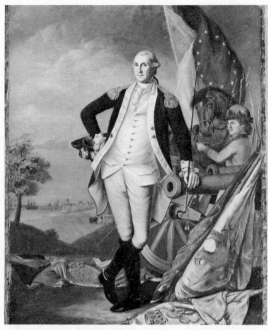

(Left) Charles Willson Peale: Governor Thomas McKean and his son, Thomas McKean, Jr., 1787, oil. 50½" by 41". Philadelphia Museum of Art; bequest of Phebe Warren McKean Downs. *(Right)* "George Washington at Yorktown," oil on canvas, 36" by 27", by James Peale, American, 1749–1831. The Metropolitan Museum of Art, New York; bequest of William H. Huntington, 1885.

His sons were named after famous artists—Rembrandt, Rubens, Raphaelle, Titian, and Franklin, who were but a few of the seventeen children he had by three marriages. A younger brother, James, learned his technique from Charles and later became father to five more Peale painters. At one time Charles opened a museum to house his paintings in Independence Hall in Philadelphia, and others in the family contributed works to be exhibited there. Between 1797 and 1800 Raphaelle and Rembrandt sponsored a museum in Baltimore, and later Rembrandt opened his own in 1814 after a trip to Paris, where he studied historical painting.

This was also the period of the famous John Singleton Copley, who was born in Boston yet worked in other cities such as New York and Philadelphia before retiring to London, where he died. He is best known for his portrait and historical work and was employed by the wealthiest of families and national figures.

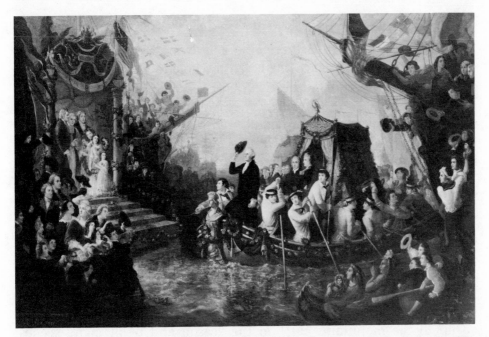

"The Arrival of General George Washington at New York City for His Inauguration as the First President of the United States on April 30, 1789." Oil on canvas, 93¼" by 142", by A. Rivey. New York Historical Society, New York.

"Tontine Coffee House, Wall and Water Streets, New York, circa 1797." Oil on canvas, 43" by 65", by Francis Guy, 1760–1820. New York Historical Society, New York.

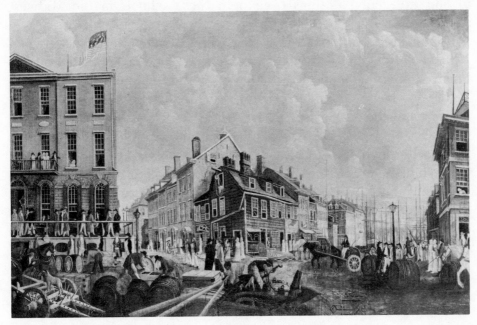

After the War of 1812 there was a growing interest in landscape work, perhaps stimulated by the English who either hired local painters or sent their own to do scenes in America which could be transposed by means of transfers to china for resale in the States. This venture was quite successful and provided a stimulus to America's infant art industry. Some at work here then were William Russell Birch and his son, Thomas, who settled in Philadelphia; Thomas Cole, of New York; Henry Inman, of New York; and Asher Durand, of New Jersey. They provided the inspiration for a future group of landscape artists who soon took to the rivers and mountains in New York State and New Hampshire to create what we call today the Hudson River and White Mountain schools of painters.

As early as 1825 Thomas Cole and Alvin Fisher had climbed Mount Washington in New Hampshire to paint scenes there which aroused great interest. The technique of most painters was that they would go up to the mountains early in the season and paint many scenes. When tourists finally arrived, they would show these pictures as examples from which additional copies could be ordered. By the time the cold weather arrived, the artist would retire to his warm studio in the city and proceed to make the necessary copies to fill his orders. Since people from all over the country began summering in both the New York State and the New Hampshire mountains, it is not unusual to find excellent paintings from both these schools in the Midwest and Far West.

Printmaking had been known in the colonies since 1670, when John Foster cut the first woodblocks and had them impressed on the then-primitive paper. His earliest work is that of pictures of Richard Mather, a clergyman; copies of these are in the Harvard College Library and the Massachusetts Historical Society in Boston. Boxwood was used for end-grain cutting, and apple and pear were most suitable for cutting on the plank sides. Gradually, the colonists evolved into the etching of copper and other metal plates, which was more difficult work, but it created better pictures. The earliest printmakers seem to have lived in Massachusetts, but it was not long before other colonies contributed their own. Peter Pelham is credited with doing the first mezzotint—that of the noted Cotton Mather—in 1727. The first engraving on a metal plate—a map of Boston—was done by Thomas Johnson, of Boston.

The mezzotint technique is best described as a complete roughing of a metal plate with crisscross lines and burnishing down the roughness to effect a gradation of the color when it was applied before printing. Many English mezzotints of the eighteenth century found their way to America and today command very good prices. There is not enough documented American work in this manner to seriously collect.

After 1800 the intaglio process of printing, which was a combination of etching and engraving, took hold, especially in the printing of bank notes, but it was also applied for the making of colored prints, often called aquatints. Lithography, done by carving on limestone, also came into being to dominate printmaking for that century. Solenhofen quarries near Bavaria supplied the best stones for this process, and they were widely used by all countries. The process involved polishing them and drawing on them with a sort of greased pencil or crayon in such a manner that the ink would not stick to the crayon markings but rather to the uncovered stone; the picture would be printed from this.

All through the period printmakers as well as painters were very busy recording the life and times, and these representations give us our most accurate account of life in the United States. That so many survived is an indication of the esteem in which they were held. The collectors of oils and prints today must become aware that subject matter as well as early workmanship is important. Pictures of historical interest or those involving famous men of the times are high on the list. Good marine and harbor scenes will always have good value. Portraits are based on the artist's name, the subject matter, and the age. Almost any portrait that can be proved of the period will have value, as it is regarded as a type of folk art, even if the names of the painter and the subjects are not known.

Too many of us have been willing to accept as fact that the figured and scenic wallpapers found in colonial homes were made overseas—most often in France or the Orient. Research is continuing on the wallpaper-makers of America, and it may not be too long before we are able to reexamine many of them in a new light with possible attribution to Americans. Names are discovered in old journals at the heads of businesses that sold wallpapers, but not all of them are explicit enough to determine whether this just meant the selling of those not made here.

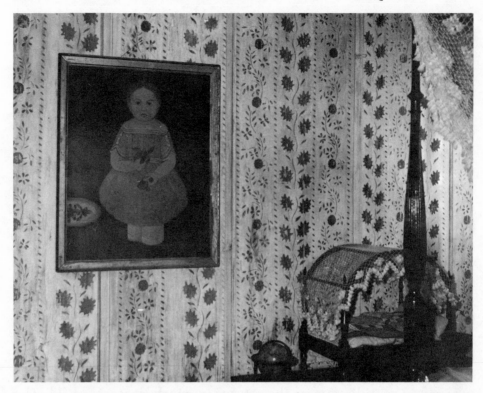

Painted and stenciled bedroom, circa 1830, from the Joshua La Salle house in Windham, Connecticut. Folk-art painting lends a good touch. Reeded bedpost suggests Sheraton design. The American Museum in Britain, Bath, England.

Records do show the establishment of a plant for the making of oil colors and paper hangings at Springfield, New Jersey, by Mackay and Dixey. They advertised:

The Public are respectfully informed that they have now for sale an elegant and fashionable assortment of paper hangings —equal in quality and considerably cheaper than any imported. As they sign their own patterns, and also prepare every material necessary for conducting said business, they have in their power to gratify the taste of those who please to encourage their undertaking in the most extensive variety. Plain paper of any colour that may be desired. Festoon borders of every description. Colours duly prepared in oil, or

in water, may be had at short notice. A few patterns of this paper may be seen at Mr. J. Trousons No. 11 Great Dock Street, where orders for any of the above articles will be thankfully received and executed with strict attention.

This concern, which opened late in the eighteenth century, at least signed its work, so more wall hangings, certainly in the New York —New Jersey area, should be more closely examined to see if they are a native product.

In 1795 another concern was advertised in Albany, New York—that of Thomas S. Webb, who was located at the lower end of State Street, two doors from the dock. He advertised rolls twelve yards in length.

In 1790 Philadelphia saw the beginning of a wallpaper-manufacturing plant, the Green Porch, at the corner of Black Horse Alley, Second Street South. This was under the ownership of Samuel Law.

Perhaps the man whose influence was to be felt most in the wall-covering industry was Ebenezer Clough, who set up the Boston Paper Staining Manufactory on the north side of Prince Street, near Charles River Bridge, in 1795. He is responsible for the memorial wallpaper made in 1800 just a year after Washington's death. On it is inscribed, "Sacred to Washington." The colors were a pale blue background with gray-and-black figures and ornaments. He advertised the paper in the *Independent Chronicle and Universal Advertiser*, Boston,

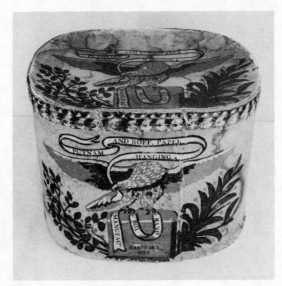

Bandbox with cover. Putnam and Roff, Paper Hanging & Band Box Manufacr., Hartford, Connecticut. Woodblock-printed paper on cardboard; 1823–1824. Cooper-Hewitt Museum of Decorative Arts and Design, Smithsonian Institution, New York.

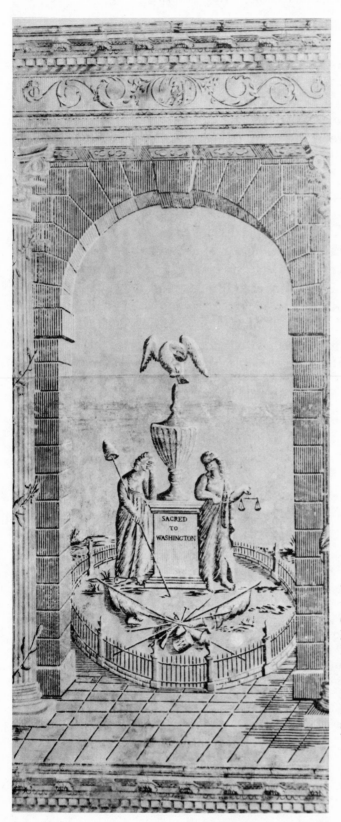

Washington Memorial wallpaper by Ebenezer Clough (active circa 1795). Paper, printed from woodblocks in black, gray, and white on blue ground. Boston, 1800. Cooper-Hewitt Museum of Decorative Arts and Design, Smithsonian Institution, New York.

September 22–25: "As the above attempt to perpetuate the memory of the Best of Men is the production of an American, both in draft and workmanship, it is hoped that all real Americans will so encourage the manufacture—that manufactories—may flourish and importations stop."

There is a legend that enough of this Washington Memorial wallpaper was given to the governor of each state to paper one room, but no evidence of such a gift has turned up to substantiate this. There are panels of it existing in homes in New England, listed by the writer; one may speculate that some of the reported gift papers might have landed in these homes rather than on public buildings. There were sixteen states in the Union at the time. The only authentication of the original story that might be considered is the fact that Isaac Tichenor was then governor of Vermont, and a panel of this paper is in the Governor Tichenor House in Bennington.

Since this period figured so closely with the birth of the country, it is only natural that books and documents that relate to these times should have great interest and value. Of the first printing of the Declaration of Independence only seventeen copies are to be found, which has resulted in an extremely high value being placed on them. These were printed the night of July 4, 1776, by John Dunlap in Philadelphia. In 1969 a copy of this document sold for over $400,000 at a Philadelphia auction.

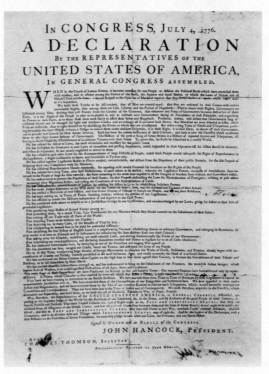

First printing of the Declaration of Independence, done the night of July 4, 1776, by John Dunlap in Philadelphia. There are only seventeen known copies of this famous broadside. Such a copy sold in 1969 at auction in Philadelphia for $404,000. Parke-Bernet Galleries, New York.

Considering the value of these printed copies, one can only speculate at the value of handwritten copies of this same document done by the original author, Thomas Jefferson, and also one by John Adams, a member of the Continental Congress and later President of the United States. Both these originals are in the hands of the Massachusetts Historical Society in Boston. Or consider the handwritten report of his famous ride, sent by Paul Revere to Jeremy Belknap, the founder of the Massachusetts Historical Society, which is included in the priceless documents preserved there. A printed copy from the first printing of the Constitution of the United States was sold in 1970 at a Parke-Bernet auction for $160,000. At the same time, Parke-Bernet exhibited an extremely rare copy of the Articles of Confederation —an unrecorded issue of the third draft of the first Constitution. The only other known copy of this printing belongs to the New Hampshire Historical Society in Concord.

It would be possible to list many other historic documents, either original or printed, but these few point up the importance of examination of boxfuls of papers and letters, which are often found at auctions of old estates. From these have come many that are not only monetarily valuable, but historically as well. It is amazing how much data has been assembled just from letters alone, as often they represent eyewitness accounts of important events in American history.

The entire nation will always be indebted to a mild-mannered Congregational minister, the Reverend Jeremy Belknap, who founded the Massachusetts Historical Society in 1791. He recognized the importance of preserving early documents and writings as his generation was witnessing the birth of a nation, and he knew these items would be treasured in years to come. Among his friends and contemporaries was John Pintard, who was later to form the New York Historical Society. Dr. Belknap was born in Massachusetts and taught school in Milton. He felt a call to the ministry and eventually landed in New Hampshire, serving as pastor of the Congregational Church in Dover from 1767 to 1786. While there he took a keen interest in history and began to besiege his friends all over the country with requests for information and documents. He wrote the three-volume *History of New Hampshire,* which was first printed in 1784 and which today is a valuable collectible. He wrote, "I am willing to scrape a dunghill if I may find a jewel at the bottom."

In 1787 he was installed as minister to the Federal Street Church

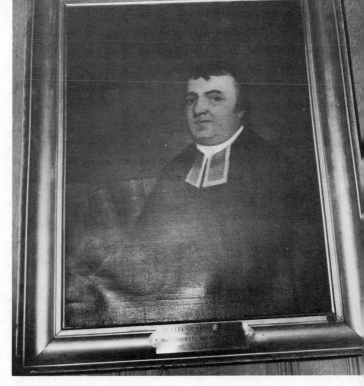

Rev. Jeremy Belknap, founder of the Massachusetts Historical Society, Boston. He was born in Boston in 1744, attended Harvard College, and died at the Federal Street Church on June 20, 1798. This is an oil on canvas by the American painter Henry Sargent, 1770–1845, a native of Gloucester, Massachusetts. Massachusetts Historical Society, Boston.

in Boston and while there worked diligently to interest his friends in creating the Massachusetts Historical Society. He wrote at its inception, "We intend to be an active body; not to be waiting like a bed of oysters for the tide (of communication) to flow upon us, but to seek and find; to preserve and communicate literary intelligence, especially in the historic way." His trailblazing efforts paved the way for creation of all historical societies as we know them today. Without the interest stimulated by Dr. Belknap, one can only speculate on how much written heritage would have disappeared.

The fad for writing histories of the United States and gazetteers of the various states did not come in until the 1830's, but these early books have historical value. Many were printed during the period, but they lacked sufficient historical and political matter to be worthwhile collectibles. For this period one must content himself with documents, letters, military commissions, signatures of prominent Americans, and military manuals. Bibles and school books of this period are of interest, but they lack much value unless they were owned and signed by historically or politically famous people.

Industry within the home furnished many collectibles. Until the spinning mills were in operation and spread around the country, the making of cloth and clothing was a full-time household project. Flax

was sowed early in April and harvested in July. It was pulled up by the roots, and the seeds were removed and pressed for linseed oil. The outside shell of the plant was retted and pounded by hatchels and flax breaks to free the fibers inside. Popular during the period was the making of the linsey-woolsey bed coverings that had been made during the century before. Some feel they are a mixture of linen and wool; others say they are all wool. Whatever they are, they are quite desirable. Generally different-colored on each side, they are made of homespun. Other popular cloth items were show towels, which were made and decorated to hang over the regular towels, and samplers, which command much attention today. Early dated quilts before 1830 are difficult to find, but Pennsylvania is best known as the quilt state, so maybe the best and oldest of the period can be found there.

Sheep-shearing and washing of the wool were generally done in May. The sheep would be driven into a stream where they would be scrubbed before being sheared. Often, even after shearing, the wool might be placed in a wool-washer, which was made much like a wooden colander, or strainer, and was left in the stream for the rushing water to pass through it. Dyeing was most often done in the field. Indigo blue was most likely bought; brown and yellow came from the bark of different trees; yellow could come from black oak or

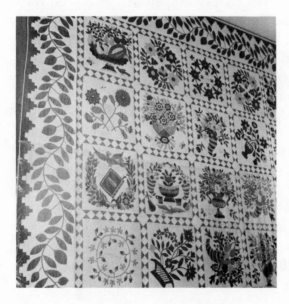

An early nineteenth-century Baltimore bride's quilt of unusually fine design and workmanship. The American Museum in Britain, Bath, England.

hickory bark; white maple bark would impart a gray color; berries of the sumach furnished red and brown; sassafras bark, orange; and pokeweed, a crimson red.

It would take eight spinners to provide enough yarn to keep one weaver occupied, which is one reason that so many wheels keep turning up for sale today. Two grades of yarn were spun—one for blankets and clothing, the other for rugs. In spinning three grades of thread were made. The best was used by the weavers, who did all the fancy and plain patterns for blankets and clothing. The covers for the Conestoga wagons were made from a coarser linen thread, and the coarsest was used for grain sacks. The cord to the sack was considered so valuable that it was made right with the sack so it would wear out with it. All bedcords, plowlines, and clotheslines were made of linen. Buttons for men's shirts were made with linen thread; they were shaped by winding the thread around two crossed pins. After being shaped the buttons were made solid by sewing the thread through and around them.

This was an era of a great deal of wood carving, as the raw material was plentiful, and people had a lot of time on their hands once the sun went down. In addition to making the regular treenware for the

Embroidered picture, of silk, ascribed to Mary Green, 1804. Subject is *Liberty*, after Edward Savage, American. Worchester Art Museum, Worchester, Massachusetts.

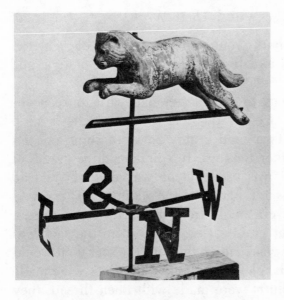

Figural weathervanes were made extensively during the eighteenth- and nineteenth-centuries. This one is a rare figure of a cat astride hand-wrought iron directionals.

table, the master of the house might be found carving small dolls or toys for the children; handles for utensils and tools; figures for weather vanes; birds and animals; spoon-holders; pipe, salt, and candle boxes; and even some decorative pieces such as religious plaques. These rather crude, country items have great appeal today and are collected as folk art.

In the more prosperous communities wood-carvers were sought to beautify homes, and here they were put to work doing doorways,

Mantelpiece; first quarter nineteenth century; made by Robert Wellford, Philadelphia. Height 58¾". Philadelphia Museum of Art; given by the Board of Public Education.

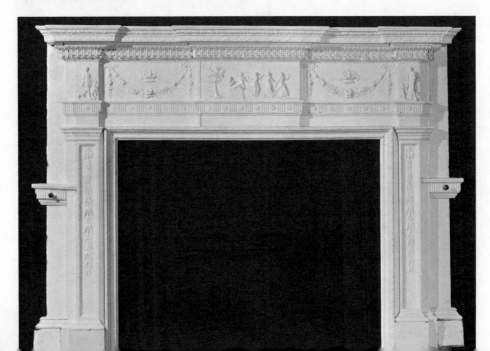

mantelpieces, fireplaces, and moldings. Many were at work doing cupboards and pieces of furniture. It would seem that the talents were equally distributed around the colonies, as the work is very good everywhere. As older homes are wrecked today to make way for urban renewal, a good business can be created by buying up fire frames, staircases, window frames, doorways, and built-in carved cupboards, as there is a demand for items like this all the time by architectural restorers.

Another facet of wood carving was directed to the sailing vessels of the time, and none would leave port without an appropriate carved wooden figurehead at the prow. Even early fire marks that were posted on homes by insurance companies were carved of wood, with

(Left) Pilgrim figurehead; wood carving in the round, dated 1781. Made of mahogany in vertical blocks glued together, coated with gesso, and painted in polychrome; 21½″ high. Found in Camden, New Jersey, this portrait bust was used on the private armed ship, or privateer, *Pilgrim*, in commission at the end of the American Revolution. The boat sailed from the port of New York City. The following inscription, incised in the wood, appears on the back of the bust: "Privat [sic] Armed Brigg/PILGRIM/1781." Shelburne Museum, Shelburne, Vermont. *(Right)* Carved wooden gatepost eagles were a common fixture during the Federal Period. They reflected a welcome to the hospitality of the home.

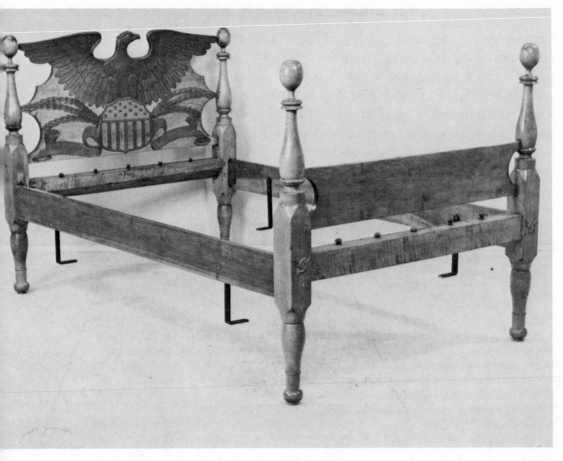

By the end of the Federal Period, the eagle was firmly ensconced as our national emblem. Here it is carried to great fruition as the headboard of this maple four-post bed. Morton's Auction Exchange, New Orleans.

possibly a brass or lead figure attached. These have assumed great importance, as they are rare. The carving of decorative burl bowls was demanding work, for the wood was hard, but many have survived with beautiful patina to be prized now.

The bald eagle became quite popular when in 1782 Congress selected it as the national emblem, much to the consternation of Benjamin Franklin, who stumped for the wild turkey, which is truly a native bird. However, the eagle won out, and he was immediately eulogized in all forms, and wood carving was no exception. He was carved in every size and position and is still one of the most collectible

items for homes, restorations, and museums. Craftsmen have never stopped carving wooden eagles, so one must judge them all carefully if he is interested in an authentic one of the Federal Period. Few clues can be given for positive attribution; wood carved fifty or seventy-five years ago will have sufficient age and patina to fool the best of experts.

The first native-made weapon of any quality was the rifle, first developed by gunsmiths in the Lancaster, Pennsylvania, area; it later won the name of "Kentucky" rifle from the settlers who went south and performed many daring deeds with them. The early matchlocks of the colonies gave way to the superior flintlock, and the heavy imported weapons gave way to this graceful, lighter, much more accurate weapon first made in Pennsylvania. At a time when the nation was still plagued with wolves and Indians, a fast-firing rifle was very welcome. Both the wolves and the Indians were tenacious in giving up their land, but both were gradually pushed westward. The wolves menaced early New York City and had to be fought off continually. They depredated flocks of sheep in Vermont and Connecticut. It was almost impossible to travel in upstate New York without being attacked

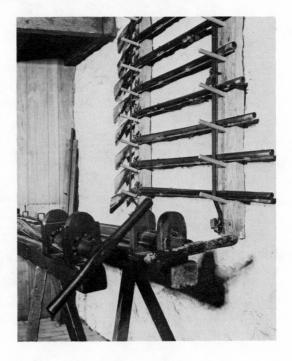

Rifling vises and Pennsylvania long rifles which helped win and maintain the peace. Most are products of Lancaster-area gunsmiths and are beautiful as well as functional. Pennsylvania Farm Museum, Landis Valley, Pennsylvania.

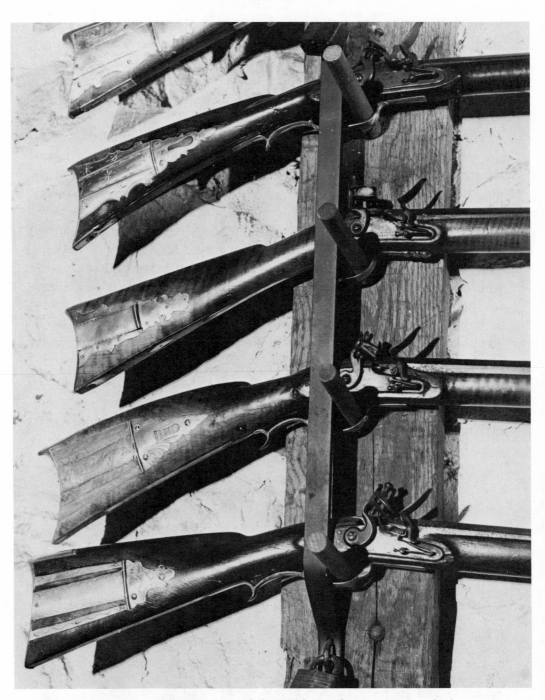

Closeup of lock mechanisms and brass butt plates and patch boxes on Pennsylvania long rifles, made by gunsmiths in the Lancaster area. Pennsylvania Farm Museum, Landis Valley, Pennsylvania.

by a pack. Pennsylvanians had their hands full guarding their dairy herds and even their dogs, which were eaten when caught.

The new rifle was made with a smaller bore and longer barrels (some up to six and one-half feet in length), was rifled for greater accuracy, and was lighter than the old Jaeger rifles which were customarily used. The first of them were made in the early part of the eighteenth century and vastly improved by the time General Washington sought out sharpshooters for the Revolutionary War from the ranks of men who carried these long rifles. Their accuracy helped to win the war, and their conservation of powder and shot, because of the smaller bore, helped the supply problem. One of the rifles played an important part in the Battle of Saratoga. A sharpshooter by the name of Daniel Murphy was ordered to shoot General Fraser of the British Army from a distance unheard-of before—over three hundred yards. Murphy fired, and down went one of the general's aides. He fired again and missed. The general knew he was being fired at but remained firmly in front to lead his troops. Murphy fired once more, and this time Fraser went down. The British troops panicked and ran, helping the Americans save the day.

Until about 1800 each weapon was individually made, but about that time Eli Whitney, more noted for his cotton gin, conceived a plan of mass production and demonstrated weapons that could be

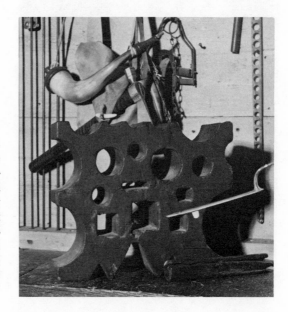

Swage, or anvil, used in the shaping of gun barrels, eighteenth century. In foreground note piece of barrel showing how it was shaped from flat steel; later it would be annealed with heat and hammering. Pennsylvania Farm Museum, Landis Valley, Pennsylvania.

disassembled and parts interchanged as they were put back together again. The flintlock gradually gave way to the percussion cap, which was perfected in 1814 in Philadelphia by Joshua Shaw. In 1811 John Hall developed a breech-loading mechanism which was the fore-runner of present-day weapons. The army installed him at the Harpers Ferry Arsenal and gave him the tools and men to mass-produce them. One of his workers was Christian Sharps, who was later to revolutionize weapons just before the Civil War.

Coastal areas are good hunting grounds for examples of sailors' art. The scrimshaw bone and ivory pieces with which they are credited are quite familiar, but this was not the extent of their craftsmanship. Long hours at sea and in port stimulated an interest in working with whatever materials were at hand to make presents for their loved ones at home—and perhaps those in foreign ports. Not all sailors sailed in whaling vessels, nor were they necessarily near a source of ivory:

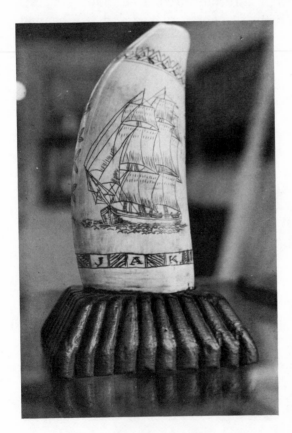

Scrimshaw, or scrimshanting, known as the sailor's art. A carved wooden base. This was a favorite collectible of the late President John F. Kennedy.

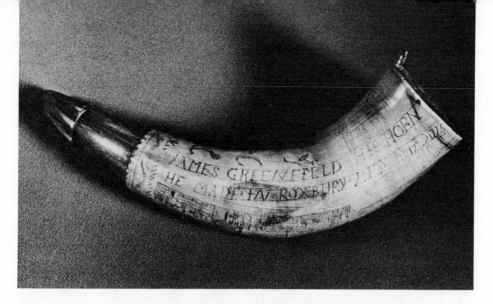

Powder horn engraved by James Greenfield, Roxbury, Massachusetts, 1775, showing the town of Roxbury, English warships, and Lorelei. Crosby Milliman Collection.

hence their interest in seashells, coconuts, exotic woods, and even tortoiseshell. Many cameo pins were carved at sea and inserted into frames purchased at ports of call in Europe, for example. Coconut shells became pin boxes, hair ornaments, and jewelry boxes. Some of these trinkets were carved in relief, showing the scene at hand while the trinket was being made.

Ship carpenters busied themselves by carving ship figures and even post eagles, which they sold on the mainland. Though not much is known of American sailors doing oil and watercolor paintings or sketches, we do know that artists of other countries painted many of our vessels while they were in port and sold the work to our ships' captains and mates. The architecture of the seaports mark the shore lines and backgrounds of these paintings.

Sailors' valentines were made from many shells arranged to resemble flowers, with their different colors and textures blended into good works of art. Jewelry was made from pearls and semiprecious stones, as these were plentiful at Oriental and Near Eastern ports. Hair-weaving was another popular hobby, and today there are many collectible trinkets, such as brooches, rings, and lockets, which contain intricate designs framed in gold or silver.

Much has been written about the early efforts in spinning and weaving, both by hand and by early machinery, but little has been said about the really fine and fancy cloths made in America. It has

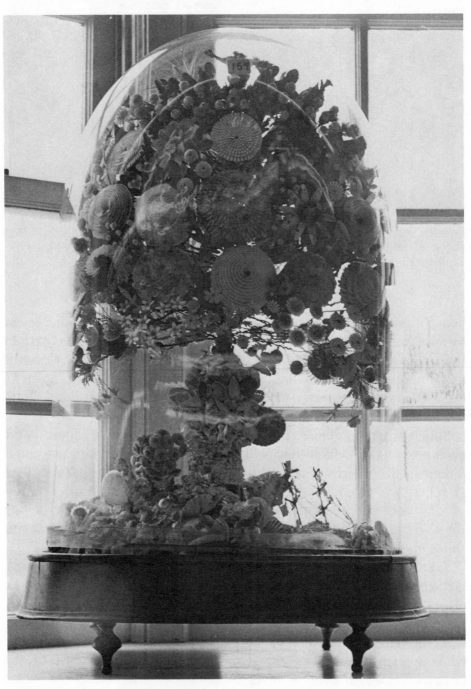

A sailor's valentine, made of shells, coral, and other sea items. This is very advanced sailor art, a considerable step ahead of scrimshaw. Richard A. Bourne Gallery, Hyannis, Massachusetts.

been taken for granted that the fine silks and satins that clothed the elegant ladies of the period came from France, England, or the Orient. Much of this is true, but actually America during this time had entered the silk-making business. The cultivation of the mulberry tree and the raising of silkworms were a branch of agriculture that had been attempted in Georgia even before the Revolution. However, the silk was of inferior quality, and the project was abandoned. It was stated at the time that every state in the Union had a climate suitable to the raising of silkworms, and by the end of the period many had developed such industry. Connecticut is perhaps the one responsible for the greatest production at the time. By 1830 a report was filed by the Committee on Agriculture, which had been empowered to "inquire into the expediency of adopting measures to extend the cultivation of the mulberry-tree and to promote the cultivation of silk by introducing the necessary machinery." They reported:

> It appears that American silk is superior in quality to that produced in any other country—in France and Italy, twelve pounds of cocoons are required to produce one pound of raw silk, whilst eight pounds of American cocoons will produce one pound of raw silk. The general culture of silk is of vast national advantage in many points of view. If zealously undertaken and prosecuted, it will in a few years furnish an article of export of great value, and thus the millions paid by the People of the United States for silk stuffs will be compensated for by our sale of raw silk.

There is great interest in collecting clothing of the period, especially those items made with native materials such as this silk. The advent of the bicentennial brings with it the promise of parades, pageants, and public events, where such garments will be worn as well as displayed.

A man who deserves more credit than he has received for his contribution to the period is John Stevens, of Hoboken, New Jersey. In 1791 he commenced his experiments in steam navigation and invented the tubular boiler. His first effort was with a rotary steam engine, but he soon substituted this for an engine made by James Watt in England. He was successful in propelling boats up to a speed of five or six miles per hour but aroused little interest with his experiments.

In 1797 Robert R. Livingston, of New York, became interested in steam propulsion and had a steam vessel built which was successfully tested in the Hudson River. He applied to the New York Legislature for exclusive privileges on the river, which they granted, providing he develop within one year a vessel capable of doing three miles per hour. He was unable to meet the deadline. In 1800 he joined with Stevens and Nicholas Roosevelt to produce a paddle-wheel steamer utilizing one of Watt's engines, but this partnership was interrupted by Livingston's appointment to represent the United States government in France. Stevens continued his experiments in New Jersey while at the same time Lord Dundas, of Scotland, became the patron of efforts to produce a steamboat. Robert Fulton was an observer of the Stevens experiments.

Fulton is said to have made copious notes. He visited Livingston in France and interested him again in supporting the building of a new ship, in which venture he was successful. He ordered a steam engine from Watt in England and built a vessel in Paris with which to experiment. In 1803 it was tested in the river Seine with great success. He returned to New York, where a newly built engine arrived from England at the end of 1806, and he installed it in his first success- ful steamboat in 1807. Since it met the specifications laid down by the New York Legislature, he was given the river privileges on an exclusive basis. It was but a few days later that Stevens was successful with his experiments, but it was too late to capitalize on the publicity attending Fulton's success. Stevens did achieve some fame, though, as he sent his vessel to Delaware Bay, which was the first oceangoing trip by steam power.

Some of these early vessels were remarkable: It was only a few years before they were traveling at a rate of over thirteen miles per hour, which made an overnight trip from New York to Albany possible. Nothing stimulated commerce and manufacture quite so much as this method of rapid transportation of raw materials and goods. The opening of new markets by these steam vessels assisted craftsmen in broadening their talents and enlarging their businesses. The craftsmen learned how to make products that were indigenous to one area and introduce them to another part of the country.

In conclusion we might consider the general account of the state

of manufactures throughout the country as made by the government in 1810. The marshals of several states and the secretaries of the territories were directed to make listings of manufacturing establishments within their respective districts, with this information being sent to the Secretary of the Treasury for submission to Congress. (Those that came from Massachusetts, Connecticut, New York, Pennsylvania, and Virginia were most complete.) The account reported that there were

> 1,776 carding machines by which 7,417,216 pounds of material had been carded; 1,682 fulling mills and 5,452 yards which had been fulled; 122,647 spindles, 352,392 looms; 153 iron furnaces; 330 forges; 316 trip hammers; 34 rolling and slitting mills; 410 naileries in which 15,727,914 pounds of nails had been made; 4,316 tanneries, producing 2,608,240 pounds of leather; 383 flaxseed oil mills making 770,583 gallons of spirits from grain and 2,827,625 gallons from molasses; 132 breweries in which 182,690 barrels of beer had been made; 89 carriage makers who had made 2,413 carriages; 33 sugar refineries in which 7,867,211 pounds of refined sugar had been made; 179 paper mills, furnishing 425,521 reams of paper; 4 stainers who stained and stamped 148,000 pieces of paper [an obvious reference to makers of wallpaper]; 22 glass works which furnished 4,967,000 square feet of window glass; 194 potteries; 82 snuff mills; 208 gunpowder mills in which 1,397,111 pounds of powder had been produced.

Tables drawn later in the period show a marked drop in production, and for good reason. In 1810 America was at odds with Great Britain as a result of events that were to culminate in the War of 1812. Though the above list includes items that are not collected as antiques today, it is interesting to note the volume of goods produced, which showed a healthy state of growth in manufacture in so few years after the Revolutionary War. The lack of imports for competition resulted in local growth, and if the war had not come along to clear the air again of differences, it is probable that the country would have advanced considerably faster in its economic growth. The British realized they needed the United States as a customer more than the United States

needed them, and it is felt that this helped influence the early termination of the war. American industry suffered from it and really didn't recover by the end of the period. By 1830 many of the products listed were being made and sold for a third the price of 1810. The tariff acts of 1824 and 1828 assisted in stemming the tide of business failures here, but with respect to the period, it ended on a dismal note for manufacturers and eventually led to the Panic of 1837.

The list of 1810 is interesting because of its omissions. The activities of cabinetmakers, who certainly offered a great contribution to the economy in both internal and export trade, were not compiled. Over $5,500,000 in lumber trade was reported, but none for furniture. Of note for 1810 is the statistic of $1,047,004 worth of glass being made as

A booming industry during the period was candlemaking. Here are dip racks, molds, and kettle as displayed at Museum Village, Smith's Clove, Monroe, New York.

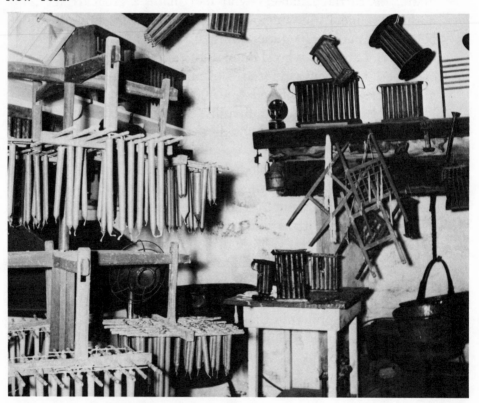

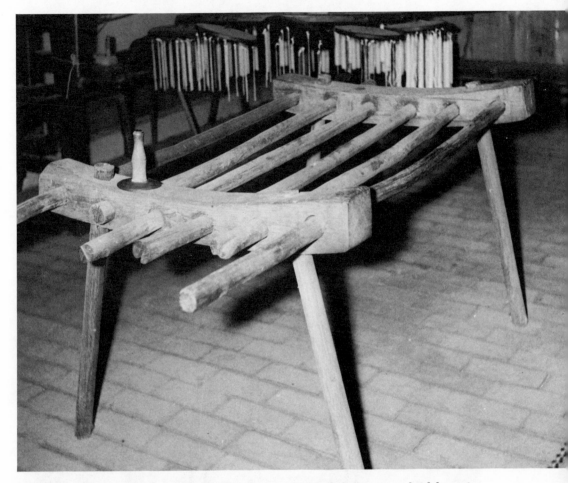

A well-used hog-scraping bench. After being scalded, hogs were laid here in order that the bristles might be removed with the scraper which rests atop. Pennsylvania Farm Museum, Landis Valley, Pennsylvania.

well as $259,720 worth of earthenware. Wig-making must have still been big business—$129,731 is credited to the "manufactures of hair." Evidently, the biggest business was that of making liquors and beers, as there are 141,191 distilleries and breweries listed.

No statistics are given for the production that took place in homes and on farms. This must have been tremendous yet impossible to compile. Every home away from a metropolitan area had to supply itself with wool and make its own clothing. All members of the families were kept busy with the making of necessities of life. Mothers and

Wooden-spike tooth harrow of the late eighteenth century. Primitive yet effective. Pennsylvania Farm Museum, Landis Valley, Pennsylvania.

daughters made soap from ashes and candles from tallow and berries; the men produced utensils, lighting devices such as lamps, lanterns, and candleholders, harnesses and other horse equipment, wagons, simple furniture, spirits of one kind or another, weapons, gunpowder, and shot. In some areas oil might be found floating in swamps, and this was scooped off for use in the home. Frequently, deposits of salt, a much needed commodity, could be found, which was cause for much rejoicing.

American citizenry of the Federal Period left many treasures. The hard life they led as pioneers was not enough to deter them from producing handicrafts, a heritage we cherish today. This was the last era of hand manufacture. No other period in American history produced so much that is truly American and of such fine quality. The English observer quoted earlier had this final observation of Americans as he left for England: "The Americans may be excused for deeming the British second to themselves." This is the greatest compliment a native of America's former motherland could have paid the citizens of the young republic.

Federal Period dining room from the Perry Plantation, Summerville, South Carolina, dating about 1806. This is as it looked in the Brooklyn Museum.

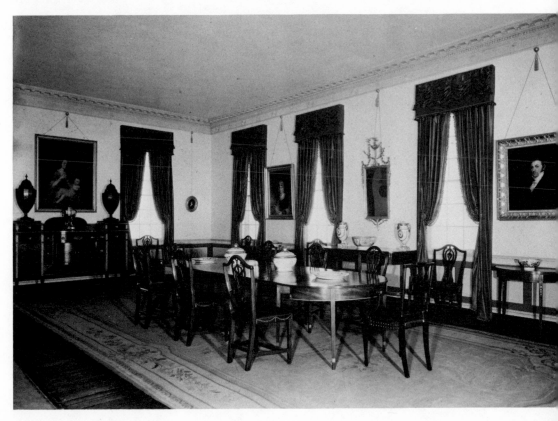

Bibliography

Barber, John W. *Historical Collections of the State of New York*. New York: S. Tuttle, 1842.

Barlow, Raymond and Joan Kaiser. *The Glass Industry In Sandwich Vol. 4*, 1983.

Barret, Richard Carter. *How to Identify Bennington Pottery*. Brattleboro, Vt.: Stephen Greene Press, 1964.

Belknap, Jeremy. *History of New Hampshire*. Dover, N.H.: O. Crosby & J. Varney Publishers, 1812.

Bigelow, Frances Hill. *Historic Silver of the Colonies and Its Makers*. New York: Tudor Publishing Company, 1948.

Bjerkoe, Ethel Hall. *The Cabinetmakers of America*. New York: Bonanza Books, 1957.

Blanchard, Charles. *Counties of Morgan, Monroe and Brown, Indiana*. Chicago: F. A. Battey & Co., 1884.

Bohan, Peter, and Hammerslough, Philip. *Early Connecticut Silver, 1700–1840*. Middletown, Conn.: Wesleyan University Press, 1970.

Britten, F. J. *Britten's Old Clocks and Watches and Their Makers*. New York: Bonanza Books, 1956.

Burbank, George E. "History of Sandwich Glass Works," *The Cape Codder*, 1925.

Burroughs, Paul H. *Southern Antiques*. New York: Bonanza Books, 1931.

Clement, Arthur W. *Our Pioneer Potters*. Privately printed, 1947.

Colonial Silversmiths, Masters & Apprentices. Boston: Museum of Fine Arts, 1956.

Cornelius, Charles Over. *Furniture Masterpieces of Duncan Phyfe*. New York: Dover Publications, 1970.

De Bles, Arthur. *Genuine Antique Furniture*. New York: Thomas Y. Crowell, 1929.

Ebert, John & Katherine. *American Folk Painters*. New York: Scribners, 1975.

Eckhardt, George H. *Pennsylvania Clocks and Clockmakers*. New York: Bonanza Books, 1955.

Elder, William Voss and Lu Bartlett. *John Shaw, Cabinetmaker of Annapolis*. Baltimore Museum of Art, 1983.

Ensko, Stephen G. C. *American Silversmiths And Their Marks*. Mineola, New York: Dover, 1948.

Fales, Martha Gandy. *Early American Silver*. Excalibur, 1970.

Fisher, Sydney Geo. *Men, Women and Manners in Colonial Times*. New York: J. B. Lippincott Company, 1898.

Fiske, John. *The Critical Period of American History*. Boston: Houghton Mifflin Company, 1892.

Glazier, Captain Willard. *Peculiarities of American Cities*. Philadelphia: Hubbard Brothers Publishers, 1885.

Goss, Elbridge Henry. *The Life of Colonial Paul Revere*. Boston: Joseph George Cupples, 1891.

Guilland, Harold F. *Early American Folk Pottery*. Radnor, Pa.: Chilton, 1971.

Hammerslough, Philip. *American Silver*. 3 vols. and supps. Privately printed, 1960–1970.

Hinton, John Howard. *The History and Topography of the United States*. Boston: Samuel Walker, 1834.

Hurd, D. Hamilton, ed. *History of Norfolk County, Massachusetts*. Philadelphia: J. W. Lewis, 1884.

Jacobs, Carl. *Guide to American Pewter*. New York: The McBride Company, Inc., 1957.

John, Dr. J. J. "The Quakers in Schuylkill County," *Publications of Historical Society of Schuylkill County*. 1905.

Kenney, John Tarrant. *The Hitchcock Chair*. Potter, 1971.

Kerfoot, J. B. *American Pewter.* New York: Bonanza Books, 1924.

Laughlin, Ledlie. *Pewter in America, Its Makers and Their Marks*. Vol. 3. Barre, Mass.: Barre Publishers, 1969.

McClelland, Nancy. *Duncan Phyfe And The English Regency*. Mineola, New York: Dover, 1980.

McGraw-Hill Dictionary of Art. New York: McGraw-Hill Book Company, 1969.

McKearin, Helen, and McKearin, George. *American Glass*. Rev. ed. New York: Crown Publishers, 1962.

_____. *Two Hundred Years of American Blown Glass*. New York: Crown Publishers, 1950.

Mellen, Grenville. *Book of the United States*. Hartford, Conn.: A. C. Goodman Co., 1850.

Merrill, Eliphalet, and Merrill, Phineas. *Gazeteer of the State of New Hampshire*. Exeter, N.H.: C. Norris & Co., 1817.

Montgomery, Charles F. *American Furniture of the Federal Period*. New York: The Viking Press, 1966.

Moore, N. Hudson. *Old Furniture Book*. New York: F. A. Stokes Co., 1903.

_____. *Old Glass, European & American*. New York: Tudor Publishing Company, 1935.

Morse, Frances Clary. *Furniture of the Olden Time*. New York: The Macmillan Company, 1926.

Osgood, Cornelius. *The Jug And Related Stoneware of Bennington Tuttle*. 1981.

Palmer, Brooks. *The Book of American Clocks*. New York: The Macmillan Company, 1950.

Parsons, Charles. *The Dunlaps And Their Furniture*. Currier Gallery of Art, Manchester, N.H., 1970.

Pepper, Adeline. *The Glass Gaffers Of New Jersey*. New York: Scribners, 1971.

Perry, Dick, and Goldflies, Bruce. *Ohio*. Garden City, N.Y.: Doubleday & Company, 1969.

Philadelphia Museum Bulletin, February, 1928.

Quimby, Ian M. G., Ceramics In America. Winterthur Conference Report: University Press of Virginia, 1972.

Ramsay, David. *Life of Washington*. Boston: D. Mallory & Co., 1811.

Roberts, Kenneth D. *The Contributions of Joseph Ives to Connecticut Clock Technology*. Bristol, Conn.: American Lock & Watch Museum, Inc., 1970.

Rogers, Frances, and Beard, Alice. *Five Thousand Years of Glass*. Philadelphia: J. B. Lippincott Company, 1948.

Rupp, I. Daniel. *History of Northampton, Lehigh, Monroe, Schuylkill & Carbon Counties*. Harrisburg, Pa.: Hickok & Cantine, 1845.

Schwartz, Marvin D. *Collector's Guide to Antique American Ceramics*. Garden City, N.Y.: Doubleday & Company, 1969.

Scoons, Carolyn. "American Pottery and Potters," *New York Historical Society Bulletin*. 1948.

Shurtleff, Nathaniel G. *Topographical and Historical Description of Boston*. Boston: City Council, 1890.

Spargo, John. *The Potters and Potteries of Bennington*. Southampton, N.Y.: Cracker Barrel Press, 1926.

Spofford, Jeremiah. *Gazeteer of Massachusetts*. Newburyport, Mass.: Charles Whipple Co., 1828.

Stevens, Sylvester K. *Pennsylvania: Birthplace of a Nation*. New York: Random House, Inc., 1964.

Stoneman, Vernon C. *John And Thomas Seymour, Vols I & II*. Boston: Special Publications, 1959.

Taranti, Alec. *Hepplewhite Furniture Designs*. Taranti, 1965.

Tilton, George Prescott. *Colonial History*. Newburyport, Mass.: Towle Manufacturing Co., 1905.

Watkins, Lura Woodside. *Cambridge Glass*. New York: Bramhall House, 1930.

Wilson, Kenneth M. *New England Glass and Glassmaking*. Crowell, 1972.

Wyler, Seymour B. *The Book of Old Silver: English, American, Foreign*. Rev. ed. New York: Crown Publishers, 1965.

Price Guide to Federal Period Antiques

The following values are based on recent selling prices of the articles in question. The best descriptions available are provided as a clue to quality.

FURNITURE

Four post bed with both reeded and tapered posts, maple, c. 1800–20 *$1500–2500*

Four post bed, reeded posts in Sheraton style, with tester, mahogany stained birch, c. 1820–30 *$1200–1800*

Stepdown Windsor chair, pine seat, hickory spindles, seven spindle, early 19th century

Sheraton fancy chair, arm; rush seat *$150–300*

Hitchcock pillowback side chairs, black with old stenciling, set of four *$300–400*

Bowfront chest, four graduated drawers, mahogany-stained birch, French legs, with figured birch veneer on drawers, mahogany banding, c. 1810–15 *$2000–3000*

Flat front chest, Sheraton, turned legs, graduated drawers, birch case, birds-eye maple veneer on drawers, mahogany banded, c. 1820–30 *$800–1200*

Bowfront chest, with French legs; mahogany, mahogany veneer on drawers, holly banding, c. 1800–1810 *$1200–2000*

Bowfront chest; four drawers graduated, mahogany-stained birch; figured birch veneer on drawers, mahogany banding; drop panel at center, c. 1810–1815 *$2500–4000*

Four drawer chest, flat front, French legs; walnut, inlaid with tulip wood, crescent drop panel, southern, early 19th century *$2500–3500*

Tambour desk, mahogany, tapered legs, holly stringing, mahogany veneered drawers, cuffed leg, Salem or Boston, early 19th century *$5000–8000*

227

Secretary, French legs, mahogany, glass doored top; birdseye maple veneer on drawers, mahogany banding, three graduated drawers, New England, c. 1800–1810 $1500–3000

Sheraton sofa, eight legs, reeded, mahogany, crest rail inlaid, New England $2000–3500

Empire styled sofa, acanthus leaf carved, mahogany, claw feet, c. 1820–30, New York State $1250–2000

Pembroke table, tapered legs, c. 1800–1810, mahogany, marquetry, one drawer $2000–3000

Pine dropleaf table, 48"; leaves 12"; turned leg, Sheraton, one drawer $300–400

Card table, rope carved leg; Empire, c. 1820–30 mahogany with mahogany veneer $400–600

Card table, tapered legs, ovolo corner; birch, mahogany banding on front, marquetry, New England, c. 1800 $800–1250

Card table, cherry, tiger maple banding on front, marquetry, c. 1800, New Hampshire $3000–4000

Card table, reeded and turned legs, Sheraton, c. 1810–20, mahogany stained birch, birdseye maple banding on front, marquetry, New England $800–1250

Federal period mirror, reverse paint; Constitution and Guerrier; gilded, c. 1820–30 $100–200

GLASS

9" lacy dish, Sandwich, flint $75–100

Coach salt, pressed, New England, clear $75–200

Masonic flask, Marlboro Street Works, Keene, New Hampshire, amber green, GV-IX, c. 1820–30 $150–250

Sunburst flask, Marlboro Street Works, Keene, New Hampshire, c. 1820–30 $200–300

CERAMICS

Two gallon jug, redware, signed Charlestown, c. 1800 $150–200

Two gallon jug, Remmey, Manhattan Wells, c. 1790's $600–800

Two gallon jug, Crolius, Manhattan Wells $800–1000

Two gallon crock, Osborne, Gonic, New Hampshire $400–500

Two gallon jug, Commeraw, Corlear's Hook $800–1000

Crock, two gallon, Xerxes Prices, South Amboy $600–850

Pitcher, porcelain, 1828, William Ellis Tucker, Philadelphia $2500–3000

Pair of pistol handled urns, Tucker and Hulme, Philadelphia $4500–6000

Redware shaving mug, Maine $150–250

Redware dish, decorated, Pennsylvania, 9" (no maker's name) $600–800

CLOCKS

Tall clock, Aaron Willard, Jr., mahogany case, moon dial *$25,000–45,000*
Tall clock, Simon Willard, mahogany case, moon dial *$45,000–60,000*
Banjo clock, reverse paint, unsigned *$1000–1500*
Banjo clock, Samuel Whiting, Concord, Massachusetts *$750–1200*
Banjo clock, Aaron Willard, eight day, reverse paint *$2000–3000*
Pillar and scroll mantel clock, Seth Thomas, Plymouth, Connecticut, mahogany case *$1500–2500*
Pillar and scroll mantel clock, wooden works, Silas Hoadley, Connecticut, mahogany case *$850–1200*
Tall clock, unmarked, English brass works, American case, maple & pine, New England *$1200–2500*
Transition clock, Riley Whiting, Winchester, Massachusetts, mantel, mahogany case, reverse paint *$800–1000*

METALS

Coin teaspoons *$15–35*
Coin tablespoons *$20–45*
Coin sugar and creamer *$65–85*
Coin compote, 8″, with handle *$300–450*
Cream pot, Paul Revere, silver *$10,000–12,000*
Teapot, Gerardus Boyce, New York, silver *$2000–3000*
Teaspoon, Benjamin Burt, Boston, silver *$350–500*
Sugar and Creamer, Simon and Chaudrons, Philadelphia, silver *$1200–1500*
Sugar and creamer, Franklin Porter, New York, silver *$500–600*
Comport, George Snyder, Philadelphia, silver *$1200–1500*
Tin document box, decorated, Zachariah Stevens, Stevens Plains, Maine (Westbrook), 6″ *$350–500*
Tin tray, decorated, floral, Chippendale *$300–450*
Iron rush holder on wooden stand *$250–350*
Copper warming pan, punched eagle, wood handle *$350–450*
Iron utensil rack with four utensils *$85–95*
Iron rooster weathervane figure, 20″ *$350–500*
Brass fireplace fender, tubular, 42″ *$400–500*
Iron Betty lamp, with pick *$100–200*
Charger, pewter, Samuel Boardman and Thomas Danforth, Connecticut, 12½″ *$300–400*
Dish, 9″, George Lightner, Baltimore, pewter *$250–350*
Porringer, 3½″, Richard Lee, New England *$250–350*
Basin, Thomas Danforth, Connecticut, pewter 7″ *$350–500*
Dish, 12″, pewter, Nathaniel Austin, Charlestown, Massachusetts *$350–500*

MISCELLANEOUS

Carved wooden butter mold, round, cow $50–75

Pine doughbox on legs, Pennsylvania $400–500

Splint basket, 14″ with handles, Shaker style $75–125

Jacquard coverlet, eagles, Pennsylvania, 1820 $600–800

Powder horn, engraved, War of 1812 $3000–3500

Sampler, 1820, floral, house, animals, South Dorey $600–800

Candle lantern, punched tin $75–85

Flintlock, 47″ barrel, with ramrod, Whitney, for War of 1812 $750–1000

Pistol, single shot, flintlock, unmarked, brass mounts $350–500

Hanging spice cupboard, eight drawers, pine $200–300

Pine blanket chest, 4′, dovetailed, six boards, with ditty box, rat tail hinges, old red $200–300

Schoolmaster's desk, pine, maple legs, 3′, Sheraton period, early 19th century $250–400

Pine pipe box, with drawer, hanging, in old paint $1200–1500

Index

236